Archive 48

FICTION 03

Earthly Days

José Revueltas

Introduction
by Álvaro Ruiz Abreu

Translated
by Matthew Gleeson

Mexico City and San Francisco

Archive 48 books
Edited by Pedro Jiménez
www.archive48.com

©1949 by José Revueltas

English translation ©2020 by Matthew Gleeson
Introduction Copyright ©2020 Álvaro Ruiz Abreu
Introduction English translation ©2020 Matthew Gleeson
Nick Hoff contributed to the editing of this translation
Reprinted by permission of Ediciones Era (Mexico)
Originally published by Editorial Stylo in 1949
First published by Era Ediciones in 1973
Back cover copy ©2020 Arturo Dávila
All rights reserved.

Book design and cover by boo.design

Library of Congress Cataloging in publication data
Revueltas, José [1914-1976] author. | Ruiz Abreu, Álvaro,
1947 — writer of the introduction. Gleeson, Matthew,
1979 — translator.
Title: Earthly Days
ISBN: 978-0-9992455-2-1
p. cm – Archive 48
i. Mexico—fiction II. Matthew Gleeson. II. Title.

Earthly Days

INTRODUCTION

Revueltas: Mystic or Redeemer?

I.

Toward the end of 1949, José Revueltas finished the long and ambitious literary project into which he had poured great artistic, ideological, and political hopes: *Los días terrenales*, the book translated here as *Earthly Days*. It would become not only a controversial piece of writing, but a work that represented a generation. The following year, his play *El cuadrante de la Soledad* premiered at the Arbeu Theater, also becoming the target of fierce criticism by his Marxist comrades—and so both of his works were heaped on the pyre by the Mexican Stalinists of the era. Revueltas begged his readers' and critics' forgiveness, admitted to having committed faults in his two impugned works, and didn't doubt his comrades' good intentions. He instigated a discussion within the ranks to help delineate concepts. During this heated conversation, Revueltas finally found clarity regarding his creative activity and accepted that the criticisms of both of his works were "objective," made in the light of "the most advanced thinking of our time," including that of the great masters of international Marxism, and that they "warrant that I immediately conduct a radical and exhaustive reassessment of my

work as a writer."[1] He also promised to correct the errors so plainly observable in *Earthly Days* and, with this attitude, perhaps enrich literary criticism in Mexico and art in general. Once he had accepted his "error" as a sin he would not commit again, Revueltas made the according expiation, declaring, "I meet the reassessment of my work with the joy of someone who has no fear of the truth, but rather desires it; and with absolute confidence in my own resolve to carry on, through the test I face today, my contribution to the cultural life of my country."

II.

As early as 1944, Revueltas had begun to write various chapters and conceive certain characters in what would be his great response to the Mexican Communist Party (PCM, for its initials in Spanish). But his years in film and theater, his second marriage, and his tireless labors as a journalist kept delaying the work. Finally, from his guts sprang a novel of clear confrontation between the exegetes of Stalinism, loyal to the doctrine of Moscow, and those who recognized the ideological tyranny implied by such an understanding of Marxism. The author, under pressure, fell prey to uncertainty when he saw that he had publicly exposed not only the dogmatism and dehumanization of the Mexican Communist Party, but also a partisan behavior that was held secret among the same comrades.

1. José Revueltas, "Decide revisar profundamente su obra literaria el escritor José Revueltas," *El Popular*, June 16, 1950, 3.

This tense, visceral context explains the inquisitorial accusations the Communists launched against José Revueltas, ex-comrade of the PCM (he had been expelled from the party in 1943), as well as his response to them. Revueltas surrendered himself to the excoriations of his comrades and the moralists who confined him to silence. These attacks began in 1950, but they went on circulating for many years, and Revueltas lived with their accusatory echo until his death. In interviews and in certain writings that looked back on Stalinism, he tried to explain in clearer detail the partisan maelstrom that had insisted on destroying his book. He went on considering *Earthly Days* to be his best work, his most fully achieved novel, in which he had deposited all the skepticism and ideological baggage he carried from his years under the party's tutelage, along with a large part of his vision of humankind, human nature, and art. So then, what is the book you hold in your hands about, and what is it like? Its narrative structure involves several simultaneous stories that intersect; in each one, the characters' backgrounds and actions are retraced through flashbacks, and the author uses interior monologues in particular as a trigger of the unconscious. It is the story of a handful of militants in the Communist party who, in their attempt to change the world, forget their desires, their intimate lives, their love for their children, and their fellowship with their comrades. They become robots in an infernal machinery that guides their sad lives. The narrative reflects the situation of the years

1928–34, when the PCM was outlawed by the Mexican state and operated clandestinely, which gave its militants an angelic aura that sanctified their actions.

This was the story that Revueltas's friends didn't understand and didn't want to understand when they abruptly saw themselves portrayed in the author's direct, cruel writing. A blind, top-down polemic broke out against Revueltas, who, playing into his colleagues' hands, placed all his chips on one bet and was outmatched: he gave the benefit of the doubt to those who lambasted him, and he lost. It was clear that Revueltas saw himself as more of a mystic than a revolutionary, that his social endeavors were an Earthly compensation for the absence of God, and that there was a Father always watching (the Communist party, or his brother Silvestre, the fathers this orphan recognized), at whose right hand stood the son, but not in order to obey: rather, in order to rebel against all images of authority.

III.

The history of Mexican literature had never seen a case like Revueltas's when he asked his editors to withdraw *Earthly Days* from circulation and halted the stage production of *El cuadrante de la Soledad*. The attacks had brought the author to his knees this time, and the goal was achieved: to drive him to retract his work. The most ambitious and serious criticism of the book was leveled by Enrique Ramírez y Ramírez, and Revueltas accepted it in all its terms. The critic advised the young writer to

rethink things, for he needed to save himself and "come back to Mexico." Ramírez y Ramírez saw in this novel a confirmation that the defeated, the perverse, the frustrated, the invalid, and the criminal—the "dark side of reality"—was all Revueltas was interested in describing. With openly partisan intentions, Ramírez ideologically twisted Revueltas's arm when he asked: Where are the workers and campesinos? Where are their struggles? Where is their longing for freedom, where are their desires to change the capitalist world that exploits and oppresses them? No, Revueltas didn't want to see any of that. And so his novel wasn't a reflection of Mexican reality, since, Ramírez insisted, the Mexican people aren't just those deformed and vice-filled masses, but also immensely enlightened souls. And he describes the opening scene of *Earthly Days* with marked irony, deriding the characters, who for him are caricatures of a deformed world in ruins. "I want to believe that Revueltas's divorce from the daily, intimate, living and breathing facts of the people's struggle has weakened his sensibility, his natural sense of things. And that, on the other hand, the 'cosmopolitanism' of the sad pseudointellectual coteries, his yoking without any decisive counterweight to the influence of that 'dream factory' of commercial cinema, which is today a factory of degrading nightmares—and, by the same token, his weak contact with the grand revolutionary ideas of our era—have severely narrowed and schematized his thinking."

History has shown that Revueltas was right and that his "critics" belonged to a Stalinist sect that blindly

obeyed the diktats of the Kremlin, a dogmatic clique that did everything it could to put him through the wringer and reduce a novel like *Earthly Days* to dross produced by "bourgeois decadence." But what is there in this book to have made it the target of such criticisms? Far from the partisan accusations and political condemnation aimed at the novel, poet and editor Alí Chumacero reviewed *Earthly Days* in 1949 and said that no other Mexican literary work that year had aroused so many "misguided" judgments. For him, the novel proposes the tension between action and the individual, between "social cause and personal endeavor." Nevertheless, Revueltas's sin had been to demonstrate that the world of the time was miserable because of a guilt complex. This perpetual questioning of existence is one of the most recognizable qualities in the work, Chumacero explains. Revueltas only wanted to show where humanity's hopelessness leads and what it is, even making use of a phenomenology of excrement that many find daunting and demoralizing. "It is the human spirit— that highest product of matter which is thought—that must, when all is said and done, designate a meaning, a terminus, a justification for the arbitrariness of the universe."[2] Chumacero doesn't see an "exaggeratedly tendentious" novel; he sees a plunge into the dark inner labyrinths of humanity.

2. Alí Chumacero, "*Los días terrenales* de José Revueltas," *México en la Cultura*, no. 46, December 18, 1949, 3.

IV.

In his first novel, *Los muros de agua* (The Walls of Water, 1941), Revueltas offered a profound report about the Islas Marías, where he himself had been imprisoned, and the parade of martyrdoms the Communists were subjected to during the time known as the Maximato, between 1928 and 1934. In *El luto humano* (1943; *Human Mourning*, also translated as *The Stone Knife*) he provided an X-ray of the Mexican people, history, and national identity, returning to the 1930s and the Communist redeemers who would save humanity through sacrifice. He tried to place *Earthly Days* in that same line, with a caveat: the Communists no longer believed in life or in the shining future announced by Soviet socialism; instead they rebelled against any kind of hope. Revueltas himself had rebelled in 1943 against the central leadership of the PCM, and his expulsion from the party was the natural consequence of his defiance. But he went on sketching apostles of the proletariat in his 1949 novel, and he came up with a "red priest," Fidel, an example of dogmatic obedience and orthodox Communism (like the Communism Revueltas had practiced in real life in the 1930s), side by side with a dialectical redeemer of the exploited, Gregorio, and two celestial angels of socialism, Rosendo and Bautista. These four figures structure the narrative, drive the story told within it, bring life to it, and impose a rhythm of frank confrontation. There is no dialogue between them; instead, each one elaborates his own private monologue, which leaves them floating in the universe. Revueltas lived

many years alone, in a permanent state of reflection about his existence in the world and the party; the monologues in *Earthly Days* are perhaps the monologues of hopelessness that upset his comrades so much. These characters never seek out dialogue, an exchange of opinions in order to know the world—they lock themselves up in their thoughts, shutting out all communication with the rest, and torture themselves. Each of them is alone, separated from the world, on the edge. At times the fiction seems traced from real life: during the years Revueltas was passionately and painstakingly working on this novel, he was tormented by the question of money and the need to pay the rent. Every week new money woes took him by surprise, in a city that held him trapped, among his comrades and a hostile artistic and intellectual milieu. His characters bear the stamp of suffering—their lives are never free and full, they don't even enjoy their youth, and an inner demon hounds them: faith in the revolution.

It's easy to see in this novel a crucial confrontation between Gregorio and Fidel. But in fact, as in other Revueltian narratives, these are characters who reflect an unbridgeable duality inside themselves. Ventura is a cacique and at the same time a seer, a demigod; Gregorio is the rational, critical conscience of the Communist Party and also a redeemer of the oppressed, an incarnated Christ of Communism very similar to the character Natividad in *El luto humano*. But Revueltas doesn't just show us an opposition between good and evil, rich and poor, beautiful and horrifying, blind and seeing,

dogmatic and dialectic; he also tries to lead his creations into the torment entailed by free will, an idea he took from his early and in-depth readings of Dostoyevsky.

It's evident that many scenes in *Earthly Days* are taken from the author's own biography; his friend in those years, José Alvarado, saw this clearly and wrote that Revueltas's activity was like a piece of luggage he carried with him all his life: "to redeem the miserable and organize literary assemblies. His characters are precisely those miserable people and his novels are precisely those assemblies."[3] The flame that had begun to consume Revueltas's soul ever since his earliest years of political militancy became more intense between 1950 and 1956; the attack on his novel and his play devastated him. Mystic or redeemer? Both at once—that is to say, Revueltas lies somewhere between Fidel the exegete and Gregorio the rebel, the most controversial creations in his entire work, the ones dearest to him and the ones who gave him the most gigantic headache. It's people like him that Walter Benjamin's phrase exists to describe: "Only for the sake of the hopeless ones have we been given hope."

<div align="right">

Álvaro Ruiz Abreu
Coyoacán, January 16, 2020.

</div>

3. José Alvarado, "La obra de José Revueltas," *El libro y el Pueblo*, no. 36, January 1968, 16–17.

TRANSLATOR'S NOTE

The savaging of *Earthly Days* when it came out is made sadder by the fact that Revueltas seems to have poured everything he had into this book. This is the novel of his that provides the most wide-ranging portrait of early-1930s Mexico, when it was illegal to be a Communist Party member. Those had been formative years for Revueltas, a lifelong militant who joined the Communist Party as a teenager and was sent to do hard labor on Mexico's prison islands, the Islas Marías, for it—and who later, at age 54, joined the 1968 student movement that would be brutally suppressed with the Tlatelolco massacre, and was again sent to prison. *Earthly Days* strikes me as the most personal and the most political of his novels at once. It's the one that most openly and directly deals with uncomfortable questions Revueltas must have been wrestling with in his own Marxist activity: of whether party doctrine is compatible with being a real, living human being; of whether people are essentially noble or essentially squalid and brutal; of how to find hope when filth and exploitation pile up on all sides. But these questions go far beyond political activity here, pervading all realms of life, from a guilt-ridden memory of a night with a lover to a 4 a.m. walk through the city dump, from an attempt to analyze a dead man's face to a meal at a soup kitchen for the unemployed.

The backlash at the time was fixated on the book's political heresy and seemed to ignore its literary qualities.

Or perhaps that's not quite true: maybe Revueltas's turn to other concerns that didn't aid the party line was part of the insult. This novel is indeed as "existentialist" as his angry comrades accused it of being (and existentialism, according to Communist leader Enrique Ramírez y Ramírez, was "worse than poliomyelitis"[1]): haunted by the seeming purposelessness of existence and the prevalence of bad faith. But seventy years later, that seems to be a strength. It's also full of intense drama and sometimes gruesome detail—there are murders, affairs, romantic relationships gone sour, acts of voyeurism, police violence and torture, the death of a child, and a horrific trip to a medical clinic. If this book, published in 1949 and set in 1932, is only now arriving in English for the first time, translating it did not even remotely feel like dusting off a historic curiosity. The text still lives and bleeds and doubts, and it's hard to read Gregorio's vision of "the face of the executioner" at the end without the feeling that it's disturbingly relevant in the United States in 2020.

This is the novel in which Revueltas first let out all the stops with the complex style he would later take to its elegant extreme in *El apando* (translated in 2018 as *The Hole*, published by New Directions). It's a baroque, exuberant, hyperbolic style, full of long vines and creepers of syntax, clusters of jarring and beautiful imagery, and sometimes thorns and cobwebs. Revueltas switches

1. Quoted in Florence Olivier, "*Los días terrenales*, un debate," in *Los días terrenales*, by José Revueltas, critical edition, ed. Evodio Escalante (Madrid: Fondo de Cultura Económica, 1996), 252.

registers on a dime, veering from the informal speech of a rural prostitute to erudite discourses on El Greco. He fascinatingly combines the gritty darkness and dramatic tools of noir narrative—which we often associate with the clipped, minimal writing and tight-lipped approach to emotion pioneered by authors like James M. Cain—with a patient delight in lush, convoluted descriptions and thought processes that might seem closer to Henry James or Herman Melville (though more street-savvy). Translating this style was a juicy challenge. Because of the differences between Spanish and English rules of syntax, sometimes I felt the need to adjust phrasings or break sentences, but I tried to be sensitive to the rhythms of the original and to preserve its tangled, overgrown, labyrinthine qualities. It doesn't fit the contemporary United States' aesthetic taste, which tends to equate simplicity and minimalism with "good writing." I think this taste will prove to be arbitrary and historically contingent.

A few notes about specific choices made in the translation: The book is rich with colorful—but not folkloric—detail related to urban and rural Mexico. In a very few cases, I left words in Spanish when they seemed inextricably tied to Mexican settings and meanings. The word "pueblo" is left as is at a few strategic moments because of its crucial double meaning that covers both "town/village" and "the people," which no word in English quite expresses. "Campesinos" has been left as is to refer to people who live in the countryside and work the land, very often Indigenous; to me it's a noble word. The word "peasants" might work only if invested with

the meaning and admiration that John Berger gives to the term, and I don't think most readers of English will read it that way unprompted, while terms like "country people" or "farmers" strike me as having connotations to U.S. readers that are off-base: thus it almost always remained "campesinos."[2] The characters in the book refer to each other sometimes as "camarada" and sometimes as "compañera/compañero." "Camarada" has been rendered as "comrade," familiar Communist Party usage. But "compañero" has been left as is; it combines meanings of friend, companion, and partner in struggle in a way that no single word in English does. I agree with the journalist and author John Gibler that "compañero" deserves to enter into English with all of its meanings intact. It's used among the Communist townspeople in Acayucan here instead of "camarada"; it's a term that more organically grows from campesino and worker culture in Mexico; and the distinction in this novel seems significant to me.

Readers today will probably find that Revueltas sometimes draws on insensitive ethnic and gender stereotypes. This is how Revueltas wrote in the 1940s, and rather than eliding these elements, I see more value in leaving them visible to generate fruitful critique. And, though there are attitudes to be named as problematic here, there's also a huge amount of complexity to grapple with: women may be sidelined and humankind may

2. Among other works by Berger, a good starting point for his thoughts and feelings about peasants is the introduction to *Pig Earth* (New York: Vintage, 1992).

be called "man," but there are also penetrating criticisms of masculinity and glimmers of women's liberation from sexual double standards and toxic relationships; many may wince at seeing the offensive adjective "primitive" used in relation to an Indigenous community, yet the characterization is more nuanced than that, and Revueltas vehemently drives home the point that in the end it's the urban whites and mestizos who are primitive, base, barbaric, and subject to dark myths and superstitions. Revueltas's voice, coming from among the downtrodden and the outsiders, vacillates between empathy, idealism, cruelty, and horror in unsettling ways.

Every translator should have a good editor and trusted comrades of another mother tongue to consult with. I want to especially thank Nick Hoff, editor with Archive 48, for his dedicated dialogue and strong eye for language, which surely improved this English text. Thanks to Pablo Márquez and Citlali Zavala—sharp, sensitive readers who were ready to pore over arcane and anachronistic terms, street slang, and Revueltian convolutions in Spanish. And deep thanks to head editor Pedro Jiménez, whose enthusiasm and knowledge carried this project along the entire way.

Matthew Gleeson
Oaxaca, January 2020.

Earthly Days

For Rosaura and Andrea

For María Teresa

...there is a certain logic, a course that each person must give their destiny. As for myself, I tolerate nothing but hopelessness of the spirit...

Jean Rostand

I.

In the beginning had been Chaos, but all at once the agonizing spell was broken, and life arose. Atrocious human life.

"It must be around four," replied the voice of one of the caciques. "We have plenty of time."

In the beginning, before Man, had been Chaos, until voices sounded.

The cacique hadn't replied immediately; instead, like a grave and mysterious oracle, he had let a long moment elapse before telling Ventura—whose voice Gregorio had recognized when he heard the question—what hour of the morning it was.

"Around four," the voice of One-Eyed Ventura agreed. "We have plenty of time. But we have to get moving."

Then, like a far-off bonfire shooting out small, invisible sparks—with the same sharp popping logs make in the embrace of a distant fire—the night began to mysteriously crackle, in one shadowy corner and then another, wounded by a wind of daggers, at first softly and intermittently, and then cruelly, impetuously, in a lively *allegro*.

Gregorio half closed his eyes, but when he lay back against the ceiba tree, trying to understand what was happening, he couldn't experience again that first sensation he'd had in the time of Chaos: the bitter, seductive enchantment had disappeared, the spell had been broken, and now everything was completely different. There was nothing of the immense void that had assailed him, that solid sensation of a night so tremendously nocturnal that nothing else existed, the uneasy yearning that came along

with it. Night, shadows, resounding emptiness, just like before. Impenetrable blackness, yes, but now without the anxiety he'd felt a few minutes ago, for the night's negation of color, its strange absence of living things, had suddenly become human, suddenly harbored monstrously human things that had forever disrupted the presence of that nameless, deep, essential, and serious something he was on the verge of apprehending, which now slipped hopelessly away.

The soft noise that robbed the night of all its unprecedented depth and absolute colorlessness was only the pattering of small stones and bits of dried clay the men were throwing onto the withered ferns that lined the river up to its nearest bend, to drive the fish out of hiding and into the current.

Hearing it, Gregorio sensed that the solitude wasn't empty, but rather turbid and mysteriously inhabited: this strange and contradictory fact was what had broken the spell, the indefinable anguished sensation he tried in vain to summon again.

The silent shadows of the fishermen moved along the bank slowly and calmly, as if, apart from some superstitious motive they might have, they were trying to rein in their greed now that their satisfaction was assured. They weren't like other fishermen who read their fortunes as a matter of sheer chance; their movements were serious, restrained, and slow. But despite their slowness, or perhaps because of it, they betrayed a confident, joyful, quiveringly secret yearning, seeming to anticipate the pleasure of possession. And so, in the cautious way they bent their bodies toward the river's edge, in their magical way of discerning upon the dark and solid-looking

surface of the river the undetectable concentric circles that betrayed the stirring of subaquatic life, in the way they penetrated to the very bottom of the waters with a gaze like a black knife, in all their poses and gestures were a firm calculation, a strong and aggressive resolve, and a knowledge of things stretching from the most distant past into the most remote future, containing both harsh wisdom and ruthlessness.

One-Eyed Ventura stood out from the other shadows because of his missing left arm. He detached himself from the group to approach Gregorio.

"Ah, what a compañero!" he said from a distance. It was impossible to tell if he was speaking sarcastically, since the habitually flat tone of his voice was given expression only by the lively, intentional movements of his face, now hidden in the shadows.

"Ah, what a compañero!" he repeated, suddenly next to Gregorio. "Look at you, no one can even see you here in the dark, you're so quiet!"

Gregorio could smell—without disgust, since he was used to it—Ventura's sour breath, with its odor of fermenting corn. Ventura's words made him smile: his silence and stillness, the fact of being "so quiet," in a strange mingling of the visual and the auditory, made him an invisible being, a being that "no one can even see" because he couldn't be heard—one that didn't exist, in other words. "Perhaps," he thought, "even if Ventura didn't mean it that way, it's a perfect definition of Death." That which has stopped being heard. All that is no longer heard.

"The pool doesn't have enough poison," Ventura explained, unnecessarily. "It's not working—it needs a little more. You wouldn't have any bits of barbasco left...?"

If he asked for the poison with such an oddly humble and circuitous question, he surely meant for it to be taken as proof of his regard, almost a form of reverence.

With melancholy indifference, Gregorio handed two pieces of the toxic vine to Ventura, who walked away. A few moments later he heard his voice, but from farther off.

"I see you looking sad, compañero Gregorio. What's the matter?" His voice might have been ironic or mocking or sincere; it was impossible to tell because of its faceless-ness. "I see you looking sad."

I see. Again like a kind of sensory incest. Again that damned way of expressing himself, so twisted and precise. Seeing into the shadows purely by means of a person's silence or lack thereof. "Of course," thought Gregorio. "He doesn't need eyes to see me. He sees me with other senses. He only needs to know I'm not talking, he only needs to not hear me, and he can see me."

"Don't worry, compañero Ventura. Really, I'm not sad," he replied, purely in order to hear the sound of his own words.

Below, near the gentle curve of the riverbank, Ventura began to crush the barbasco on a tree trunk, making a harsh noise. With this the vine would "let go of" its detestable power of death and soak itself in its own bitter, criminal juice.

When Ventura finished, it grew quiet. With religious silence and stillness, the other men awaited the slow work of the poison.

Gregorio half closed his eyes again, while a warm breeze stirred his shirt and made him feel the sweat on his chest. He wanted to abandon himself among these shadows so conducive to his thoughts, to his anxious desire to locate

himself and take the measure of his own existence down to its depths. But the reality floating all around him had far more power: the motionless and watchful men, the dark slow tumbling of the river in its bitter silence, this world of prowling and lying in wait. It gripped him violently and would not let him escape.

A short distance away on the steep riverbank, the reeds gave a low and dolorous groan of complaint, made all the more poignant by how huge and strong they were. It was like the lament of old boats tied to the docks, languishing in melancholy with their creaking frames.

The passing of each instant felt awful and implausible, as the night released the future in discrete, anxious pauses, black lakes of longing and ambition, in a single chain that tied the men together, breathing identically, their hearts beating identically.

Suddenly the surface of the river began to bubble with small eruptions of water from its depths.

The voice of One-Eyed Ventura sounded, jubilant with victory: "The poison's working! Go to the crossing! To the floodgate! Get the nets ready!"

The anguished bursts of the fish seemed to rain thousands of quick, indistinct splashes onto the surface of the water, as if perfectly round hailstones were falling in different rhythms. One could imagine the desperate rushing underwater, the frantic gasping for breath, the senseless darting of the frenzied fish, uncomprehending and astounded, who fled downstream as the asphyxiating poison invaded their atmosphere, almost human in their brutal determination not to die.

Then the lone voice of Ventura: "To the crossing! To the crossing!"

Gregorio pulled off his shirt and ran down to the crossing along with the rest of the men, feeling their violent, ravenous, animal joy on his skin like a wound.

Impossible to hold them back. From one dawn to the next they had worked for this moment, and now they launched themselves senselessly and chaotically, their souls immune to blame, toward their manna. The manna of the river. It was absurd, but nothing anyone could hinder. Almost religious in the rashness of their fever, in their intolerant anxiousness, the men ran downstream toward the crossing, their vision true in the night, finding their way among the rough byways of the riverbank and the wet shrubs that rustled with faint sobs under their feet.

Dazed and abandoned, Gregorio almost felt physical pain. He even felt infected a bit by that virus too, amid these people whose inexorable, primitive nature imposed itself on his spirit as invasively as the virgin forest. "A minute ago," he thought with distress, "a second ago all was silence. True, it was a horrible silence of living beings, but even that silence is gone now; and there's a reason, because the night hasn't ended yet." For the night, like a prenatal shelter vaulting overhead, a dark womb over the hemisphere, seemed indeed to have no intention of becoming any less profound and vast. Yet it stirred too: as if spurred by the pattering footsteps of those three hundred men launching themselves toward the river, impelled by this disruption of its expected stillness, seeming even darker because of this noise, the night was moving the slow, sure scales of its colossal, unanimous snakeskin, grim and alive. "The silence is gone," Gregorio thought again, "but not because the night's over. No, this night won't be over until life itself is."

But did these thoughts have any basis in reality, he wondered, or were they influenced by a hypersensitivity that made him see things with supernatural eyes? He wanted to ponder this, but the violent, overwhelming press of that mass of people, like a hoop binding him, wouldn't let him. They had poisoned the river. That was all. Yet in this fact Gregorio privately glimpsed the existence of something else, something barbarous and stupid. The mass of men, though, almost lewd in their eagerness to possess, wouldn't let him reason. It was as if clarity of thought, the normal paths of logic, had succumbed to a peculiar, bestial thoughtlessness that perhaps didn't lie solely in the men, in their naked bodies, in their eyes flashing with a secret, almost disinterested greed. Something. Something he still couldn't put into words, but which would strike him later, when he was far from them, with a tremendous and perhaps eternally heartbreaking clarity.

"Half on that side, the rest on the other!" ordered the booming voice of Ventura.

This was the place. The women, who had hung back unnoticed all the way from the deep pools to the crossing, now came down quickly on both sides of the river, making no noise, rushing with abstract voracity like furious ants, to light great bonfires that were born suddenly in the night like turbulent hands of flame.

It was incredible that he hadn't noticed the women. Hadn't noticed those bodies that must have run with the same fury and desire as the rest—but they'd done it in less than silence, without breathing, shadows of shadows next to their sad, despotic males. Living images of dark, hermetic, loving and unloving submission, images of voluptuous suffering.

By the light of the bonfires he could see the sturdy dam built of large sticks that blocked the river's current at its shallowest point, with a floodgate in the middle of it. When lifted at the right moment, the gate would let the water rush out along with a tumultuous flood of thousands of fish—the *juiles*, with the dignified expression lent them by their rough mustaches, giving them a singular Asiatic look, like pale, plump old mandarins—which, in their horror-stricken attempt to escape the barbasco's effect in the waters upstream, would end up falling into the fishermen's crude nets.

Again, as if a tense spell had been cast, as if in obedience to an unspoken command, a silence fell, just like when the men had stood in perfect stillness earlier, hard and yielding, cold and warm, capable of stopping their heartbeats through sheer willpower. It was the watchful silence of an evil, hostile multitude acting with impunity, yet one that was exerting its legitimate right of ownership over the river.

Behind the fires the women looked on, as still as goddesses and blind to the world, staring not outward but into themselves. Their eyes were so calm they looked artificial, while their bodies were naked from the waist up, and their dark breasts seemed to move with an eloquent rhythm in the undulating light of the flames.

Meanwhile the men had stationed themselves around the floodgate in the middle of the river, their nude obsidian bodies glinting darkly. A front line of ten men formed an angle with the dam as its base, and other angles extended in a series behind the first, like a squadron in precise combat formation.

A sense of sureness and of furtive anticipatory joy reigned, and the men's eyes, all fixed on the spot where the *juiles* would pour out, shone with lust.

The solemn moment was about to arrive when the gate would be lifted and the action would begin, but Ventura, with his great penetrating cyclops' eye, had apparently discovered something out of order.

He gestured emphatically. "The skinny one in the front line on the right!" he shouted in Popoluca, pointing at the floodgate. There was a general movement toward him, but Ventura suddenly halted his gesture in mid-air, and a lively, pleased smile lit up his great eye.

"I didn't realize," he said, now recognizing the man as one of the sons of the cacique of Santa Rita Laurel, "that you're Santiago Tépatl, Jerónimo's son."

Jerónimo Tépatl spoke up softly, "He's my boy all right, as you see."

Ventura regarded him closely with a mocking eye.

"He's grown a lot, but he's still very skinny," he said smoothly. "Take him out of the line and put a strong man in his place."

Ventura was obeyed without argument and once again, silently and inexorably, things took their course.

By the light of the bonfires One-Eyed Ventura's face was visible in all its unexpected and extraordinary magnitude. Men with such faces had governed the country since time immemorial, since the days of Tenoch. His features expressed something impersonal and at the same time unique and conscious. On the one hand, it was as if they'd been inherited from all the caciques and strongmen of the past, yet even more from the stones and the trees—the way, perhaps, the faces of Acamapichtli or Maxtla, Morelos or Juárez, must have been up close, faces not completely human, not completely alive, not completely born of woman; as if they were made of leather, or

earth, or History. But they also had the vulgar exactness of something tangibly organic, capable of passions and vices and shame, these features on a material, physiological face subject to natural phenomena, bodily secretions, and the contingencies of cold and heat, love and hate, fear and suffering, life and death.

The firelight showed Ventura's true colors and made his potency and seductiveness understandable. His bold vulture's nose, his gifted forehead, his lips parted in a smile subtly tinged with disdain: all of this made his figure, which was actually short and plump, something epic. It wasn't hard to imagine the times he mysteriously slipped away for two or three weeks to steal cattle in Oaxaca and Chiapas, and to picture him as a kind of equestrian lightning bolt striking in one place and then another, his horse's reins held in his jaws while his widowed arm cracked the rope in the air; nor was it hard to conjure up his youthful image from '07, when he fought with the guerrillas under Hilario C. Salas and must have been, beside that forerunner of the Revolution, a kind of dark flash, a kind of black and implacable blast.

Gregorio couldn't tear his eyes from this man who represented such a living piece of the people: mocking, crafty, sensual, and cruel. Closely attached to the earth, so solid, so present, he couldn't have been further from what one thinks of as a mythical or legendary figure. But perhaps the fact that he hadn't died, even after so many accidents, or the way he (at least apparently) sought out every possible opportunity to meet his death, made the people, with something like loving superstition, grant him the authority of a miracle worker, a priest, a chief, a patriarch.

With the celerity of a wounded reptile, Ventura suddenly sensed the prolonged weight of Gregorio's gaze and swung around to face him. His hasty, apprehensive movement might have seemed to show cunning, but it was really only out of self-defense and, uncharacteristically, fear. His lone eye bored intensely into Gregorio like a stone spike. For a few seconds that eye, astounded, didn't move, failed to understand, and at that moment it was as if Ventura's spirit had flung itself wide open, revealing a profound, bitter, inconceivable truth. But then a screen of indifference, like the terrifying opacity that precedes death, seemed to veil the surface of his eye, and he turned once more toward the men who were waiting in front of the floodgate.

The dam of sticks distended, swelling under the river's pressure, but it was necessary to wait until the last possible instant, when the waters were about to burst the dam, if they were going to get a big enough catch to satisfy all the represented pueblos. All the anxious pueblos of Comején, Santa Rita, Ixhuapan, Chinameca, Oluta, Acayucan, Ojapa, who had come to fish the sad, poisoned river.

The waters rose slowly and dully, and started to leak between the sticks, with a persistent grumbling that grew gradually angrier, as if someone on the other side were pushing with his shoulder. Some severe and brooding titan.

"Open it!" Ventura ordered suddenly. His threatening face shone with an indomitable glow, and his arm, quivering with joy, brandished his black machete blade in the air.

One of the men opened the floodgate and an exclamation of savage bliss arose from the crowd.

The first line of men fell back under the water's furious force but recovered instantly, and, leaping to action like demons, they began to fill their nets with dozens of dying *juiles*, whose white bodies thrashed with unspeakable anguish.

Very soon, as if a sudden downpour of silver ingots had fallen, the riverbanks were covered in fish, and the men, like prospectors mad with gold fever, stooped over the waters again and again, tireless and ravenous, their eyes darting with inconceivable quickness between a thousand places at once.

Naked like the others, Ventura stood on a low rise and conducted the maneuvers with decisive gestures of his right arm, hurrying the men who stood there stupidly and forestalling mistakes by the inexperienced. The stump of his mutilated left arm, mirroring the motions of the right, was transformed into an absurd piece of autonomous, living flesh, like an independent little animal, almost seeming to have its own consciousness—malevolent, sinister, moving busily.

Noticing this, Gregorio began to comprehend the part of the mystery of Ventura that hadn't yet been revealed to him, the part that had been impossible to see in that excruciating moment when Ventura's lone eye seemed to flood Gregorio's insides with a caustic liquid. That stump of his was a kind of contradiction, but at the same time it was as if the contradiction, the negation, were the only true thing.

For Ventura seemed, in his own essence, in the foundations of his soul, to obey a deep, congenital sense of negation. Hence that lively bit of flesh, small and subnatural, with a mind of its own, and that dirty, blind eye.

Perhaps this was the only reason the campesinos followed him with such deep and submissive faith. It certainly wasn't because of all those things that were unessential to his core being, like his improbable valor or the legend of his exploits—if called on, the other campesinos would be capable of these things, too. Rather, it was because of what was indisputably his: the parts of his body that were maimed, the dead eye, the living stump, which made him the same as the broken effigies of the old idols, the old gods who still gave orders and kept watch from the shadow of time. He was a god. He had the voice of a god. It was enough to look at him there, naked among those hundreds of naked men, to see that, compared to the others, his mere body already endowed him with vestments, a body whose skin enclosed a secular stone—the true nakedness, the true body that was never shown—that had passed down from hand to hand through infinite generations, since the remotest centuries, until it reached the present generation, the last of all. A mutilated and defeated god, who could offer no more than the secular stone of death. Because of this they all loved him and were ready to sink along with him when he disappeared into the abyss. "All of them, and maybe me too," thought Gregorio.

Just then Ventura ordered the men to shut the floodgate and let the waters rise again on the other side of the dam, since the current had fallen to a trickle. He gave Gregorio an enigmatically understanding look, and then glanced quickly at all the rest.

"All right then!" he said loudly. "Let all the pueblos come and gather under that *nacaste*!" And he pointed to the tree.

The caciques, who were "the pueblos," slowly obeyed, taking their places beneath the *nacaste* tree, serious and leisurely, proudly conscious of their own dignity, their slack arms hanging by their sides and their palms facing behind them. Their familiarity with the function they were going to perform imparted a severe, liturgical stiffness to their faces—brusque, superhuman, inexorable—and in their nakedness they took on an even more solemn and austere air.

Again Ventura gave Gregorio a sympathetic and intelligent look, as if he were calculating the effect of what he was about to say and enjoying it ahead of time.

"All of us must share everything that comes from the river," he said, peering over his thick belly at his feet, "because the river belongs to us all."

A general murmur approved the justice of these words, and the people's gazes involuntarily fell on the heaps of fish that lay on the riverbank.

Contemplating this sight, one of the women couldn't contain her joy: "How happy Our Lady of Catemaco is going to be!" she exclaimed.

"How happy she's going to be, yes, thank God!" several voices chorused.

Because the river belongs to us all. Because the river belongs to Our Lady of Catemaco.

Gregorio had almost forgotten that all of the profit from this catch, once it was sold in the market in Acayucan, would be used to pay for a pilgrimage to the sanctuary of Catemaco and for the offerings and ex-votos the Indians would use to thank the lovely Virgen del Carmen, whose church stood on the shore of the lake of the same name, for her miracles. This was the reason for their greed, and

the reason that, despite the Regional Campesino League's regulations against it, the villages along the Ozuluapan agreed to poison the river with barbasco—their river, which, along with the land, the Revolution had granted them usufruct of. Christian greed. Ardent desire to keep Our Lord God happy.

Gregorio stood motionless, in a pose that seemed to catch an unfinished action and split it in half, leaving it suspended in mid-air, the way mannequins appear to be surprised in the midst of movement. A living manne-quin, standing astonished before everything he was see-ing. As if he were inside a painting: just the way the great masters, centuries ago, had left their subjects on canvas-es—the beggars of Amsterdam, the starched councillors and aldermen of Holland, the Spanish infantes—with the same surprise and stupor on their visages and an identical desire to stir themselves and break their chains.

Then, out of the blue, an unexpected image arose, no doubt from his time as a student at the San Carlos Academy. Gregorio pictured the Count of Orgaz, the smoothness of his face, the softness of his vanquished body. He thought how, if he himself were a figure in El Greco's *Burial*, he would feel the anxious desire to es-cape as fast as possible from that limitless admiration, that perilous state of having one's soul—murky or di-aphanous, wicked or kind—right upon one's lips. How amazing it would be, in any case, to be part of that en-tourage and see himself there inside it, from this end of time, with twentieth-century face and eyes. He might even be a legionary of Saint Maurice or one of the an-gels of the Assumption, if they had been naked. Or the entire *Burial* in the nude, with its Saint Augustine, Saint

Stephen, the count's friends, and the other gentlemen and clergy, without chasubles and habits, without doublets and ruffs, their intentionally elongated waists and arms even more religiously slender, naked just like the men here on the banks of the Ozuluapan.

Gregorio thought about the second monk from the left in the painting, the Capuchin who, with an utterly unique expression, gestures toward the deceased with the palm of his hand turned toward a heaven where so much is happening and where the supreme timelessness of the Beyond synthesizes all of Time's dimensions. The resigned and intelligent sadness on his face doesn't keep him from shooting a reproachful glance, impersonal and full of discreetly sorrowful admiration, at no one in particular. It seems to contain the calmest and most eloquent consciousness of how transitory and perishable life is.

"Maybe it's childish," Gregorio said to himself, while a smile in tune with his thoughts flitted over his lips, "maybe it's ridiculous, but really I'd like to look like that second monk—or I wish someone did, maybe a woman. The one on the left next to Antonio de Covarrubias, who's surrounded, the same way I'm surrounded right now, by people who are thinking only about their own destinies and salvations." Though he couldn't explain it, this thought made him uncomfortable, made him feel a kind of unpleasant shame. Still, it occurred to him that he didn't mean to convert himself into the monk from the *Burial*; he'd only thought it because he was in such a similar situation here, among people whose spirits seemed so far from each other, their goodness and wickedness exposed as nakedly as their bodies. People who could never be completely comprehended, whether

by the side of the Count of Orgaz or on the banks of the Ozuluapan—but here were their bodies, nocturnal and elongated, with the same impulse of supernatural growth toward the highest point of the night, toward the impossible heavens. The same impulse to grow. "Never listen," his painting teacher at San Carlos used to say in his smooth baritone, soft but tempered and harmonious, "never let yourselves be seduced by the siren song of those who tell you that Domenikos Theotokopoulos was astigmatic and that this explains the startling deformation of his figures. No. El Greco's figures lengthen toward the heavens to represent the rising of the human spirit toward God. Hence their purity and grace and the deep renunciation of mortal things that we glimpse in their expressions." God's astigmatism. Deformation of man toward Nothingness.

The flames of the bonfires stretched the naked bodies of the fishermen toward God; the men seemed to call all the shadows of earth toward themselves, while the caciques gazed devoutly toward Ventura, waiting for his words. Ventura raised his machete, using its sharp tip to point. "All of the pueblos are here," he said. "Soteapan is here, and Santa Rita, Comején, Jáltipan, Acayucan, Chinameca, Ixhuapan"—he pointed to himself, for this was where he came from—"and even Oluta and Ojapa."

Each of the caciques nodded gently upon hearing the name of his village.

"Very good," Ventura went on. "You're all here, and all fine and healthy. The sharing will be fair and equal. We will count the *juiles* and each pueblo will be given its proper share."

The tip of the machete pointed at Gregorio.

45

"Comrade Gregorio," he finished, "comrade Gregorio, who is incapable of unfairness, will be in charge of dividing them."

Ventura made a long and enigmatic pause. The light of the bonfires was reflected in his eye, lending it the strange effect of a monstrous rolling movement, as if the eye were turning a full hundred and eighty degrees, although in reality it remained hard and unmoving.

"After the river fills up again, we will share more."

Another pause, until his eye seemed to thaw into a smile.

"In this land, thank God, everything belongs to us all," he concluded.

Now Gregorio understood those sympathetic and intelligent glances shot his way by Ventura, who must have already been planning to give him the honor of dividing up the catch. Without waiting for another order, he bent over the pile of fishes, but a voice made him look up.

"Ventura, you forgot the Organizations," the voice said.

It was a thick-set woman with a beautiful face, who had black hair and nipples like buds of gray ash. Ventura's own wife.

Ventura couldn't hold back a loud laugh that the others endorsed with a condescending snicker, a sarcasm Ventura's laughter made permissible.

"Jovita is right," he said, still laughing at his oversight.

His single eye swept across everyone there, examining them one by one.

"Who," he asked, "are the representatives of the Rosa Luxemburg Center and the Communist Youth?"

An aged woman with a wrinkled belly and quivering cheeks and a spry boy with alert features quickly joined the group of caciques under the massive *nacaste*.

The woman seemed blind to the world, her eyelids half-closed, but the way she picked at the rough skin of the back of her hand, her thumb and forefinger pinching it like a furious grappling hook, must have made her feel alive, and it made clear her animal force and emphatic decision to exist—to exist under any circumstances.

Ventura carefully considered the two new arrivals.

"Very well," he said, turning to Gregorio. "Give them each a share for the Organizations."

The Rosa Luxemburg Women's Center. A surprising anachronism. The members of the Center—Gregorio had been surprised when he'd first arrived in the area, unable to account for the fact that its only members were older, if not downright ancient, women—surely had no idea that Rosa Luxemburg's home country even existed. In the middle of the forest, among the naked men and nearly animal women, it was a fantastical thing to hear the German socialist's name. Rosa Luxemburg. Our Lady of Catemaco. Really, both must be purely celestial figures.

"Why don't the comrades of the Rosa Luxemburg Center," Gregorio once asked Ventura, "want to form a youth division with all the village girls?"

It was one morning at Ventura's hut. Ventura was rocking in a hammock while, not far away, Jovita was grinding nixtamal. He kept silent a long time with a faint smile on his lips.

"Ask Jovita," he said.

From where she stood at her grinding stone, the woman gestured toward Gregorio.

"Comrade Revueltas asked us the same thing when he came here, two years ago now," she explained. "And do you know what I told him? That it was our business,

the women's. The young ones"—Jovita was thirty at the time—"the young ones have our God-given duty, which is to get married, sleep with our husbands, have babies, and raise our children. The older ones can't do any of that anymore; the only obligation they have left is to fight for women's rights in the Rosa Luxemburg Center."

Ventura, with an ironic gleam in his eye, leaned out of the hammock and attempted to get rid of something around his toenail that was bothering him.

"Woman," he said all of a sudden, cross and impatient, "come get this *nigua* off me, I can't do it."

Jovita hurried over.

"Where?" she said, bringing her eyes close to Ventura's bare foot. She tried to do it with her hands. "There's the stubborn little thing, but it doesn't want to..."—and faced with the resistance of the insect that had lodged itself between the nail and the flesh of her husband's big toe, she began to chew at it with her teeth, like a dog, until she managed to extricate it. Just like a dog.

The river was "loading up" again on the other side of the dam, and it was already pressing with a stubborn rhythm against the sticks. The current was more compact now, and pieces of rotten wood and leafless branches floated here and there, along with the occasional dead *juile*, its livid belly turned up in the middle of the dirty water. The water was beginning to reek and the barbasco had turned it a dull, somber red.

Someone brought a torch near Gregorio to light his task, and this reminded him again of El Greco's second monk in *The Burial of the Count of Orgaz*. He reconstructed the figure in his mind: those eyes veiled by sadness, the pained gaze with its ardent depth, the noble, generous forehead,

and the almost incorporeal hands with their long, caressing fingers like a woman's. Gregorio would have liked to view himself in the light of the smoking flame, leaning over the fishes among those watchful, silent men, in order to paint the scene; but all he could see was his own hands, absurd and senseless, seeming almost not to belong to anyone at all. Hands. El Greco's mystical insistence on painting such translucent and painfully expressive hands. The terrible and revealing hand of Cardinal Guevara. Mary Magdalen's two hands, one earthly and alive upon her breast and the other on the edge of death, fallen like a leaf of pure love, still faint and weightless with her passion for Jesus. The hand of Saint Dominic, pious but probably cruel; the hands of Saint Jerome opposed like enemies, once as a scholar and another time as a hermit, first laconic and casuistic and then so human they might break; the endless hands of Saint John the Evangelist, and the smooth, painless hands of Christ carrying his cross. The hands reveal the man, because hands are work and creation and fecundity. Hence the sinister proportions of Ventura with his lone hand and his lone eye, the things that gave him his power and negative force.

Gregorio tried to remember his past, his very dead past. His long hours studying, hunched over monographs; the final essay he prepared on the painter from Toledo, which must still be kicking around somewhere; the lively evenings, the discussions, the nights of drinking. It was impossible to summon a vivid memory. He smiled to himself while he heaped the fish in piles under the all-seeing vigilance of the villages. "One, two, three, one hundred, two hundred." This task. The dividing of the fishes. The multiplication of the fishes.

Maybe he would never understand the real nature of all this, the mystery it contained. These Communist peasants with Party membership cards—some carried theirs hanging around their neck like a scapulary—who were owners of the land since before the Revolution, when they'd seized it by force in the days of Hilario C. Salas, these campesinos had asked him, when they found out that he painted, to do them the great favor of retouching an old and beautiful image of Saint Joseph and the Virgin, probably from the sixteenth or seventeenth century.

It was one afternoon in the outskirts of Acayucan. The light was splendid, and the indirect reflections of the sunset lent a diaphanous contrast to the volume of the clouds. A dreamlike light, almost immaterial, full of incomparable magic and seduction. Gregorio knew it would only last a few moments and would all disappear in an instant. Moments of aching temptation and anguish, the eyes intoxicated, and then everything mercilessly gone, like the frustration of a great love that might have been when a train pulls out of the station in the opposite direction from you, carrying away the intense and audacious gaze, bold and true, of an unknown woman who could have been eternal glory, passion, and radiance.

He just wanted to capture the colors, pin them down before they betrayed him. Gray, mauve, sepia, blue, red, black, orange, rose, blue again, a strange mauve, white, all of them again, gray, sepia, red... Three indigenous men watched from behind with an air of profound connoisseurs, glancing at the canvas, then at the sunset. They nodded their heads in affirmation. A

glance at the sunset and then at Gregorio's colors. They were obviously satisfied.

"I have a feeling," said one of them, "that compañero Gregorio can do us a great service." Gregorio looked up. "Would you like to give us a little hand putting some color on the Most Holy Virgin and the Lord Saint Joseph? Their paint's coming off," the campesino finally said. Gregorio accepted with pleasure.

"In this land, thank God, everything belongs to us all." The river belongs to us all. Our Lady of Catemaco belongs to us all. Saint Joseph and the Virgin as well.

Silently Ventura had settled next to Gregorio, again with his breath smelling of fermenting maize. As the piles of fish grew, one of the caciques, unable to wait, reached both hands toward his.

"There'll be more," Ventura said, stopping him. "Don't get ahead of yourself! Let the river fill up again."

The cacique gently backed off, and Ventura, crouching there, began to draw meaningless figures in the dirt and then wipe them away with the palm of his hand.

He looked up at Gregorio.

"Now you'll see it," he whispered, and straightaway started to sing a local *huapango*.

> *The rose and the carnation*
> *went out to dance one night...*
> *The rose went throwing flowers*
> *and the carnation picked them up...*

"Now you'll see it," Gregorio repeated to himself, noticing again how Ventura's expressions switched the senses around. Seeing for hearing. Hearing for seeing.

...The rose went throwing flowers
and the carnation picked them up...

Remarkably, every time his soaring and plunging voice paused to hold the very highest note of his range, Ventura covered his lips with his single hand, in an inexplicably bashful and oddly timid impulse. He sang in barbarous shouts, his voice shrill and feminine, while a flickering smile danced in his bloodshot eye.

Little by little, as if emitted by the darkness itself, there grew a faint tune that seemed made of glass, while at the same time hollow, inward, and watery. Then three young indigenous men appeared next to Ventura, each with a tiny guitar in hand, playing with desperate jubilation.

Brusquely, somewhere between friendly and inconsiderate, Ventura snatched an instrument from one of them.

"The jarana," he said, and proceeded to make noise like a demon, strumming the strings with his free hand while his stump furiously clutched the body of the minuscule guitar.

Imperceptibly each of the young men left off singing until only Ventura's monotonous, strident racket was heard.

The rose and the carnation
went out to dance one night...

Everyone listened, restless, until suddenly Ventura stopped: he froze like a hunted iguana, attentive to things only he could hear. Everyone turned to watch him as his body drew itself slowly erect with shrewd, mistrustful movements, cautious and ready to defend itself.

Then very quietly, with an almost amorous gentleness, he moved one of the caciques who was blocking his view of the crossing.

His monstrous eye bored into the night.

"You!" he said to the closest of the men around him. "Go down and open the floodgate!"

Behind the sticks of the dam, the water stirred with a sordid thickness, and the sullen tangle of ferns and branches on its surface swayed clumsily back and forth, obstructed by a black and mysterious force.

"Open it, *pendejo*! Don't be scared!" Ventura shouted, a snarl of tremendous anger on his lips.

The men watched with bated breath, while the women, motionless, stood apparently unperturbed behind their glowing bonfires, their eyes like stones.

Down at the river crossing, the man leapt back from some danger he'd seen on the other side of the dam.

"Give me a stake!" he called. It was impossible to say whether it was his normal voice or a different one trembling with panic. "It's the caiman! It's the caiman!"

Ventura himself, with incredible quickness, arrived in one bound at the floodgate. Shouldering the man aside, he opened the hatch with a vigorous movement.

On the other side of the dam the water sat undisturbed, with the sluggish meekness of a slow and hostile oil, swelling as it drew breath with filthy, congested lungs. Nothing could be seen through the floodgate but a confused tangle of trunks, vines, ferns, and roots blocking the flow of the current.

A sharp and scorching beam shot from the pupil of Ventura's eye, while that hateful, primitive snarl still distorted his lips.

"Caiman, what fucking caiman do you think you're talking about?" he shouted in a hoarse voice that emerged roiling and fearful from deep in his guts.

Possessed by a measureless frenzy and rage, he began to hack furiously with his machete at the tangle that was obstructing the current.

Everyone stood impressed, and although this was nothing out of the ordinary, something filled them with an inexpressible and superstitious dread. They looked sadly at the piles of fish.

Suddenly Jerónimo Tépatl, the cacique of Santa Rita Laurel, gave a piercing cry, as if a snake had bitten him.

"Stop, Tata Ventura, stop!" he said in a quavering shriek. The fact that he'd used the title "Tata," abolished by the Campesino League when the indigenous people declared themselves free of masters, betrayed his distress.

"Stop!" he insisted. "Look at your machete!"

By the light of the bonfires one could see Ventura's machete stained with blood.

Like a whirlwind the men ran down to the crossing. It must be a sign from God, a punishment. A river that spouted blood. God's punishment.

No one knew what to do. All eyes were focused on Ventura's machete. Ventura flung it away from him, and with his clumsy, trembling hand he went on clearing the clogged floodgate.

"It's a man!" someone murmured very softly behind Ventura, but his voice resonated throughout the forest as if he had shouted.

"It is, it's a man," said Ventura in the same soft voice.

For a long time no one moved, no one tore their eyes from the greenish torso and misshapen, bleeding leg that

were just barely visible trapped among the vines; but then a few of them began to work the dead man free until they could lay him out on the riverbank. The corpse looked solemn to them this way, despite its frightfully swollen belly and Ventura's horrendous machete blows. The face, covered with a thick layer of foul river slime, couldn't be made out.

"Jovita!" Ventura ordered his wife. "Let's see if you can clean his face, maybe even make it look decent."

Then he turned toward the men and pointed at the heaps of *juiles*.

"Two of you, go to town," he said, "and bring the priest to sprinkle holy water on these fish. We can't let them go to waste after being in the water with this dead man."

II.

"Three forty-five in the morning," Fidel said to himself with a dull sensation of annoyance, looking at the face of the shabby old clock. Julia's words sounded more monotonous and vacant with each passing moment. "That's just grist for the mill!" he said suddenly in a loud, ugly voice when Julia got to the part of Gregorio's week-old report that struck him as "politically intolerable." The exclamation cut Julia off, and Fidel's outraged eyes, like those of a cleric ready to crush all heterodoxy, were given a cruel look by a yellowish halo around their pupils.

Deep inside, though, Fidel was satisfied to have found a fresh chance to demonstrate, even in front of his wife Julia, the devout and intolerant—sadistic, to be precise—zeal that he was so proud of displaying when it came to "questions of principle." And so it gave him enormous pleasure to see a frightened shiver course through Julia, who, hearing that harsh and loveless voice, couldn't keep the letter from trembling in her nervous hands.

Fidel turned away for a moment so that his face wouldn't betray his pleasure in feeling morally superior not just to Gregorio, but to Julia—a pleasure he would have felt ashamed of if someone were to discover it.

"How stupid! Why are you trembling? That's exactly what it is: grist for the mill and nothing more!" he repeated, making a fist of his hand and sticking out his thumb, as he habitually did at times like this, to underscore the tremendous accusation his words contained. His anger was directed at Julia herself, as if his rebuke wasn't meant for Gregorio. "Careful now," his fist seemed to say to her

with the eloquent erection of its thumb, "careful now that you don't *give them grist for the mill* yourself!" It was his favorite phrase—even if he never used it in its full form with "of the bourgeoisie" at the end—for combatting opinions opposed to his own or stances he deemed contrary to the rules that should be observed. A precise expression: if it spared its target from being accused of a more serious offense (or, if you prefer, a crime that couldn't possibly be pardoned), it still attributed to that person, without expelling him from the circle of orthodoxy, a fault or slip-up that was suspect as a "deviation." If the deviation had to be considered unintentional, given that at any rate one was talking about a fellow party member, this didn't make it any less dangerous and punishable.

"He's sordid, completely cold and empty inside," thought Julia with unusual audacity, but she still didn't have the force of mind to strip Fidel's phrase of its so illogically irrefutable and imposing sense. The expression had become, due to his esoteric use of it, something that resisted all analysis, something independent of any rational and genuine content. Grist for the mill. The mill of the bourgeoisie. Or, depending on the case, the mill of the Trotskyites, or the fascists, or the Mensheviks. Esoteric, deployed like an ecclesiastical procedure: the sheer superstitious fear of being included within it was what rendered it forceful, effective, and obscurely full of power.

A priest. Fidel was like a priest. A red priest aided by ten thousand phrases like this one. "But," Julia thought with dread, "a priest that you can't hate or attack because he may be a sincere, honorable man, and one with a great heart. Or even worse: a man who's useful to the cause."

She let the hand holding Gregorio's letter drop onto her legs, and her countenance showed an absolute weariness and grief.

"At least have a cup of coffee," she said in a blank, neutral voice. "You've been working very hard."

Fidel's jaws shut firmly, and the bones near his ears rose and fell with minute precision. The discreetly compassionate tenderness and submissive admiration he sensed in Julia's last statement gratified him exceedingly, for he needed these feelings now, especially after the thoughtless, uninterrupted activity that, in the face of the horrendous circumstances, he'd performed with barbarous frenzy over the last twenty-four hours. Indeed, aside from the few minutes' distraction of attending to little Banner and looking at her tiny face as it grew more and more translucent and ugly in the crib, he hadn't stopped to rest since the previous morning, spending the whole time bent over the typewriter among letters, political resolutions, and organizing instructions, full of pride and self-satisfaction because of the inhuman, steely mettle it proved he possessed. This was why it was impossible for him to give in to Julia's appeal: to acquiesce risked seeing his grand sacrifice diminished. Her voice, though, entreating him in such a sad and pallid tone, was full of fatigue and indifference, as well as a certain inexpressible spite that Fidel didn't notice, for an enormous arrogance impeded the clarity he needed to realize that at that moment a new, unforeseen type of relationship was beginning between him and Julia, something dark and deep that might take the most disconcerting twists and turns.

"I'm sorry," he said with a humble, pained air, like a priest trying to inspire his flock to piety by his example,

"I can't. It would mean losing precious time. I need to put together all the information today so I can make a very thorough and fair report."

Julia wanted to clutch her temples and scream. The man used those terms in the most chilling way. Like what he conceived of as *fair*. A narration of the facts that was objective, of course, and accurate, a correct and faithful enumeration, but bent to fit an unassailable preconceived notion of truth that lay above or below the facts, to the right or the left, which gave the facts a value other than their own and made them—according to the cleverly rigged relationship Fidel devised—good or bad, useful or useless, important or unimportant, worthy of the highest praise or, as they inexorably turned out to be in the worst of cases, lacking any function other than to provide "grist for the mill." Which mill, who could say. The dreadful mill that had been invented—jealously and monstrously invented and safeguarded—by Fidel.

A deep agitation quivered through Julia's body. Her chestnut eyes darkened. With all her soul she wished she could unmask all these things that were so impossible to unmask. Everything. That horrible, goddamned, sanctimonious hypocrite.

"Having a little cup won't make you lose any time at all," she offered for the second time, with a cold and secret anger. "In any case it'll help keep you awake."

Fidel gave a start, as if a spring had suddenly snapped inside him. Between Julia's offers there had stretched a tense, icy, soundless interval that seemed to have no temporal relation with the preceding seconds, as if there existed no form of measurement for it, or at best a certain incredible unit of spirit light-years in which absurd,

unintelligible interior universes arose and disappeared. The breathtaking nature of this deaf and silent void, the kind that only appears when a secret battle arises between two kindred souls, or two souls who believe they've been so and thus only dare to confess the rift between them with the most twisted circumlocutions, had become evident only when Julia made her second offer of coffee in that voice full of aggressive indifference and desperate weariness.

"In any case it'll help keep you awake." Incredulous, Fidel repeated those words that concealed such a different, premonitory meaning within them, mulling over how perceptively his abrupt sense of unease had identified the accusatory undercurrent, the unforeseen thing inside her, that was now coming to light.

He gazed at Julia as if he were seeing her for the first time in a thousand years, and before he could somehow prevent it—which was impossible anyway—his voice became tremulous with sweet, black, apprehensive love.

"All right!" he said. "I think you're right. Make me a cup of coffee, good and hot."

His eyes landed on Julia's breasts with an opaque, needling desire, somewhere between filial and sexual. Julia. To never possess her again. To lose her forever. In the phantasmagorical process that had led him to accept the coffee there was an imprecise but anguished fear that Julia might end up no longer belonging to him, might end up, dreadfully, belonging to another man. This fear grew and changed as he felt it, was pervaded with more and more painful fantasies, until suddenly, with a horrible leap into the void, it was no longer the dread of some future eventuality, but the panicked certainty that, now that

he'd intuited the possibility, it was inevitable that she'd give herself to another man, in fact it was as if it had already occurred. And this panic merged with a stupid, roiling, depressing sensation of inferiority, whose murky efforts to compensate for itself found their only outlet in a tingling arousal that came from imagining a furtive pleasure, masked and unspoken, more sharply real if he thought of it as the pleasure the other man must have experienced with this woman who now, suddenly, was no longer Fidel's, who had become no more than a sign, an abstract form of some nameless malady, despite being right there next to him.

Fidel clenched his teeth with rage. Love. Maybe this, this sixth sense of desire that reads into the smallest trivialities the probability of losing what it desires, was love—or if not, it was the minor orders of love, its ancillary doubts, the babbling, primitive yearnings and anxieties that have hardly been formulated, that haven't yet struck the conscious part of the self. Maybe this was love. "Or at least," he thought, "the form *my* love takes." These thoughts and the sensations they aroused maddened him to the point of vertigo. It was unthinkable that after he had completely assimilated Julia into his being, after she had ceased being the object of his desires thanks to the daily security of unquestioned possession, she might nevertheless be the source of this disquiet, this anxious seething and vulgar, uncontrollable excitation. He bowed his head, feeling an absurd chill wash over his shoulders.

"Finish reading me Gregorio's letter," he then said, astonished at his own words when he might have said something else instead, his truth in that moment, or might have confessed in all its nakedness and brutality—the

same experience Julia might have in similar circumstances—that obscene resurrection, that dirty miracle, that rediscovery of desire. Something else. Some words to comfort Julia after the calamity that had befallen her, any allusion at all to the fact that she wasn't alone, or to the fact that it was a shared calamity they had to bear together, with the simplicity of husband and wife, with the seriousness of resolute spouses fused in a single cherished harmony, with the desperation and exhilaration of boundless lovers who would not separate in life or death.

But no. Horrible silence. That awful, diabolical state we sentence ourselves to by withholding our ideas, our words, our states of mind, even the simplest caring gestures or attitudes, preventing those closest to us—especially the most intimate and essential companion of all—from knowing or understanding us. Whereas if these things were expressed frankly, bravely, and with integrity, instead of being locked in the underground prison where the things that never get said lie waiting for centuries like an anchor of regret, if they were spoken with a spirit of perfection, they might become the substance that could repair the subtle thread whose unacknowledged breaking suddenly produced, between two hearts who had still loved each other a moment before, an unfamiliar, unbreathable void, a void beyond belief, laden with stubborn loneliness.

"Did you hear me?" Fidel insisted brusquely and imperiously, with the keen alarm of an alienated soul who, try as he might, can't make his words match the real thoughts behind them. "I want to know Gregorio's opinions in full. Anyhow, they're interesting."

Julia examined Fidel's face with a cold, impersonal gaze, unattached to any references or memories, exactly the way she'd looked at him that first time a year and a half ago. Now she truly felt that she was separated from Fidel for the rest of her life. It was an unexpected and invigorating return to that time outside history, not yet begun, that prior age when Fidel was an absolute stranger to Julia—or when, like a celestial body that comes from a place known only to men of science and that has concrete reality only for the rustic peasants who will watch it drop out of the sky onto their fields, Fidel was at the juncture in time and space just before he crossed the boundary between his own unidentified atmosphere and the atmosphere of the earth. Which was to say Julia's atmosphere, her romantic and biographical fields, the fields of feelings she owned—worries, hopes, pain, pleasure, and a thousand other things. He was a stranger now. A being with no link to her at all, thanks to this magic moment in which that first time she saw Fidel, repeating itself, had closed the parenthesis of love without the slightest sense of something being torn.

Fidel drank from the steaming mug Julia handed him, and little by little his forehead became covered in sweat, while his astonished pupils followed the path of the bubbles over the surface of the coffee. Nothing keener than Julia's gaze, like an icy lightning bolt. Nothing keener or more hateful. "The rotten whore!" he thought, heedless of how disgracefully unfair it was to think this. "The damned whore!" Another man's. She'd belong to someone else. A frenzied impulse seized him. Seeing her there next to him, her sad and childlike face, the two bands of black hair gathered at the back of her neck, her sharp knees showing below

her plain skirt, Fidel realized he wouldn't know whether to beat her senseless, ravish her to death, or both at the same time, in a savage avalanche of unchecked lust. Beneath the transparent tissue of his temples, the rash throbbing of his blood was visible. Julia would surely notice it. And so, with hermetic willpower, only after a violent effort, Fidel contained himself, but he still couldn't suppress a certain hoarse, superhuman tone in his voice: "Don't stop now," he managed to say. "Finish."

Gregorio's letter trembled again in Julia's hands. Good God, that voice. Fidel's voice might resurrect everything, but it would come too late. She was struck by a fear, a sharp presentiment, like a knife invented by her own guts, stabbing her inside. A fear that if Fidel became human again for even a minute, if he tugged her with one simple phrase, one gesture, away from this already neutral and emotionless present and even slightly toward the imme- diate past, the just-lived past when their baby girl fell ill and he was almost about to feel pain, almost about to be something more than a machine, she'd love him again, she'd chain herself again to that soul, so lonely and so gloomy at heart, who inspired such pity in her. "Don't stop now. Finish." That wasn't what he wanted, of course. But Julia looked down at the letter, determined to contin- ue reading it. She mustn't let herself be defeated if in her heart she had already disengaged completely.

The room grew more hushed as Julia read Gregorio's words.

Above the typewriter the portraits of Lenin and Flores Magón blurred into the upper part of the wall, where the light of the candle didn't reach, and both men's foreheads, one with pronounced spherical contours and the other

less distinctive but more elegant, seemed to lean back ironically, Lenin in good cheer and Magón as if with a touch of nostalgia.

"I don't see prospects," she read, "of organizing any kind of agitation against the government of Colonel Tejeda, and I don't judge it politically necessary or correct. I've confirmed that he has the support of the masses and that his enemies are precisely the old hacienda owners, the clergy, and the Federal government."

A humid, bilious cloud of antagonism seemed to pass over Fidel's face, leaving it a wan, ugly yellow. Ever since he'd contracted malaria back in the city of Jalapa—and he no longer took care of himself conscientiously—his adversaries tended to suppose that this coloring of his skin, rather than the effect of an accident that had become an organic part of his physical self, was a neurotic reaction that showed cowardice and lack of control over his nerves.

Fidel found Gregorio's opinions especially disagreeable because they were so brazenly heretical. If the Party had determined that the *entire* Government was made up of traitors to the Revolution, it was insolent for someone within the Party to dare to describe a member of the Government as a progressive and revolutionary element. He opened his lips with the intention of stating some categorical condemnation of Gregorio, but despite the displeasure he felt at hearing the man's points of view, which he deemed those of a "petty-bourgeois with deviations toward the right," his attention quickly shifted from the matters at hand and slid down other channels, seeking out and interpreting the hidden signs that beckoned to him from behind every fact and grew more

urgent as their discovery threatened to change the character of a certain gleam in Julia's eyes, a very particular rhythm of her breathing, or the nuance of some word on her lips; beneath these external signals, the secret passageways of an overwhelming system of the soul's catacombs would slowly become visible to him, full of the most unsettling revelations of truth. And so, as he listened to her voice, as he studied her face and the way her eyelids seemed to close partway while she read, Fidel gradually isolated her, removed her from immediate reality. Out of raw, callous cynicism and a deep, furious sexual resentment, he began aggressively to assemble a different Julia, creating an absurd hippogriff from the most diverse and contradictory materials, engaging in an ardent logomachy in which a Julia made from the scraps of another woman who had once existed and then ceased existing in Time took form again in the realms of Desire, in the extraterritorial impunity of the imagination where a greater monstrousness was possible.

And so from that Julia—the Julia whose face momentarily assumed a severe, serious look of close concentration when she began the sexual act, as if listening for some grave organic occurrence only she could hear, and who afterward would lie with her eyes closed, utterly absorbed in capturing each and every detail—together with this Julia here, sad and distant, something was created that wasn't the juxtaposed image of another woman, as one might expect, but rather the image of an unnamable sensation—hate, tenderness, violence—to which those two different women gave a desperately piercing corporeality.

"I've tried," Gregorio went on in his letter. "I've tried," Julia repeated in a dull voice, her gaze obstinately glued

to the page, "to get the campesinos to organize in cooperatives with the aim of keeping their seeds in the possession of the communal land administrators and not letting them fall into the hands of those who would monopolize their sale."

Another stupid opinion. As if Gregorio wasn't familiar with the *immutable* principle that in a society divided into classes, cooperatives are destined to fail. But, above all, Julia's voice. "To get the campesinos to organize..." As if Julia's voice weren't a memory of the bedroom, of brief nuptial words spoken in low tones. It was painful to imagine that warm netting being ripped apart, that tissue of events, habits, pleasures, and private liberties which, sheltered in the cozy fog of domesticity, the exciting intimacy that was his refuge, had been gradually constructed every minute of their shared life with a sort of exploratory patience and trembling joy at each new discovery. Hearing that voice couldn't have been more painful. "In spite of everything," Julia finished reading, "my attempts have failed."

Fidel cast a dejected glance about him. It was painful. Keep the seeds in the possession of the campesinos. A dark lightning-flash brought Banner to mind, that ten-month-old baby girl, that little corporeal and human seed. Terribly painful. But it made him think too about Julia moaning damply, prisoner in the shadows of an already-lost bed, during those nights together that would no longer exist. It couldn't have been more painful.

Though there was no crack in the room where the air might leak in, the candle flame shivered, touched perhaps by one of those concentric circles of darkness emitted now and then by the walls during a night of insomnia or work,

which, though no one can explain it, make the wick sputter with the soft little noise of a clumsy kiss.

Moistening her thumb and forefinger, Julia stroked the flame, and the light gave the room a shine like aged gold.

A profound silence reigned. All that was audible, res-urrected in the ears after its eternal hours of unnoticed preexistence, was the ticking of the clock, whose hands stood crucified at three fifty in the morning.

Something suddenly seemed to crack inside Fidel, and his face broke into a grimace, sincere and revealing, that he could not suppress.

"He's wrong," he said in a soft, worn-out voice. "He's absolutely wrong!"

A brief cold shiver, a sordid gray hope, ran through Julia at these words. The system of catacombs. The lab-yrinth. The secret passageways. Fidel wasn't expressing what he wanted to say. Not at all what he wanted to say. It was in his bearing, in the sad, even pathos-filled gesture he sketched in the air, in that pitiful, impoverished look in his eyes—a coded message in the shadows, a hybrid cosmogony of feelings and provocations whose obscure symbols could only be distantly and contradictorily ap-proached by words.

Fidel pierced Julia with an intense, unearthly gaze. "If I touch her, if I stroke her forehead, if I lean on her breast and sob, she'll belong to me again in a way she never did before." Three fifty in the morning. Belong to me in a way she never did before. It was this impulse toward furious possession that corresponded to the grimace on his face. But at the same time, the fear that his expression might be deciphered made him disguise it, even if Julia nevertheless seemed to understand everything.

They both held back, waiting for the other to speak the confession that would dispel their deaf refusal to understand each other, this refusal to resume what was between them. From the back patio there suddenly came the insistent, mocking sound of an almost perfidious trickle of water, cleverly impertinent, that seemed to be conversing extravagantly in Nahuatl or Chinese. Julia's mind leapt to an imprecise future time when all of this would already be past. In this future that lay four or five years ahead, she was enveloped in an amorphous atmosphere in which Fidel was only a willed recollection, subject to laws of existence only if she wanted him to be, a memory she could summon as if she were turning on a light. "Back then," Julia said from the future, "back then, that moment was when I knew the love between us had ended." Was it a smile of triumph that drifted over her lips at that moment? "Now I can smile, because it's all over for good now, I can smile without spite or regret, but at that moment I felt like the saddest and loneliest woman on earth. Still," she heard her future self say, with slight horror, "the only true reality I could discern in the midst of it all, who knows why, was the sound of that water from the back patio. I've never been able to tear that trickling sound from my memory, and even today it's a sickness that I'll carry with me to the grave, or to insanity."

No. She wasn't smiling. Her lips were folded back in an almost indecent grimace of terrible suffering.

Fidel looked again at the clock. Astonishingly, it was only three fifty-one. "It's logical," he said to himself, drawing the connection between the time and the sound, since he too had noticed the trickling water. "They've started filling the water tanks; now is when

they usually do it." Then, as if to reaffirm that it was indisputably three fifty-one in the morning, the whistles of the electric trains leaving the depot at San Antonio Abad sounded. "Now is when they usually do it," Fidel said to himself again.

"Is that all the letter says?" he then asked. "He didn't add anything else?"

His face expressed an extraordinary stupefaction. Clearly he himself believed something different had come out of his mouth. "He didn't add anything else?"

Julia looked at him from her future world. "He didn't make the slightest effort to make me go back to him, although I'm sure he understood absolutely that I didn't belong to him anymore. He could have referred to what was going on between us by saying anything at all, but instead he started in on the damn letter again. It doesn't hurt me anymore to describe this. I obeyed; I looked at Gregorio's letter, beneath his signature, to see if there was any postscript."

"Yes, he added some other things," she said with a sigh, back in the present moment. "But they're personal. He wants some books or pamphlets or who knows what."

"She thinks the lowest and vilest things about me," Fidel thought with his teeth clenched. Then he laced the long, tobacco-stained fingers of his two unpleasantly transparent hands around his right knee, resting the heel of that foot on the other knee, and he sat, motionless and sullen, gazing fixedly at Julia. He was the same as always. The same damn man as always.

Julia took the empty potbellied mug that Fidel had left at the edge of the desk and brought it over by the brazier. She caressed its smooth, pleasant surface with her fingers

while turning it to read, one by one, the suddenly evocative and heartwarming words of an inscription written on it in childish, charmingly naïve letters. First there came a little dove, fat and serene, holding the intricate curls of a ribbon in its beak. Julia had bought the mug in Toluca, when she, Fidel, and twenty other members of the Communist Youth had organized an outing to the Nevado on a lovely April Sunday. The more intrepid and festive of the hikers had opted to climb the extinct volcano not by the road, which was wide, comfortable, and gradual, but by the steepest and most laborious approach, covered with rocks and difficult passes—if it wasn't outright perilous, it was at least a rough, exhausting ascent. Bautista Zamora—who at this very moment, while Julia was gazing at the mug, must be out with Rosendo, posting propaganda under cover of night—led that group. Even today Julia could remember Bautista's words precisely as he said goodbye, half joking and half serious, to the other comrades, with his usual warm tone, at the foot of the first mantles of snow, round and grainy like the structure of some organic tissue seen through a microscope. What did Bautista mean by those words? Why did he imbue them with such profound, endearing, hopeful prospects? There was an intense, affectionate smile in his eyes, but not on his lips, as if it were only through his deep, sincere gaze that he might betray his inner tenderness and capacity to see a sign behind everything, a secret detail of joy and tremendous vitality, visible only to him. "We'll see each other at the peak," he said, "at the very top, at victory." And immediately he blushed, just like a novice who can't help being a little ashamed at the immensity of his faith, afraid that people will judge

it vain, conceited, and self-satisfied. At the peak. At victory. They'd gone off singing, and later their voices could be heard, frank and splendid beneath that extraordinary April sky, more radiant than she had ever seen.

The little dove disappeared in the hollow of Julia's palm as she turned the mug, and the first words of the inscription appeared: "The Friendship of Your Loving Care..." She paused on the words "loving care." She could never reconstruct all the details of that day on the Nevado de Toluca, though. The memory arrived in fragments that rolled in like waves, each one with a different color, a different aroma, a different taste, carrying emotions distinct from one another, yet all joined to some physical fact—the deep, precise fragrance of the pines, or the vibrant blue transparency, perhaps a bit metallic, of the lake trapped in the crater of the volcano, or the image of a specific face, like Bautista's. But together these emotions added up to an impression that she had felt tremendously happy—a memory that was whole and real, a placid, cheerful sense of well-being and a certain languor and fondness that established the strongest, most joyous and concrete sense of deep attachment between her and the world. "What they call," she thought, "the joy of being alive." She turned the little mug in her hands until she could read the final part of the inscription: "...Has Stolen My Attention." Her lips parted in a vague, sweet smile that brightened her face with a gleam of placid kindness, like life being blown back into the embers of a dying fire. "The Friendship of Your Loving Care Has Stolen My Attention." The wondrous joy of being alive. Yet behind her, at this moment, was Fidel, stubborn, mute, and unmoving, his tall shadow breaking at the point where the ceiling, meeting the wall,

crushingly and invasively foreshortened the upper half of his body, like the rock of Sisyphus buckling his shoulders. There was no way to omit, to detach from reality, either that shadow or the human being who projected it. If for a few moments Fidel had been no more than a figure in her memory, as Julia's mind escaped into that formless and longed-for future time, making him a reality based in past facts and stripped of living attributes like Julia's affection or inclination toward him, now, by contrast, by means of the exact opposite mental operation, Julia was transported into the Past, and Fidel became once again an entity who couldn't be ignored, imposed on her by the tyranny of real events, not dependent in any way upon her will, and in the face of whom there was no choice but to submit. And strangely, there appeared to be no difference between the Fidel of the past and the present; instead, both images fed each other in a nebulous, confused exchange of blended spite, resentment, nostalgia, bitterness, desire, affection, and anger, and at the same time a vague wish that none of this were true, that it were nothing more than the shadow of a terrible nightmare that would end with a pleasant awakening.

"The Friendship of Your Loving Care Has Stolen My Attention." No, it hadn't been the bliss of being alive; perhaps all it had been was the desire to experience that bliss, and today, good God, Julia understood why. Even that morning of their outing to the Nevado, when they were alone for a few moments and Fidel heard it from her own lips, she hadn't been able to tell if he felt moved or if his innermost fibers, even just the elemental, animal self of a fecund male, had vibrated with that particular enjoyment, virile and satisfied, that writes itself like a lightning bolt

of gratitude in the eyes of men when they hear such news. Julia's cheeks had turned red, but Fidel showed no sign of his feelings. The tone of his voice might have changed minutely, but that was all, and it wasn't possible to say exactly what caused this. Wasn't it the same tone of anguished fatigue, of unpronounceable longing, with which he objected to Gregorio's letter—"He's wrong, he's absolutely wrong"? Julia remembered his words of that day in the past: "If it's a boy," Fidel had said, "he'll be named *October*, October Serrano." That was all, and Julia didn't understand why, but those words seemed completely unrelated to their child. Utterly divorced from the fact that she was pregnant, they merely related to the historical fact they alluded to: the October Socialist Revolution. "The Friendship of Your Loving Care Has Stolen My Attention." With her gaze fixed on the two doves that held the inscription in their beaks, the most hurtful thoughts seared her imagination, and, forgetting entirely that she meant to pour herself some coffee, Julia mechanically placed the mug in the cupboard. Her movements seemed unreal, with the sage slowness, firm and sure, of a sleepwalker miraculously steered along a hazardous parapet or down a staircase by something other than her senses. *October*. It hadn't been a boy; it had been a poor little girl born at seven months. It was Fidel himself who pointed it out the same day her contractions began. "It can't be," he said, and only now did Julia recognize the reticent suspicion Fidel had pronounced that phrase with: "It can't be, because it hasn't been nine months yet since you told me." At the time Julia hadn't noticed if his demeanor held misgivings of some kind, and instead of attributing Fidel's frostiness, detachment, and indifference to possible

doubts on his part, she'd preferred to ignore his reaction without seeking an explanation.

But now things took on their true meaning in that sad, messy room. Not only had they stopped loving each other, but the moment they fell out of love had occurred for them in an entirely characteristic way: they had both discovered that a rift apparently existed between them, and they both constructed—and might continue to construct—freely and unrestrictedly, the most varied and audacious hypotheses about this rift. "Is he trying to drive me crazy?" thought Julia. "Why doesn't he say it? Why is he avoiding it, why is he pretending, why is he torturing me?" Let him rebuke her once and for all, fling the insult directly in her face. Let him tell her he'd never believed he was Banner's father, all because of that damned business with Santos Pérez in Jalapa. Assuming that he harbored this brutal thought was the only way she could explain his behavior during the last twenty-four hours, ever since the baby's health had begun to worsen by the minute. The only way.

She turned to him with a lost expression, but Fidel himself stopped her with a gesture.

"Write down," he ordered with inhuman coldness, "the things I need to do tomorrow. First: letter to Gregorio ordering him back here. Second..."

Julia couldn't restrain herself. Dumbfounded and incredulous, she interrupted him.

"You're not even planning to go to the funeral?" she managed to stammer.

Fidel was about to reply, but right at that moment he heard the sound of footsteps on the main patio, and he vigorously gestured for silence. Whether the

gesture was intended for himself or Julia was unclear. She looked with heartrending apprehension toward Banner's body. "Stay calm!" said Fidel. "Someone's out there, it had better not be the police." His face had turned white and his lips were an ashen line. It could easily be a raid, even though only a few completely trustworthy people knew this place, which served both as a residential apartment and clandestine Party office. They sat a long moment without moving. The nearness of danger, enveloping them both, created a mood that seemed to reestablish a kind of warm, renewed understanding between them.

Julia felt a great sorrow, an acute pain, at what might happen to Fidel.

"Should I put out the light?" she whispered in a voice thick with desperate maternal tenderness.

Fidel's only reply was to take one of her hands in his.

Outside on the patio, the footsteps faltered clumsily, pausing again and again, unsure where to go. Next to Banner's body, the light of the candle trembled and flickered, and it seemed as though a murky butterfly were fluttering around the little girl.

"Do you want me to put it out?" Julia asked again, hardly able to speak.

Fidel didn't respond, concentrating with his entire soul on what might happen. The butterfly of black shadow flitted about the baby.

Just then they heard knocks, discreet and familiar, at the door: first three, with very brief intervals between them, and then one more, according to the code.

Fidel loosened his grip on Julia's hand, reassured.

"Ask who it is," he said, the muscles of his face relaxing.

The person on the other side of the door answered Julia's query in a pasty, inarticulate voice. Julia stepped forward to open it, and as she did so she noticed she was acting with the embarrassing indulgence one uses when trying to excuse, in front of the most rigid critic, the small failings of someone who is kind-hearted and noble but weak of character, for whom you nevertheless—or perhaps because of these very weaknesses—feel a compassionate affection.

"It's poor old Ciudad Juárez." She turned ever so slightly toward Fidel, and then, so that it couldn't be said she'd let the new arrival escape without a scolding, but at the same time unbarring the door hastily, anxious not to leave him out on the patio too long, she added, "I don't know why he showed up, when we've told him so many times not to come sleep here at all hours of the night."

Ciudad Juárez stood in the middle of the room, swaying from side to side. He gave a smile of shame and humility and, by way of excusing himself and pleading for forgiveness, held up in his right hand a half-empty bottle of tequila, and in his left a withered bunch of *zempaxúchitl*, the Mexican flower of the dead.

He was an old metal worker from the Peñoles Foundry in Chihuahua, born in Ciudad Juárez, whose sickly aspect and weak build seemed accentuated by his height. He'd come to the capital as delegate to a congress, but afterward a series of circumstances had prevented him from returning home, and since then he'd been living with Julia and Fidel. He fixed a pitiful, humbly smiling gaze first on one and then the other, full of ardent yearning.

"I... comrades..." he stammered, his eyes crumpling with tears, "I hope that... excuse me... It's no way to behave, I know... comrades..."

Fidel brusquely turned his back. Ciudad Juárez didn't know what to do, becoming more confused and humiliated with each moment. A heavy shadow of grief darkened his features, but his lips still wore the lamentable smile he'd arrived with, now no more than a grimace of profoundest dejection.

"It's very late," he said mechanically, but as if he were summing up with those words a large amount of vastly expressive things he would have liked to say.

Then, with great tact, he placed the bottle on the floor next to the wall, and without putting down the flowers he approached Julia and stroked her head with extraordinary gentleness and tenderness.

"Why didn't Bautista and Rosendo wait for me?" he exclaimed. "Why did they leave without me?"

He was alluding to the fact that tonight he had the obligation, along with Bautista and Rosendo, to paste up propaganda in the streets. His question was pointless, though, since Bautista and Rosendo had been out since midnight, and he was perfectly aware of this. "He's saying these things," Julia thought, "because he doesn't know how to speak to me about Banner. He's afraid to say anything to console me."

She sought out his eyes with a meaningful, eloquent look. She realized she was right, and she broke into tears for the first time since Banner had died, unable to contain herself.

Ciudad Juárez took one of Julia's hands and put the bunch of yellow *zempaxúchitl* into it. Then he looked over to where Banner lay.

"Put them next to her," he said gently. "I brought them for the poor little thing. Who else would they be for?"

The woman's sobs rang out loudly and clearly in the room. Fidel looked at her, and his eyes were veiled by a deep, terrible, genuine suffering. But Julia, now bent before the tiny body of the dead girl, didn't see the sorrowful light of those eyes.

"Why didn't Bautista and Rosendo wait for me?" Ciudad Juárez asked again, without paying attention to his own words.

III.

Bautista and Rosendo walked blindly along the railroad tracks with the propaganda under their arms. Behind them, above their heads, all around their bodies, close to their skin like a dancer's leotard, the black and limitless city surrounded them, completely unrecognizable now without the familiar dimensions and solidity that by day allowed one to establish its bounds.

No sky was visible, no north star that might help the city navigate its course or signal where its geography had been born as it sailed intangibly aboard the planet, unbreathing in the thick, lightless liquid of the night. Its very existence had become doubtful, vague, the faint existence of an underwater metropolis beneath the gloom.

And so, though they were safe from the police, on an organic, physiological level Bautista and Rosendo felt uneasy—as if the darkness were a hostile tissue, a kind of adverse protoplasm that surrounded the spirit and wouldn't let it be born, wouldn't let it break through a stifling enemy placenta. It was like a faintly awful memory of being inside the womb and experiencing strange things that were the desire to feel and, at the same time, the anguished impossibility of fulfilling that desire.

All of a sudden Bautista stopped, almost with a sense of joy.

"Wait!" he said to Rosendo, trying to create a more propitious, precise, fruitful silence in which to listen. "Let me count!"

Both stood very still and listened to the distant tolling of a clock, finding extraordinary significance in its sound.

"Four," Bautista murmured. "It's four o'clock. We'll wait an hour then."

This was new and beautiful. It was release from the darkness and finding their path once more. But in fact the clock had actually tolled three sets of four strokes, one after another, indicating only three forty-five in the morning.

Under the spell of these sounds, the city improvised a new domain, mapped out invisible borders as if a drawbridge had been lowered between Non-being and Being, between the city's previous shadowy nonexistence and the audible territory it suddenly acquired because of the tolling of that living bell in a concrete, earthly space within it—something possible only on nights as absolute and hermetic as this one.

Something occurs in the Valley of Mexico, Bautista thought, that makes this possible. The diaphanousness, the visual transparency of its luminous mornings is matched, in the darkest hours of the night, by an acoustic diaphanousness and transparency: a way sounds have of making themselves heard, the tolling of some clock, the whistles of the locomotives, the barking of dogs, the sigh of the wind in the trees, sometimes even the strange, unsettling footsteps of someone walking who knows where or toward what goal, sounds that trace their contours not arbitrarily but rather as if intelligently arranged, forming wondrous Euclidian lines of noise—a dodecahedron of voices, or the cubical hum of the night-shift workers—sheer in their purity and perfection and full of orderly wisdom.

It was a strange, magical transposition, it occurred to Bautista. The same way that in the translucent autumn mornings no distance at all seems to separate the shapes

of the trees, the mountains, and the plains down in the valley, and yet those elements never blur together. Or, more precisely, the distance doesn't seem to have a rectilinear depth that follows a horizontal trajectory from the foreground to the distance, but rather a different and contrary depth, guided by a kind of deliberate sense that works to order things from bottom to top, like in an Egyptian bas-relief. Thus you can see the pines on the foothills of Popocatépetl and Iztaccíhuatl, each tree separate, it would seem, standing apart with no connection to the forest, or from far off you can follow the route of someone walking in Lomas de Padierna. And so, in the same way, on this starless night, in the deep and solitary darkness, Bautista and Rosendo beheld the orchestration of a new and unfamiliar city, whose contours, its distant parts brought together into a whole, seemed no longer to be those of the modern, cosmopolitan city, but instead of a primitive, unknown, deep Mexico, pre-Hispanic Tenochtitlán even, represented later in time and born anew in the ear, almost through a kind of metempsychosis of a city centuries old.

They sat down at the foot of the sloping bank of the Curve, the place where the tracks of the Beltway Railroad turn at the edge of the city to connect later at the North Canal with the lines that depart from the Peralvillo gatehouse.

They were astonished to hear the clock's tolling from so far away, for it was the clock of the Penitentiary at the city's eastern extreme. "This is my city!" Bautista thought with emotion. He felt surprised and full of love, for the nocturnal geography of Mexico City subverts the cardinal directions and, mixing the bread and wine of time and space, transubstantiates itself into a strange unity

that makes it possible for four-hundred-year-old events to coexist with the things of today, for stones present in the year Cé Ácatl to coexist with bells and factories and stations and railroads. He listened closely, as if blind: tenaciously, greedily, with a kind of thirst. Voices coming from Tlatelolco, where Zumárraga had founded the Colegio de los Indios Nobles, were audible more than two or three kilometers away, in the plaza where Moctezuma's acrobats played El Volador; in Mixcalco and La Candelaria, which long ago were *calpullis* and *chinampas*, city districts and crop beds traversed by gleaming canals, one heard wails and whistles from Popotla and Azcapotzalco, where the tyrant Maxtla promenaded his harsh cruelty and sullen, silent melancholy on the backs of his vassal lords. It didn't matter if the sounds from Tlatelolco and Nonoalco were the flapping, like a blind red bird, of some locomotive's exhausted breath or the fiery transmutation of matter by the workers feeding the blast furnaces of La Consolidada, nor did it matter if that drawn-out sob from Azcapotzalco was transformed into the siren of the refinery; they were also the murmur of the ancient *tianguis*, the singing of the priests making sacrifices, and the pathos-filled beating of distant *teponaxtle* drums.

Bautista searched in the bib of his overalls for his cigarettes, producing a faint rustle of paper like the crackling of dry leaves, at the same time soft and silky. But this, too, might have been a different sound—something anxious, hurried, and ominous, like the noise of a man condemned to be shot, who, five minutes before his execution, hastily tries to smoke as many cigarettes as possible. Rosendo felt a kind of fear and grief when he heard this, but the moment the match flame lit Bautista's face from below, casting

thick lines on his cheekbones and a halo of shadow upon his forehead, Rosendo relaxed—Bautista's broad eyebrows and his eyes, deep and violent but tinged with kind intelligence, expressed the assurance that nothing would ever happen to this man, even in the worst of dangers.

Bautista inhaled the smoke as though he were gathering the night in his lungs and saturating himself inside. His lips smiled teasingly and affectionately, but at the same time, it seemed, with a certain nostalgia for something that perhaps had no name, which might be childhood or love or some unconfessed tenderness. Many things. Even plain sadness, although it seemed impossible to feel sad at that moment despite everything that had happened.

Despite what had happened with little Banner at ten that morning. And in the face of which, in any case, the most appropriate feeling wasn't sadness, though who could say why.

It had been inconceivable that anyone, much less such a tiny child, could have died at such an hour with so much light, when the radiant, shining morning sun spilled colors so contrary to death onto the patio of the housing complex, blues and pinks on the clotheslines, florid greens on the flowerpots, transparent cobalt on the water in the basins; and while the voices of little children were shouting outside, separated from the loneliness and suffering of this room by a mere wall.

When she found out about the little girl's death, the doorwoman came to Fidel and Julia's "to see what she could help them with." Furtively trying to peer inside, she asked, with an expression of pain that was nevertheless secretly pleased, "if they didn't want any help dressing the little angel."

This caused a minor yet apprehensive and vexed commotion inside. The doorwoman hadn't been apprised of the true activities of these serious, quiet renters. They had told her that Fidel was a bookbinder, and, indeed, since the people who entered their room came out afterward carrying large packages, she had no reason to doubt this if she were ever questioned.

It was Rosendo who opened when the doorwoman knocked. She covered her mouth with a corner of her apron as she spoke, something she tended to do when faced with occurrences that touched her emotions and sparked her curiosity. It was as if, protected by the apron's hem, her words acquired a delicate modesty, an almost loving obeisance to the other's misfortune.

"Tell her to go to hell!" Fidel ordered from the far end of the room, in a hushed voice so the woman wouldn't hear.

Rosendo hesitated an instant while the doorwoman's eyes shone with a spark of diabolical pleasure and delight.

"Thank you very much," Rosendo lied, "but my sister Julia"—a second lie—"feels very bad and doesn't want to see anyone. We're very grateful, in any case."

Bautista, for his part, had arrived when the little girl was already dead, and his face only expressed an infinite stupefaction, incomprehensible in someone who always seemed to have such poise; he didn't dare speak a word or ask a single question.

Julia looked him in the eyes in an appalling way, like a beaten dog. Then, unrelated to anything that had been said, she nodded her head in affirmation, twice, three times, four. Horrible.

"This morning at ten," she said, as if answering a question she wished with all her soul Bautista had asked.

Bautista let his hand fall onto her shoulder and squeezed it firmly. Then he sat down, still without speaking, his jaws clenched with rage and his brow furrowed in anger.

Long minutes passed. The only sound was Fidel's typewriter. When he finished the page, he removed it very carefully, with the delicacy of an artist who doesn't want to spoil his work. Then, noticing that the carbon paper was stuck between two sheets, he began to peel it away cautiously. He was completely focused, magnificent and austere, like the priest of a fearsome, bloodcurdling religion. Then he turned toward the others and looked at them one by one, with a sad, disconsolate astonishment, contradicted perhaps by a barely discernible smile—of pride?—first at Bautista, next at Julia and at Rosendo, and finally at Ciudad Juárez, who was sleeping curled up in a corner after having spent the night keeping vigil by the baby's side.

The room—the "illegal office," as they called it among themselves—was narrow, shabby, poorly ventilated, and cold; in these close quarters, they all became aware of the odor of death that Banner had rapidly begun to emit.

No one would have dared confess it, but each person's attention—their secret, submerged attention, the attention none of them could control—was fixated on that smell, connected to it by a disturbing umbilical cord; it made them somehow accomplices to some crime or shared sickness, people who knew they were guilty and strove with all their might to cover up for each other.

Fidel's eyes looked like those of a man hallucinating. He must have been completely blind for a few moments, seeing only who knows what succession of terrible emotions inside himself. What had earlier seemed to be a smile was

actually no more than the convulsive trembling of his gray, cracked lips, which he uselessly tried to moisten with his dry tongue. He looked for a long time again at Bautista, as if he'd forgotten the words he ought to say to him.

"What time," he finally exclaimed, "are they going to give you the propaganda?" Everyone understood, though, that the question had no purpose other than to mask the smell and indicate that it wasn't of the slightest importance when life was so full of far more serious and transcendental matters than this inevitable organic decomposition.

Before answering, Bautista got to his feet and stood by the crib where Banner lay. His gaze fixed itself with absurd insistence on the corpse's little whitish-yellow forehead, so transparent that one could imagine seeing inside her skull if one only looked hard enough.

"You know perfectly well," Bautista replied. "I don't know why you're asking! I just came from the press. Ambrosio González and Gómez Lorenzo told me it will be ready between six and seven."

Rosendo felt great admiration at all of this. The words "I just came from the press" made Bautista into an extraordinary, superior person in his eyes, since knowing the location of the Party press was a privilege scarcely granted even to the most trustworthy militants, those who were utterly beyond suspicion. But he also felt a certain guilty discomfort at having found out the names of the comrades who ran the "illegal printing press." Then he heard a curious term he'd never heard before that moment.

"Careful what you say, comrade Bautista!" Fidel exclaimed menacingly, striking the desk with his fist in a fit

of sudden rage, pointing his thumb to the sky. "You're *deconspiring*! Why do you have to say you came from the press and tell us who works there? Don't you know that if there were an agent provocateur among us, all he'd have to do is follow your tracks and the police would find the press?"

Bautista sensed Fidel's holy zeal, especially when he pronounced that mangled bit of jargon, the zeal—at once glad and irate—of a Doctor of the Law who hastens to denounce an atrocious heresy, an impermissible infraction against the sacred texts.

"Bullshit!" he replied, without tearing his gaze from the dead child, his face flushed. "You know that none of us here right now is an agent provocateur!"

He was indignant at Fidel's unnecessary words, but above all that stupid *deconspiring* Fidel used to signal his superiority—the kind of "technical" superiority that doctors or specialists in any activity, with a certain inevitable pedantry of their office, revel in before the profane by giving the most abstruse names to the most simple and common things. It was incredibly irritating, even though Bautista understood that the whole exchange was simply an effort to ignore, or to act as though they were ignoring, Banner's death. This didn't make the effort any less futile, though, since at heart nobody—including Fidel himself—could rid themselves of the thought, no matter how hard they tried.

Bautista held the stiff fingers of the dead little girl, which were like a spider's legs formed out of wire, but he couldn't spread them open, they were so incredibly thin and rigid. "Out of sheer malnutrition," he said to himself, thinking of the child's death with a profound, bitter desolation, as Fidel replied to his retort.

"Of course none of us is a provocateur! But the point is never to forget the rules of conspiratorial work. We always have to proceed as if we were surrounded by provocateurs, even if they don't exist."

Bautista shuddered. Horrible. To always proceed as if surrounded by provocateurs. Not just the delusion of organized persecution as a conscious system and a norm, but the most infinite solitude of the soul as your only way of living with others. With power in his hands, Fidel would be an indescribable nightmare.

Rosendo felt even more uneasy, as if a suspicion about him lay behind Fidel's words, seeing as he'd been part of the organization for barely a year and perhaps they still didn't trust him to share such serious secrets.

"Bah!" said Bautista, shrugging his shoulders. "That doesn't matter at all!"

Then Bautista turned toward everyone with an expression of great anguish and suffering. Because they hadn't suspected or imagined he had it in him, this made them tremble as if he were suddenly going to pronounce the forbidden words concerning Banner, words that no one, except Julia, wanted to hear.

They looked at him, frightened. He was terribly pale, as if on the verge of fainting. Something confused and tormenting weighed upon his chest. "Hunger," he said to himself, "she died of hunger." And then he immediately added, in a complete non sequitur, "at ten in the morning," moved by that mechanical impulse that fuses unconnected facts together in the mind and grants them a stupid but dolorous analogy, since Banner dying at ten in the morning had nothing to do with the cause of her death.

"I'll be back in a bit," he then said in a thin and shaky voice. "I'm going to see if I can put a few centavos together for the baby..."

"For the baby." It was a prudish circumlocution, an elusive way of not calling things by name out of fear of causing the others more pain, or weakening them when they needed to be strong and not heed personal sufferings unrelated to the cause.

Julia met Bautista's eyes briefly with a look that communicated great affection, and as soon as he'd left, she went to sit on the floor next to Ciudad Juárez, hunching over herself, as if she were wrapping her body in its own loneliness. The things she wished she could say. The deep and soul-rending words. The tears she wished she could spill. Hunched in the corner she was just like those sad *huizache* trees, leafless and bare, that nourish themselves on who knows what, the last and poorest bits of sustenance that a barbarous and sterile land can give them, a land where only they, out of all the creatures of their kingdom, are capable of living.

Rosendo was seized by a strange discomfort that seemed to be located in the lower part of his throat, an anxious feeling as if some diseased tissue was obstructing his breathing. He understood that if he looked at Julia or Banner, he wouldn't be able to contain himself, for what he was feeling was the desire to cry.

He tried to gather himself by focusing his eyes on the wall, where there was an old, oversized Russian propaganda poster that Fidel had brought back after a trip to the Soviet Union. It depicted a group of workers behind a Maxim machine gun during the 1917 assault on the Winter Palace in Petrograd.

It was a bold and energetic image that seemed to surpass the skills of the artist, whose likely mediocrity, as can happen in the face of very vivid, powerful, rich events, was illuminated by a kind of genius that came primarily from the historical occurrence itself. Because even if the face of each of those workers was a specific, concrete physiognomy, one soon discovered that their beauty lay in the deeper, more general fact—which wasn't aesthetic in nature—that each of them was simultaneously the face of an entire class: the working class. It would always have deep meaning for the people of this class, even if this beauty might not inspire any emotion at all for others who didn't understand the destiny of the workers and their epoch.

One of the workers, his face glowing, held a rifle that flew a huge red flag with a revolutionary slogan in white letters, in Russian and French.

Rosendo read over the inscription twenty times without the words managing to penetrate his mind. "*XIVème Anniversaire de la Révolution Socialiste d'Octobre. À la victoire sous le drapeau de Marx, Engels, Lénine et Staline!*" In the background behind the main group of workers, the impetuous multitude swarmed about the walls of the Winter Palace, and the statue of Peter the Great stood silhouetted against the pale milky sky of Petrograd's white night, like a reminder of an old world that had been called upon to disappear.

This ought to have signified for Rosendo a message full of hope, of faith in things to come, of sure triumph, but, on the contrary, it made no impression on him at all right now.

Fidel glanced at Rosendo out of the corner of his eye and saw that his eyes were moist with tears. He went up

to him and chucked him gently and affectionately under the chin.

"What's this?" he said with a smile. "We shouldn't have time to feel sorry about anything. Our job is to carry on the struggle without ever letting up. That's our only truth."

He said it in a fond tone, like a mentor outside the classroom abandoning his aloofness with a good but timid student who needs to be impressed with the fact that, beneath his teacher's stern and implacable appearance in class, there hides someone capable of understanding his problems and kindly granting them his indulgence.

Julia raised her head and looked at Fidel with indescribable astonishment. Something had been suddenly revealed in his behavior that was contrary to what this behavior seemed to indicate. She'd never seen such a thing. He wasn't just a different man from the one she knew—he'd become something awful in the blink of an eye. "Why is he talking to Rosendo that way?" she wondered with alarm. It wasn't the formal and bureaucratic content that mattered; it was the affectionate tone and that smile designed to give the impression that he was capable of being moved by human "weakness" while still not violating his strict principles. This marked contrast revealed a subtle ploy of voracious proselytism with which Fidel was attempting to effect the complete and ruthless subjugation of a spirit he wished to capture and win the admiration of.

After this Fidel returned to his seat behind the desk and once again began tapping at the typewriter, drawing up the draft report about political and organizing activities that he had to hand in two days from now to the Central Committee.

Rosendo followed him with his eyes and felt a sudden, deep excitement. Fidel was a marvelous and exemplary comrade. While people like this man existed, everything could be considered good, trustworthy, and pure. Even the room itself, poor and dirty, had now been converted into a symbol of the ideal, an image of the unselfishness and sacrifice with which the rough and stormy path of revolutionary struggle had to be followed. Rosendo felt his soul transported by a potent, youthful bliss, full of fruitful, happy forces. The Soviet poster itself, which seconds before had transmitted no message to him whatsoever, was now an inspiring truth in the life and veins of hundreds of thousands of women and men around the world, united by the single flame of a shared idea. "*To victory, under the flag of Marx, Engels, Lenin, and Stalin!*" What did death matter if life's purpose was to burn like a torch lighting the gloom? The dead child herself, Julia and Fidel's daughter, wasn't she also a desperate symbol of awful generosity and unlimited surrender? "We shouldn't have time to feel sorry about anything. Our job is to carry on the struggle without ever letting up. That's our only truth." Yes, clearly. What should it matter if your own children were consumed and died, if in return you were fighting for a world where hunger, pain, and death won't exist for a single child on earth?

Because now Rosendo thoroughly understood what it meant to have witnessed that unspeakable sacrifice in person.

He'd arrived at the "illegal office" just after seven in the morning, when little Banner, though still three hours from death, was already showing signs of being irretrievably lost.

"She hasn't been able to close her poor little eyes for two days now," Julia told him in a gray and melancholy voice.

Rosendo offered her the last thirty centavos in his wallet, which they used to buy some milk and charcoal, and four rolls so that Fidel and Julia could eat too; they hadn't touched a bite for several days, because the organization's post office box had been seized by the police and they hadn't been able to collect the money that arrived from the provinces.

Rosendo leaned over Banner's crib. Was the girl seeing anything with those eyes whose lids she could no longer close, as anemic and hideously wasted away as she was? Bluish or even off-white, her eyes vibrated imperceptibly and incessantly, like the twitching body of a mollusk out of the water in its death throes.

"She won't even cry anymore," Julia explained.

The baby couldn't keep the milk down, spitting it up in wretched spasms and staining the deep, hard little wrinkles of her aged-looking face with a half-digested green paste.

"It would be best if it would just *end* as soon as possible," said Julia, with a sob caught in her throat. Rosendo gave her a desperate, hungry look, as if he wanted to uncover something different behind those words. But no. She'd said exactly that: "*end* as soon as possible."

Rosendo looked away to conceal a strange and sudden aversion. But impossibly, dreadfully, when he turned his gaze toward Banner's face, he realized that the child's features were ageing step by step, in an awful transposition, until they resembled the features of her mother. It was as if, in revenge for her approaching death, wanting to gain ground on her, Nature was forcing the baby to live

through years in mere hours, to complete that long process in which atavisms, inherited traits, the features no one in the family remembers anymore of that ancient great-grandfather or some other relative of whom only a flickering image remains, all flow into the forming of a human being, woven together in a secret mesh that remains unseen during childhood. "If it would just end as soon as possible." Julia had said it. Julia herself.

Rosendo's hands trembled, and a pang of something like resentment shivered through him. He wished Julia would cry; it was baffling to see her, vacant and mute, by her daughter's side, with only a weak and sorrowful gleam animating her eyes.

Julia placed her hand on the baby's head, but the strange chill of that substance that was gradually ceasing to be of this world made her pull away immediately. Then, regretting the motion, she turned toward Rosendo seeking his indulgence, his forgiveness. Lacking another gesture or expression, she smiled sadly.

"Don't you think," she said to him, "that the baby's starting to look like me?"

Rosendo shuddered. Julia had noticed the fantastic process, then.

"Yes," he replied in an inexplicably involuntary way, "it's because it won't be long before she dies."

Julia listened to these words from very far away, from another country or sphere of existence. She didn't notice, and neither did Rosendo, that the sound of the typewriter had stopped and Fidel was behind them peering over their shoulders at Banner's body.

"How strange this all is!" said Fidel very softly. "It couldn't be stranger."

Julia stared at him, astounded. Fidel's jaw, strangely loose, hung open involuntarily, as if moved by an internal weight; it was probably, though, a measure of his suffering. His lips rested half-open, independent of the rest of his face, as if expressing, all by themselves, a terrible, unexpected loneliness. "It's because he still loves me," Julia said to herself, and she would have liked to hold him in her arms so that together they might dispel all the pain and grief of life.

"I'll tell her I love her with all my heart," thought Fidel, "and that Banner's death will unite us forever, because it's an exalted sacrifice, one we've made with our own guts." Something like that. He looked at her, his gaze communicating something eloquent and clear, deep and truthful, and Julia waited for the words, as if her body had opened warmly to receive this new fertilizing seed.

"It's inevitable," one of those hostile deities within Fidel's soul suddenly said—one of those deities whose murky existence he recognized so clearly, but who always astonished him, not so much because they rose up to say the opposite of what he wanted to say or thought, but because they grew more and more powerful, irresistible, and necessary to him, the way an addict has to keep increasing his dose of the alkaloid. "Banner's death is inevitable," he said calmly and coldly, as if giving a bureaucratic report. "So the facts have to be judged objectively, just the way they are, without any sentimentality." He said this impersonally and made a severe and strict pause, finally and definitively dispelling the shadow of grief that had clouded his face. "You haven't slept all night," he then said to Julia. "If you don't feel like resting, you might give me some help."

"He's like an abominable saint," she thought, "capable of committing the most awful sins of sanctity."

Rosendo had seen it. Rosendo had witnessed the awesome detachment and heard the ardent words. "We shouldn't have time to feel sorry about anything. Our job is to continue the struggle without ever letting up. That's our only truth." Without any sentimentality.

Rosendo thought about all this with the kind of heroic fortitude, rash and naïve, of a newly converted catechumen. He felt proud to be performing a task for the Party on this night. Why be sad when he'd seen a testament of such great faith, such a colossal affirmation of love for the cause? And why did he now see this gentle melancholy on Bautista's face when his cigarette lit his features each time he inhaled its smoke among the shadows of the Curve?

The city's bounds seemed to disappear again in the silence that had fallen after the tolling of the clock.

"Have a smoke!" Bautista exclaimed suddenly with an almost authoritarian tone, passing Rosendo the cigarette. But then his voice immediately grew soft and very slow: "...with your hand this way." He cupped his hand around the glowing ember. "So that no one sees the coal."

Behind him, on the other side of the Curve, lay one of the city's trash dumps, full of rags and dirty cloth, old cans and scraps of tin, on top of whose unbelievable putrefaction and misery a few ghastly people lived—infinitely inhuman, yet alive and terrible.

Beyond the dump stood the geometric structure of the industrial zone: the City Slaughterhouse, the United Shoe factory, and dozens of tanneries and glass factories,

lightbulb and noodle factories, though none of it could be made out from where Rosendo and Bautista were sitting.

The silence was heavy, with breadth and depth. "This is the darkest, most penetrating hour," thought Rosendo. He admired Bautista's disembodied existence, no more than a voice beside him.

Bautista was such a mature and vigorous specimen, brimming with life, and the darkness only made his existence clearer, purer, and more distinct. Rosendo felt this purity, this inner righteousness, assert itself upon his spirit without any violence, simply by being itself, by means of a certain calm and serious fire of conviction: Bautista had a secret, simple, general force inside him that invested things with new meaning.

Rosendo would have liked to tell Bautista how much he esteemed him, but to do so he would have had to shake off an indefinable bashfulness and perhaps, too, a fear of being mocked and judged—and so he decided to focus his appreciation on a third person.

"I've thought a lot about what happened with Banner," he said timidly. "It's been one of the most beautiful lessons for me. I think Fidel is an exemplary comrade. An extraordinary comrade."

Bautista let out a short, ironic chuckle.

"No doubt about it," Bautista exclaimed. "A great comrade, even if he's extremely disconcerting sometimes."

He paused, waiting for Rosendo's reaction, but Rosendo didn't seem surprised by his words.

"For example," Bautista went on, "that last thing he did with the money I brought, after everything he'd already done, that topped it all. More like a fakir than a

Communist leader—real idiocy. The newspaper could have waited in any case."

Rosendo didn't know what to say. He found this terrain very difficult to negotiate. Suddenly it seemed to him that he'd never seen sadness and loneliness like Bautista's.

"The newspaper could have waited," Bautista insisted doggedly, as if trying to say something very clear and forceful; but his words simply alluded to the fact that the fifteen pesos he'd brought for Banner's funeral had been earmarked by Fidel to pay for mailing *Spartacus*, the Communist Youth newspaper, to the provinces.

"*She's* the one who can wait, because she's dead," had been Fidel's atrocious, logical response when Bautista had objected.

They sat a long time without speaking. The cigarette had burned down to the butt, and so they both got to their feet to head toward the factory zone.

Bautista repeated the awful phrase. "She's the one who can wait, because she's dead."

IV.

With crystalline fear, and a hazy, nascent anger that ashamed him, for he knew it must be artificial and existed only to conceal his true emotions from everyone else—and perhaps from himself as well—Gregorio saw the face and body of that fantastical Count of Orgaz gradually appear as Jovita cleaned the corpse with a wet rag by the light of the bonfires and torches. The fishermen followed her movements closely, almost fondly, but without losing sight of Ventura, who stood a few paces off with a curious priestly demeanor, hermetic and inscrutable.

With confidential voices full of unction, the women prepared for the panoply of masochistic religious rites that the corpse's presence would lead to, clustering behind their men like a mourning flock of black birds, wrapped in rebozos that had appeared from who knows where.

Gregorio realized that all his moral views had been dashed to pieces in this atmosphere, that his own spirit was becoming no longer distinct from those around him and would end up just as blind. It was like an avalanche sweeping away his consciousness, transforming its essence, like what happens to the passengers on a sinking ship, their instincts unleashed with no regard for anything—free, sovereign, animal. But what was occurring in his heart still wasn't clear. What really was this advancing blindness of his soul, this wreck of his moral sense? Which concrete part of the events or the people's behavior or the atmosphere could possibly contain the secret of the hallucinatory labyrinth where his perspectives went astray and his ideas were rearranged? Could it be Ventura and his

all-pervading, ungraspable machinations, like those of a clairvoyant, a sorcerer, an undaunted *tlacatecuhtli*? What was it?

The fishermen, somewhere between grateful and frightened, seemed to be waiting for the moment when the dead man's name would be revealed; it would be like the moment of secret pleasure people gratuitously feel when, by miraculous coincidence, they witness the indiscreet revelation of some mystery or occurrence they have no connection to beyond their chance presence as spectators ready to pay for the honor by feeling properly touched by emotion as soon as the slightest indication is given.

And the incredible thing was that this pleasure wasn't foreign to Gregorio, this lustful copulation of the emotions in which satisfaction disguised itself as piety, vengeance as compassion, hatred as fear of God.

Gregorio noticed something crazed in them all, a vulgar melancholy like the sadness that assails men in brothels when the lights come on and they see each other with different prostitutes in the same room—a sadness that can only be confessed through a tormenting, barbarous, cynical shamelessness. Ventura's omniscience became more unsettling each moment, for nothing could be hidden from him: he was sure to unerringly divine, step by step, every one of Gregorio's thoughts. Always Ventura. Always his enigmas and prophecies, like a dark humus feeding the power whose rule Gregorio was helplessly succumbing to.

There was a sort of telltale, untranslatable sign in the way Ventura looked up at the sky and rested his hand on the hilt of his machete in an attempt to seem aloof, like a judge hoping to confuse a suspect by unexpectedly revealing his crime. This aloofness, along with the

strange, unconscious gleam in Ventura's eye as he followed Jovita's movements with a certain gleeful, carefully disguised scrutiny, made Gregorio realize that Ventura knew who the dead man was, and that he would try to impress the crowd with dramatic effect in order to attribute to himself—without saying so in words, solely with the imposing gravity of his thaumaturgical mien—miraculous faculties far beyond the ordinary. Who knows what savage use he intended this for. Perhaps it was to grow the liturgical humus that nourished these helpless people who, lacking any other hope, had only a kind of nostalgic desire for some god, any type of god. For from the moment he'd realized there was a corpse in the waters on the other side of the dam, Ventura might have known he was the only man, chosen by the Divinity, who could translate for the campesinos the cabalistic message through which Death or the campesinos' deceased ancestors announced to their mortal children the presence of something profound and strange, something that could only be learned from the man whose gift of double consciousness, granted by the Beyond, allowed him to perceive the other reality, the unseen inner reality of things.

And so it was, in fact, because that fraction of a moment in which Ventura had stopped singing, before anyone had even suspected there was a corpse in the river, that fraction of a moment when, with the superintelligence of an animal sensing that a snake is near, Ventura's cautious, watchful air became, one might almost say, solemnly abstracted, solemnly divinatory—the same air of pregnant mystery that all tribal chiefs assume, the same air Moses had when he left his people to receive the commandments of God's Law on Sinai: "...and Moses put the

veil upon his face again, until he went in to speak with Him..."—that fraction of a moment was when Ventura became for them all a visionary, someone in supernatural relation with the mysteries. It was a moment that bound Ventura more powerfully to his flock—those people who felt perpetually orphaned and godless, and who, when one of their gods was given back to them in earthly form, transmigrated into a patriarch, caudillo, or priest, were reassured of the firmness of their path.

Gregorio was disconcerted, ready to believe in Ventura's power despite his efforts not to let his reason succumb. If this one-eyed man's dual vision of the psyche were real, he thought, if he really could grasp the manifold nature of things, especially their unexpected courses and the apparently arbitrary and illogical links between them, it wouldn't, surprisingly, be the product of a finely honed intelligence but rather of a biological substitution of the senses, which had been forced by the disablement of their organs to transmute themselves into new instruments of perception. Thus Ventura's missing arm and eye may have reduced his knowledge of the outside world, but this loss was perhaps returned to him in the form of primitive instincts, atavistic feelings, and ancestral divinations—that way of seeing with his ear, that "no one can even see you here in the dark, you're so quiet" which had surprised Gregorio. They must be the very same capacities the species had used, as cavemen, to discover the transcendent, religious fact that behind the flash of the lightning bolt lay the wrath of a god, or that the darkening of the earth during an eclipse foretold the worst calamities and woes.

Still, however much Gregorio's reason tried to penetrate this, it all held something very dark and mysterious,

and although he didn't know it, or barely guessed it, this something was (he didn't want to let himself suspect it) precisely the way in which the external facts corresponded to the evolution of his state of mind. Given everything the corpse represented for him, his psyche had reverted to its primitive condition—superstitious, fearful, crippled, and in need of magical explanations beyond all rational principles—while his understanding, rather than laughing at these explanations the way it might have done in other circumstances, dreaded them like the onset of madness.

Ventura stood smiling at Gregorio. "You know who he is too," Ventura thought. "But what surprises you most of all is that I knew it long before you did." And he felt an enormous pleasure, for Gregorio's unease was nothing but the recognition that Ventura was a superior being who saw beyond things, "who sees what none can see."

Ventura thought about this with pride.

"When you lost your eye"—Ventura recalled his mother's prophetic words from before he joined the Revolution—"you were six months old, and there's no way you could remember it now. But don't think you're a poor wretch because you only have one eye: *you will see more than those with two eyes, you will see the things that none can see.*"

Ventura had been too young to remember losing his eye, but the anecdotes of our early childhood not only get recounted to us in great detail, they also ground themselves in distant, almost abstract impressions that live on in us, and so his mother's telling, though the scenario couldn't possibly have occurred in precisely that way, had shaped his memory. With time it ceased being an impersonal story told about that third person he saw when he pictured

himself as a child, that person with whom he had nothing in common, and it became a kind of perfect oneiric memory, experienced much more tangibly than more recent and conscious memories.

"You must have been in so much pain," his mother told him, "but you didn't cry even the tiniest bit."

With effort, Ventura could picture the event occurring on a dusty, cloudy afternoon whose main feature—and no doubt the only accurate one—was the taste of dirt and dry matter on his lips.

The memory unfolded in a confused, disjointed way, like when you try to reconstruct an oppressive dream that tormented your sleep and all you can summon is a mythological hydra with a hundred heads, each representing one of the indecipherable emotions you dreamed. But also, like those dreams provoked by some immediate reality (a cushion falling onto your chest, or the cigarette you fell asleep smoking that almost set you on fire), which lose their dreamlike character by blending into the reality they emerged from, the memory had vivid, clear, and excruciatingly precise outlines.

And so it was impossible to say if that woman muttering who knows what sorrowful prayers before the Holy Christ of Chalma, after very carefully setting the blade of an old Amozoc knife in the brazier's fire to heat up, was the image of Ventura's mother just the way he'd seen her that day as a six-month-old child, or if it was the image he'd formed of her as an adult through her narration of the events. But the knife from Amozoc, on the other hand, which Ventura still remembered—along with those words it had etched into his memory: "You will see the things that none can see"—was indeed a real, inarguable fact.

Just before Ventura lost his eye, his mother, on her knees in the corner, suddenly cried out, "If he dies, God forgive me!"

Thanks to a mystery of love, the hungry attachment between mother and son, and a deep memory of his origin, that shout—though it had no location in his memories, and had likewise been narrated to him—was a living fact, a concrete circumstance, beyond dream.

"The Holy Christ of Chalma and the Most Holy Virgin won't let things turn out badly—that was what I said to myself when I looked at your poor little eye all nasty with pus, it hurt me so much to see it," Ventura's mother told him years later.

There was nothing else to be done—if they hadn't taken out the sick eye, he surely would have lost the healthy one too.

But it was pure noise and odor rather than pain, and although Ventura retained no memory of having suffered, he still anxiously recognized odors similar to that indescribable one from his childhood (though never identical to it, for it was irreproducible), like the smell of charred meat or burning hair, and he had a pathological habit of deconstructing certain sounds, like the noise made by someone stripping maize from the cob or crushing some hard object with their teeth, and amplifying them in his skull until they hypertrophied. These reminders called forth from his deepest subconscious an image of the barbarous event, precise and detailed in his mind's eye, even if its physical outlines were by now only a murky allegory.

When it happened, his mother was only a violet shadow that, approaching, blotted out his entire field of vision, like a planet the size of the sky. A hot shadow, hotter by

the second, until it suddenly converted, as the scorching knife pierced his eye socket, into a purple bolt of lightning, a bloody flash, that mingled the most hideous impressions—the sound of the knife scraping inside the orbit of his eye blending with the odor of his cornea and the wounding lights of his ceaselessly vibrating nerve filaments.

"You will see more than those with two eyes. You will see the things that none can see."

Gregorio furiously turned to face Ventura, waiting for him to finally speak, and he thought he glimpsed a gleam of triumphant mockery in the man's lone pupil.

Everyone had very slowly and stealthily gathered around Ventura. They stood there riveted with the equivocal expressions, servile and almost smiling, of people who've witnessed a profound, redemptive miracle, oozing with atonement.

Gregorio clenched his teeth. *The Burial of the Count of Orgaz*. The same secret, shameless mix of repressed enjoyment, masked hypocrisy, and fear of death—and peace of mind because it wasn't your own death. He felt it too, since from the start, despite trying to delude himself, he'd known the dead man's name.

Ventura walked over to the corpse with a solemn air, leaned over it, and turned to the Indians.

"I knew the whole time," he said in Popoluca, "but I wanted to wait until you saw it with your own eyes: the dead man is Macario Mendoza!" He shot a mysteriously triumphant and mocking smile Gregorio's way, then added in Spanish, "But you can be sure, comrade Gregorio, it wasn't one of us who killed him…"

The crowd's satisfaction over the death of the hated White Guard leader was palpable.

Gregorio's repressed rage stirred boldly now in his chest, but, with a surprising timidity that he couldn't explain, he kept it concealed. With a sadistic impulse no one would have suspected, he approached the corpse so that he could gaze at it at length. Two of the caciques standing close to the body, staring at it tenaciously and angrily, stepped away to make room. Gregorio observed the bloated, bloodlessly white belly, the wrinkles that had appeared after death, the face.

Dead, Macario Mendoza was the same as always, yet also different. Gregorio thought that if you added up the features of that dead face, the sum wouldn't be different than the sum yielded by Macario's face in life. Yet each feature, regarded separately on the dead man, was strangely different from what it had been. It wasn't just the new colors—the aged ivory-white of his nostrils or the pale blue of his eyelids—but rather the emphasis each feature gave to some concrete part of him, producing an unfamiliar, unprecedented individuality. Like the face of a clown, which, seen in the abstract, isn't the slightest bit comical—a living face as close as possible to death.

Gregorio had read somewhere that human facial expressions were highly limited, and that even some animals have faces more expressive than those of humans. This struck him as accurate as far as living faces went, but not for those of the dead. Death imprints a new, extraordinary, shifting physiognomy on the human being, as unique to each person as their fingerprints. Gregorio had known this very well from his years at the art academy, when he'd spent long hours studying cadavers in the amphitheater of the General Hospital.

"Yes," he thought, after considering Macario Mendoza's features, "there's no doubt." Man's physiognomy (though

this all seemed too rationalist and "intellectual," he thought furiously) is a set of conventional ciphers, a set of simulations. It's very difficult, even impossible, to discover a person's inner truth by reading these signs, for the face is not the "mirror of the soul": it's the instrument man uses to deny his soul, to disguise it, to give, voluntarily or not (for physiognomy might react independently to an unexpected occurrence), the version of it demanded by the circumstances. The existence of the human face, which is nothing but a relational instrument, can't be explained without the existence of society—any kind of human society—the same way articulated language can't be explained without the existence of society, although as far as the face goes, it has far fewer resources to work with. The facial features are nothing but a social convention, one of the tools man has for living with his fellows—beings who are like him because, among other things, they have a face too—and in this sense you can't expect more of them than that.

Love, hate, piety, anger, scorn, or worry are expressed, among other means, by the face—whether genuinely or not doesn't matter. But the sum of these feelings and everything else one might add to them is not what makes up the soul: the soul's complex structure and its extraordinary mutability and versatility can't even be apprehended by its owner.

"Let's suppose a perverse monster can hide behind a beautiful face." Gregorio was breathing hard and his forehead slowly grew covered in sweat. "Just the way a monstrous face (Beauty and Ugliness: nothing but two conventions) can conceal an angelic spirit. But suddenly the perverse being with a beautiful face performs a great,

noble, selfless act, while the good person with an ugly face commits a vile and shameful act. In both cases the result is exactly what we expected from each face, yet neither the good person's evil deed nor the bad person's good one has shown us even an approximate version of each person's true spirit—they've shown nothing but a circumstantial, inexact, contrary, misleading version."

To Gregorio the explanation was quite clear: we can only possibly discover the true soul in a face that belongs to a body without a soul, he said to himself, only in a man who's no longer a social being, who no longer loves, suffers, or struggles—in a word, a man who's no longer forced to shape the manifestations of his psyche to the changing circumstances of life. To give an approximate account of a human soul, then, we would have to apply to the living, in a sort of *reductio ad absurdum*, the measure of the dead. "I couldn't be more correct," Gregorio thought.

The difficulty in the hospital amphitheater was that the cadavers were anonymous, and the information from their expressions, since you had no reference to what they'd been in life, couldn't be applied to any knowledge of the living person except blindly, by means of a very laborious procedure similar to a mathematical deduction or calculation of probabilities. For example, the feature that in one dead man indicated egotism might indicate something else entirely different on a different corpse, and could only be interpreted if you could see the person whose spirit you were trying to know, while alive, repeat it in a moment of genuine carelessness. But in this necessarily specific repetition, the particular feature that in the corpse represented egotism would have to coincide

too with some other neutral facial expression that, combined with the first one, though it might indicate egotism in a cadaver, might indicate suffering or generosity or bitterness or a thousand other things, depending on the nature of the combination, on the face of the living person. The problem of art.

"Praise God, he's dead!" Gregorio heard Jerónimo Tépatl, the cacique of Santa Rita Laurel, murmur softly behind him.

Gregorio turned to face him, not understanding these words. Tépatl, for his part, met Gregorio's somewhat dazed stupefaction with a look of abject complicity. "Praise God, he's dead." Gregorio wanted to laugh, and he looked back at Macario's dead body with rage and anxiety.

Gregorio felt a sick attraction to the dead man's visage now, and he couldn't stop thinking that in life this man had meant to kill him. Still, he struggled not to associate this thought with the dead man before him, and also not to feel—along with the others, who must be feeling it too—that despicable sweetness, that sensation of triumph lurking in his heart. Gregorio might be able to suppress the feeling if he dared to express it openly—but it was impossible. He felt that he had lost the battle without noticing it, a darkly pleasurable defeat he inflicted on his own moral core. It was like when, pretending to a kind of aristocracy, we try not to lower ourselves to the level of our accomplices in a shared crime, but suddenly the fact that we're just like our criminal partners seems to absolve us of our individuality and responsibility for what happened. And so, though our pretense of superiority may have been fruitless, we're compensated by the consoling thought that we're no better and no worse than the rest,

and our guilt dissipates and leaves almost no trace of remorse, like with people who participate in a lynching or a gang rape—or, more innocently, in an orgy—and can sit at the table with their wife and children, their tranquil conscience not the least bit disturbed.

"He can't kill me now," Gregorio said to himself clearly, with utter shamelessness, as if, despite his haggard face and feverish eyes, his spirit was bursting with joy, with satisfied glee. Immediately he felt astonishment at the crude, unvarnished cynicism his thoughts had fallen into with such impunity; but more than this, when he paused to think about it, it seemed clear that there must be something very deep in the trivial fact that he'd used the pronoun instead of those two living, biographical words that comprised the man named Macario Mendoza. "*He* can't kill me now." Why, why that enigmatic pronoun, why that *he*, instead of Macario Mendoza?

He felt his heart beat fiercely. "Now they'll all notice how worked up I am," he thought, "and they might even think I'm the killer." He felt a kind of despair. "He can't kill me now," he said to himself again, but with sadness, realizing that the word *he* substituted itself not just for a name but for a life, and that pronouncing it was like having eliminated that life with his own hands.

He examined the dead man's features closely again, but now feeling an almost animal frenzy.

He noticed that Macario's cheeks were flaccid but somehow also forceful. Maybe it was because his cheekbones had swollen most unpleasantly, as if each were concealing a walnut, and it seemed as if death had abandoned his cheeks to a kind of organic inertia that wasn't entirely renunciation: it was a protest, too, a birth of new

organisms, the advent of a brand-new, hostile microcosm where, deaf and grim, a reverse karyokinesis was at work, one that leads to extermination and brings the tormenting cycle of unending destruction to an end. Walnuts beneath his cheekbones. "And my God, his ears!" he thought stupidly. "Why are they suddenly so high, why are they suddenly so far back, almost as if they were coming out of the base of his skull?"

"He can't kill me now," Gregorio repeated, "but he clearly meant to. Although," and now he was shamelessly lying to himself, "I never believed it until just now." For that thick, fatty jowl bulging under the tilted-back chin and the two vertical lines that fell along both sides of the corpse's mouth were undeniable signs of the man's harsh cruelty, his cold, homicidal deliberation, and the intentions he'd held toward Gregorio.

"Who does his face remind me of?" he thought with anguish. "Where have I seen those particular features before?" And then, lying once again, he told himself that he really hadn't ever believed that the living Macario Mendoza wanted to kill him, and that it was only now, upon discovering the true inner character of his features as if seeing the negative of a photograph, that he had become certain that the man's soul held an abominable criminality which could have made him its victim. He felt very benevolent and self-satisfied, filled with tenderness toward his own innocence and purity, unblemished by knowledge of human evil, on the point of feeling compassion for himself.

It was as true as could be—no one could take this idea from him now—that he'd never believed Macario meant to murder him, not even after the events that led others to think this. This was why he felt ashamed, not just for

attributing such intentions to Macario without having been sure of them before, but also because he'd rejoiced in his death without even waiting to find out why he'd died.

For the nth time, almost zealously, he paused to scrutinize Macario's chin, his jowls, the two parallel grooves that descended past his lips. That these features so truly expressed the man's criminality was a source of tranquility to Gregorio, reaffirming how righteous it was to feel this sweet, vengeful placidity now.

"No," he told himself obsessively, "even in the seconds right before he was going to try to kill me, I didn't notice how eloquently his features revealed him. They didn't look like these. They were different—their true nature hidden because they still belonged to a man with a living soul who was forced to hide it, to falsify it with the mask of his face." Then he thought, with increasing pleasure in the idea, that at heart he, Gregorio, was a good man who could be fooled like a child because of his limitless trust in people's good faith and kindness.

Everything appeared with profound clarity before his mind's eye, and the memory of that thwarted crime was transformed, projected into a new moral dimension, reassuringly limpid and untainted by remorse.

On that day Gregorio had been walking to Ixhuapan when Macario Mendoza came out to meet him where the road went past his house.

It was early morning, and everything was shrouded in a soft, shifting fog, through which unexpected objects would abruptly reveal themselves from time to time: a shack, an old wagon, a bush. An earthy fragrance of young sap, of substances that seemed freshly reborn, floated in the air.

Mendoza approached Gregorio very calmly. Below the brim of his sombrero his eyes seemed to gleam with a contemptuous smile.

"My man!" Macario exclaimed after saying good morning. "What's this, not telling your friends when you're going on a trip?" His tone was like a nearly transparent knife of hatred. (Though Gregorio didn't notice it that day, the same abhorrent furrows that marked the corpse's face were on both sides of his mouth.)

Gregorio replied smoothly, trying to penetrate his enemy's hidden intentions.

"You call this a trip, walking three and a half leagues? No need to tell anyone about a walk like this!"

The contemptuous smile in Macario's eyes grew sharper.

"And why not? Don't you see my horse is at your service?"

The two vertical lines next to his lips had deepened harshly and his chin had drawn in toward his chest. It was a prefiguration of Macario's dead face. Hatred and crime, plunged into a kind of advance death and destined to emerge with the color real death gave to things. Macario's face and soul. His face. "But besides that time," Gregorio thought, "when and where could I have seen it? Who does he look like?"

Ventura's voice suddenly interrupted his train of thought. "What's wrong?" he said cheerfully. "You look," he added with festive irony, "like you never saw a dead man before."

Gregorio kept silent for a moment. His thoughts returned almost independently to the question of where else he might have seen a face like Mendoza's. On the verge of the answer, he suddenly felt Ventura's words shift his feelings onto a separate course, like Jerónimo Tépatl's had

done earlier, but in another direction. Instead of rejoicing over Mendoza's death or considering it recompense for past harms, his spirit, or at least the part called upon to react this way, reverted to a severely recriminatory attitude.

"This isn't a game," he replied to Ventura, his face pale in the torchlight. "You have to tell me who's behind this crime."

These words weren't recriminatory enough, despite Gregorio's severe tone and strict air, although they did give him the anchor that he needed.

Meanwhile, in the brief second between this statement and Ventura's reply, a miraculous collision in his brain produced the face that reminded him of Macario's, as if a lightning bolt had been gestating in the clouds of his memory, searching for the precise spot in recollection to strike, and, having found the spot at last, illuminated it with the clarity of its flash. "Of course!" he thought: Macario Mendoza's face, those eyebrows pleated with an assertive furrow above the nose and that startling, bilious swelling below the eyes, reminded him of an old painting of a fifteenth-century Venetian merchant that the students at San Carlos had used for their copying exercises.

A great, vehement, and sincere rage took possession of Gregorio's soul. But there was Ventura, that horrible one-eyed god, that invader of minds who saw all.

"Yes, I know it's not a game." Ventura still had his look of malign perspicacity. "But really, isn't it better for you that they killed this bastard?" And then he immediately adopted a mysterious, confidential air. "If someone who loves you," he said, lightly emphasizing his words, "if someone who loves you hadn't gotten rid of him, your hide would've been strung up to dry before you knew it..."

These words disarmed Gregorio without him knowing why.

"Didn't Ña Camila tell you this clearly enough?" Ventura continued, unconvinced by Gregorio's innocent demeanor. "Didn't she tell you, that day when she made you put Macario's horse in the pen so you'd take the side paths to Ixhuapan and not go by the main road where they had an ambush waiting for you? Well then, why don't you want to believe Macario would've let you have it?" Ventura burst into laughter.

Gregorio's spirits, which he was counting on to remain vigorous and effective, crumbled. "If someone who loves you hadn't gotten rid of him..." *Someone who loves you.* It implicated Gregorio himself as an involuntary accomplice in the crime.

"In any case," Gregorio said crossly, feeling tedium and even repugnance, "it's my obligation to inform the Central Committee about all of this."

He looked around him with an inexpressive gaze. He'd had an idea from the start that Mendoza's murder had some connection to his own life: this was the key to the feelings he'd experienced ever since the body had been fished from the river. And the key to the absurd lies he told to conceal his feelings from himself. It was stupid.

Several of the women had made a cross out of sticks and were trying to sink its base in the ground by Macario's head. Jovita had covered the corpse with a sarape, and a few men were readying wicker stretchers for the moment when the dead man would have to be moved. The rest set aside their share of fish in their *ayates*.

In its calm simplicity and straightforwardness, the scene was very sad.

The unsteady cross fell, brusquely striking the dead man's head. The women stood it up again and reinforced its base with stout pieces of timber.

Gregorio went a little way into the brush and sat at the foot of a tree, in the dark, once again surrounded by shadows, alone amid a storm of doubts. In the beginning had been Chaos, but then there was light. But Gregorio didn't know if the shadows he found himself in would progress toward light or toward an irremediable eternal night. "If someone who loves you hadn't gotten rid of him." *Someone who loves you.* A deep foreboding that the darkness was scarcely beginning made his heart tremble.

Amid the shadows, past the fig trees and torches and toward the riverbank, like a bitter, grotesquely funereal scarecrow, stood the silhouette of the crude cross of sticks that was Macario Mendoza's final grave marker.

"If someone who loves you..."

Gregorio smelled a very recognizable odor next to him and shivered. Ventura again.

"Now you really do look low," Ventura said very softly, in a tone that struck Gregorio as compassionate; because of this he didn't say a word in response.

Long moments of silence passed until the chorus of supplications and prayers intoned by the women for the eternal peace of the dead man's soul began to rise from the river. Soon this muted murmur would be transformed into a pathos-filled tremor of religious feeling, of sexual love for death, of alcoholic delight, loneliness, despair.

"Tell me, comrade Gregorio," Ventura said abruptly, but with surprising timidity. "Do you really have to tell the Central Committee about all this?"

The air was redolent of fish being grilled on the embers of the fire by a group of women to feed their men.

Gregorio felt himself smile at this question with a resigned, philosophical air.

"Naturally!" he replied hollowly.

He thought with annoyance about the Central Committee and how his report would be received by them—as if it had been made by an anarchist. Even worse, there was the strong possibility they'd interpret the murder as a "personal matter" in which a woman in love with Gregorio had intervened. In other words, not as a political case, even though Macario was the leader of the White Guards who served the hacienda owners.

"Up there," in the Central Committee, there was no way they would understand, not for lack of the necessary integrity, but because they simply couldn't see things through the dense tissue of formulas they were cocooned in. They were incapable of reasoning except within the atrocious arithmetic they applied to life. There was no way, unless they were all replaced by people a bit less corpselike. The arithmetic of life. Two and two make four, two and two make four, two and two make four. Fidel most of all. Poor Fidel most of all.

Gregorio could imagine him perfectly, his face stiffened by love of principles, his eyes blazing and anxious, his thumb erect and tense with the animosity of a unicorn ready for battle.

"It's a grave error, comrades," he would say, and Gregorio could imagine the exact words he'd use, "a *very grave* error, to use personal assassination attempts in place of mass struggle. But"—and here would come the red seminarian's delicious, choice accusation, which was

also one of the ways Fidel purified himself, like those in-quisitors who suffered seeing their victims tortured—"not only has comrade Gregorio always had the tendency to tolerate this type of deviation and foster such acts of pet-ty-bourgeois desperation, but now he himself, for reasons that aren't even political but rather related to his private life, has inspired a vulgar, unprincipled murder..." Two and two make four, two and two make four, two and two make four. For Gregorio, there was something fantasti-cal in Fidel, something almost wondrous, but at the same time very sad and soul-crushing, as if the man had lost his soul and substituted it with a schema of equations, an orderly algebra of feelings stratified in an icy, horrible, simplistic system. They'd been close friends, but Fidel's higher rank in the political hierarchy had created an in-superable distance between them, full of words like disci-pline, responsibility, duty, principles, and rectitude, which in turn created an atmosphere strained by reticence and convention in which the crude frankness and calm trust of earlier times were no longer possible. Two and two make four. Two and two.

Ventura very gently touched Gregorio's shoulder. "And tell me, comrade Gregorio," he addressed him, once more in that affectionate, emotional way and with the same fearful timidity. "They're really going to chew you out?"

Again Gregorio felt his own lips smiling with a kind of chagrin in the dark.

"Not only that," he said. "I suppose they'll order me back to Mexico City and I'll be *relieved*"—he paused on this military term as if considering its full scope—"of any position of leadership." (The arithmetic. The equations. The formulas.)

They sat silently for a long time, while the women, down at the river, chanted prayers for the dead.

The darkness beginning. "If someone who loves you…"

He sensed a very particular, wary, sorrowful kind of anguish in Ventura, who then abruptly took Gregorio by the arm.

"Come with me," he said softly. "What I wanted to tell you is…" Ventura hesitated. "Someone wants to talk to you."

The ancient god who contemplated all, who fathomed all. Gregorio hadn't been wrong.

The two of them stood and walked to the road, far from the fishermen. The pitch of the funeral chants gradually rose behind them.

"I already know who wants to talk to me," said Gregorio, but sadly, without any recrimination. "I knew it from the start."

In a small clearing in the foliage, next to an old, disused ramada, a woman was waiting. Gregorio recognized her instantly.

Nobody managed to say a word in the first instant. The woman, with a guilty look, kept her chin stubbornly glued to her chest. Her figure, who knows why, had something angelic about it, something very pure and chaste, despite the fact that she was a prostitute.

"Epifania wants you to hear it from her own lips," explained One-Eyed Ventura.

The woman lifted her face violently, with an endearing impetuousness that lent her a sweet, weightless transparency.

"Don't be mad, Gregorio," she murmured in a scarcely audible, unrecognizably childish voice. "I killed him—if I didn't do it, he'd have killed you!"

Gregorio felt his heart pound with a strange force.

"Thank you," he barely managed to say, for the woman had turned and run into the foliage until she disappeared from sight.

V.

Huddled over herself, her arms crossed over her chest and each hand on the opposite shoulder, with the grubby bouquet of *zempaxúchitl* still in her right hand and her face buried in her arms so that only her pallid forehead showed, Julia tried in vain to keep her body from shaking with her sobs. But her efforts only intensified the tremors in her belly, chest, and knees, and the bunch of *zempaxúchitl* became like a bare root or wounded muscle, more and more terribly pitiful, vibrating with the force of her weeping, flailing awfully with the rawest, most helpless suffering.

Fidel, his back to Julia and his eyes glued to the typewriter, couldn't fathom the meaning of the words in front of him, and he repeated them in his mind in a useless, painful exercise that only emphasized more sharply the insistent presence of other unpleasant, insidious thoughts. "Materials for the Political Report to the Party Central Committee." The letters were black and clean against the white page.

Julia was truly suffering, Fidel thought. There wasn't anything insincere about her pain. But this thought, instead of moving him to compassion, made him feel a kind of bitter annoyance, an almost furious vexation. "Materials for the Political Report..." There is a Destiny (the capital *D* appeared very clearly but fleetingly in his brain) that each of us grants himself by means of a sort of voluntary and premeditated natural selection, and we mustn't let anything or anyone prevent us from accomplishing it, for that would make life lose its worth and meaning. It was necessary to eliminate any obstacle

that might threaten your destiny. He recalled someone saying once that every person's destiny matches his image and likeness, and this thought suddenly seemed very rich and profound to him, useful for interpreting and understanding any case whatsoever—like Julia's, for example. Her daughter's death was something that was utterly hers, biographically hers, identical to Julia herself and her mission in life. For she had been called upon to suffer the woes of their shared existence and relieve Fidel of this burden. And in order to serve this purpose while letting Fidel surrender himself to a different kind of suffering that was impersonal, deeper and more generic, she wasn't allowed to... "infect" seemed like the right word—she wasn't allowed to infect Fidel with that "inferior" class of bitterness and pain, even if they were both parents of the dead little girl. "Materials for the Political Report to the Party Central Committee."

A memory surfaced of an incident that hadn't made a great impression on him at the time, but which struck him now as irritating and stupid. It was a memory—so old that he couldn't really explain why it had suddenly appeared—of a conversation he'd overheard on a trolley between two pious old ladies who must have belonged to one of those countless lay organizations the Church organizes under the names of a million different divine figures. Both women were dressed in austere black, with such hermetic, radical modesty that you could easily imagine they never washed themselves, and it was agonizing to see their skittish efforts not to notice anything around them that might offend their virtue, sanctity, and purity. One could easily guess how secretly saturated their imaginations must have been with the most audacious and monstrous inventions of sin.

An intense worry was troubling one of them, and after some hemming and hawing she finally got to the point. "Well, let me tell you," she said with her eyes lowered, "I'm very concerned because a letter came today from my brother." The other woman reacted with solicitous curiosity. "He's in a very bad way, the poor man," the first woman went on, and a shadow of remorse clouded her visage and her lips pursed in a hybrid grimace of spite and sorrow. She must have found it extremely bothersome to make this confession, but at the same time she needed to in order to absolve herself. "He says the doctors have lost all hope," she said at last, "and that there's nothing for him to do but resign himself to dying." With a contrite, pained look she waited for an answer, but in a silence loaded with calculated interest. The other let out a long, devout sigh, philosophical, transcendental, consoling. "What can you do?" she replied, with great conviction and remarkable tranquility. "That's the way things are! May he die with his conscience at peace and may the Lord pardon his sins!" The first woman's face shone with a joyous gleam of happy complacency, and her jovial haste to elaborate on her companion's judgment clearly revealed the sense of peace and freedom one feels at the removal of an enormous weight. "Exactly!" she said hoarsely, with an aggressive volume inversely related to the danger she'd imagined of not being understood or absolved. "Exactly! May he die in peace!" It was the same tone she might have used to say, "He can drop dead for all I care!" With a disdainful movement of her shoulders, she shed the last of her scruples. "And what can I do to help him? I only live to serve God now. I've given myself to Him and I won't be led astray from service to Him. May my poor brother die in peace," she insisted.

Both women sat there looking very sweet and serene, their souls swollen with pleasure over the fact that their benevolent and useful existence was pleasing in the eyes of Our Lord God. "Materials for the Political Report to the Party Central Committee." Why the hell had he remembered this idiotic episode with the two lay sisters? Those women disdained the concrete good of serving a fellow human in favor of the abstract good of serving God. But could this be somehow similar to his case? Why the hell had such a stupid thing occurred to him? "It's not the same at all," Fidel thought to calm himself. "Forsaking the imperative to do daily, concrete Good on the pretext that you're serving God is entirely different from the genuinely painful act of mastering and suppressing our sentimental tendencies in order to practice that same daily, concrete Good, when not only is our purpose not to serve a myth like God, but, on the contrary, we're faced with a tangible, real social cause that we have to give all our energy and our entire life to without haggling over what we'll get for it. It's completely different."

Satisfied with his reasoning, he suddenly understood the words typed on the paper now—"Materials for the Political Report to the Party Central Committee"—and he was able to rotate the platen of the typewriter with a little push of the carriage return lever and immediately type the word "First" below the heading.

The noise of the five keys falling into place one after another was like a small fistful of hail hitting a surface, contrasting strangely with Julia's drawn-out, guttural sobs. Then, violently and furiously, a new, heavier beating of hail followed: "Concerning the errors committed by field agents. Problem of comrade Gregorio Saldívar, currently in

Acayucan, Veracruz." Here was Destiny. Here a sovereign will was imposing a rational impulse upon the mechanical instrument, and thanks to this impulse the carriage of the Remington was faithfully performing its mission in life, following its trajectory from the left margin of the paper to the right. Everything was returning to its proper state. Everything was returning to its normal course.

Ciudad Juárez stared more and more stupidly and vacantly at Julia. In the middle of the room, with his feet seeming glued to the floor, his body gently swayed back and forth, jerking brusquely in the instants when he didn't compensate enough for its erratic course and nearly lost his balance, then resuming its elliptical path. All of this was accompanied by extraordinary facial expressions and a disjointed, garbled muttering which had, perhaps, some very deep and eloquent meaning apparent only to him.

"I did it because there was nothing else left to do," he then said, with such clarity that even Fidel turned to look at him, unsettled and amazed.

"Because there was nothing else left to do," Ciudad Juárez repeated to himself, and it made him feel desolate and guilty. "Now they know," he thought. "Now they can do what they like with me, they can even expel me from the Party if that's what they decide is necessary." He felt an immense desire to weep, and, before he knew it, copious tears were running down his cheeks and falling on his parted lips, finally bringing him a sensation of sweetness and relief. He felt a melancholy in his soul, a sorrowful calm that filled him with an enormous tenderness toward all beings, a conviction that everything was benevolent and pure, to such a point that he would have liked to kiss Julia's feet or caress Fidel's forehead.

He looked at the bottle of tequila, which he'd picked up again, and it seemed to give him a fresh sense of reality, for he walked over to the brazier with surprisingly quick, fluid movements. After filling a mug with coffee to which he added a splash of tequila, he went back to Julia's side to drink the beverage, without in the meantime removing his dumbfounded gaze from the *zempaxúchitl* blossoms making such strange and dramatic movements in Julia's right hand.

A salty heat burned Julia's pupils beneath her tears, through the red, purple, mauve, yellow blackness behind her closed eyes. She felt disembodied, a point in the dark vastness, an incorporeal wisp floating inside a huge pneumatic chamber, an idea, her daughter's death, that had no shape, that was Julia herself, that was Julia and her body, but without material existence—or, more precisely, as if Julia's whole self had been converted into a horrible sensation of being far away and alone, her limbs cut off, the shell of her body pulverized until nothing was left but this piercing thing that was the death of her daughter—her entire being, the act of being Julia, infinitely reduced to this, to pain, to Banner's death and nothing more. But as her suffering passed its apex, the hot weight Julia felt on her eyes as her tears streamed down began to separate itself from her daughter's death, and it transformed into the thought that these eyes and tears were things that belonged to a concrete human being, and that this concrete being was her, Julia. "What awful suffering!" she thought, trembling, but upon recognizing it for what it was she felt it dissipate, become no longer hers, like an old, discarded garment.

Her sobbing tapered off until it stopped completely, and although she felt a certain shame at not suffering

anymore, soon it was as if her soul had entered a clear, lustral atmosphere, spacious and serene. She sat with her face still buried in her arms, while her thoughts flew almost joyously through unsuspected fancies, contradictorily sweet, yearning, anguished, and calm, a mingling of fleeting childhood memories, hazy moments of bliss, and forgotten landscapes.

Julia saw herself two years ago in Jalapa, when she'd been working as a stenographer in the San Bruno factory offices. The memory came first as a scent of oranges, bitter and aromatic, that soon merged with the sight of the oranges themselves, round and shining, hanging above the garden fences in the back streets that led to the San Bruno road. Alongside this the image of a little boy—who knows why he came to mind, but in memory he was much more comical, far more comical, making Julia smile in spite of Banner's death. He dropped right in the middle of the sidewalk at her feet like a ripe chicozapote, a soft, soundless chicozapote, from out of the top of a tree where he'd been stealing fruit, and upon seeing Julia he dashed off with the scatterbrained fright of a rabbit around a corner. Then the grade crossing at the road; a woman selling wild apples; and the sky, sometimes blue (the delight of that intense and marvelous afternoon blue in Paseo de los Berros—and here, suddenly, came an unwelcome memory that she hastened to suppress) and sometimes gray, sullen with rain that made you feel hopeless; until finally, with all these fragments of sky, oranges, and aromas, Julia established the detailed setting of that period of her life, two years ago, before Fidel had brought her to Mexico City.

San Bruno was a tiny working-class town just outside of Jalapa. The workers' dwellings, small and white with

red roofs, clustered around the old, ugly textile factory and lined a street that didn't stretch far in the direction of the city before it was interrupted by the grade crossing of the Interoceanic Railroad, while in the opposite direction, toward the factory, the street ended at a modest cement dam that the Workers' Syndicate had baptized with the name of Karl Marx.

From the uncomfortable desk where she performed complicated transactions in the business office (the office with its old furniture and dusty desks had been anthropomorphized in such a way that it had been assigned human capacities of thought and action, and no one noticed they were in the early stages of constructing religious myths when they said, after the bosses issued some directive, "by orders of the office" or "the office has decided such-and-such"), Julia had a view through a barred window, every day except her day off on Sunday, of a section of street on one side, with the elementary school in the foreground, and on the other side the neat little dam with the sunlight glinting sharply on the water's mirrored surface.

Before ten—although not always with such regularity—the long, quavering whistle of the train would sound as it passed through Las Vigas (Las Vigas or Banderilla? she wondered), the last station it stopped at briefly before continuing on to Jalapa. After this, deep and hoarse, as if coming from below ground, the industrious panting of the locomotive vibrated farther along its path with different intensities until its initially monotonous register was finally transformed into the clatter of its wheels ringing out, briefly becoming a smoother, more concave sound when the train crossed the highway.

Warmed by this memory, Julia curled more closely into herself, squeezing her body with her arms. Far in the distance, by sheer coincidence, as if the image had been magically illustrated by reality as soon as it appeared in her mind, she heard the plaintive, aching whistle of a locomotive, almost identical to the one in San Bruno. Julia thought about the passengers on the train, all of them sad and poor, all of them searching for a hope, for an illusory ideal from which they would try to squeeze the mocking, perfidious substance of life. Men and women and children, dropping from exhaustion in some crowded second-class car, ready to disappear into the unknown distance with their stained suitcases and improbable bundles. But this wasn't the whistle of the San Bruno locomotive. God no. Here she was, by her dead daughter's side, here, with Fidel and Banner there on the other side of her eyelids, in the dark and lonely room. Why these recollections, then? Why, she thought with vague fear, did her memory brush so furtively against the impressions of what had happened in that house on the Paseo de los Berros?

She was trying to extract something from her memories, some force of conviction ("Yes, now I get it," she thought suddenly, "now I see, without any doubt") that would let her justly despise Fidel.

What upset her was Fidel's silence, so long, so loaded with accusations; his hermetic way of torturing her with that monstrous inner suspicion he'd never once expressed in words, but only through his demeanor and horrifyingly icy treatment of her. Julia was convinced. Not just these last few days, but since the beginning, since that absurd morning when they'd first gotten to know each other, and, after a meaningless chat, Fidel asked her about

Santos Pérez with a glacial and indifferent air—her memory of this was vivid to the point of hatred—culminating with those words which she'd thought generous, which at the time made her admire and love him: "It doesn't matter at all. The important thing is to believe in our purity and give ourselves to each other unconditionally." When all was said and done, Julia thought, those words were an abominable lie. Because now, as Julia interpreted the past through the revealing signs of the present, comparing Fidel's gestures, his looks, his intentions, and his behavior in the last twenty-four hours with his gestures, looks, intentions, and behavior of a year and a half ago, a painful truth, carefully hidden this whole time, floated to the surface, unmasked by the power and brutality of Banner's death, like a virus becoming visible in an infected cell on contact with the right reagent. "The important thing is to believe in our purity and give ourselves to each other unconditionally," Fidel had said when he proposed. What candor, what transparent and childlike innocence Julia thought she had detected in those words!

She and Santos Pérez had studied together at a night school, and there had been something like a courtship between them. Then she had lost touch with him until, two months before the events that would happen, they ran into each other again and resumed their old relations. The way this relationship had ended up—Julia tried to deceive herself about this, but in such a spontaneous and obvious way that she didn't realize it—wasn't just a surprise for her, it was a bolt out of the blue that had struck before she even realized it.

It must have been about eleven that morning. Julia felt a peculiar unease, a mix of anger with herself, dread,

resentment, and impotence; she knew where these feelings came from, but stubbornly refused to admit it.

She looked out at the landscape from inside the office, obsessed, even tortured, by thoughts of Santos Pérez she couldn't tear from her mind.

Looking out at the thick vegetation that extended all around, she saw above the roofs, as if viewing them through a defective pane of glass, the outlines of the palms, bananas, and papayas distorted by the hot tropical air. Farther off the entire landscape's contours seemed to delicately flex and wobble, and the cheery, colorful shapes of the orange trees trembled, their lively buds blending at disparate intervals with the most capricious range of greens. The atmosphere was profoundly calm, steeped with drowsiness and indolence, and even the noise of the factory's machines reinforced that lethargy and crushing of the will, just the way the monotonous buzzing of an insect increases the overwhelming languidness and the impossibility of doing anything on a sun-drenched morning in the countryside.

Julia tried to rebel against the voluptuous atmosphere, which was like the insidious, seductive arousal of a desire that wouldn't subside once woken from its inert sleep of ignorance. Everything connected even remotely with the memory of what had happened the night before made her suffer, almost weep with rage and bitterness. Not because she regretted it, even if it did have its brutal, wrathful, and thoughtless aspects—after all, it had been this way since the first human couple, since the first pair of dirty apes—but simply because she was afraid Santos Pérez would let her down, discard her, as happens with all women.

That morning, Julia repeated to herself without con-viction that she was a fool, a real fool. But what really bothered her ("Why the hell did I do it?" she asked her-self, though without the slightest repentance) was the danger that she might really be seen as a hopeless fool if Santos decided to wash his hands of what had happened between them, as he well might.

"Why, God, why did I do it?" she asked herself as she took long strides around the office. "God, why did you let me do it?" And this last phrase, which had evolved from her initial "Why the hell did I do it?" (the transmutation of the devil into the divine), by invoking the ineluctable fact that God hadn't bothered to intervene and stop her, suddenly filled Julia with solace, and she stopped in the middle of the room with the moving thought that she was a hapless, pitiful victim, a victim of God.

To defend against any regrets, she was equipped with the ability to generalize her case so that it applied to all of existence, to the very foundations of the world. This was expressed in a remarkable phrase, which her bitter, vehement conviction of having justice and truth on her side didn't allow her to admit was a simple evasion of her doubts about what she'd done: "And isn't life just a big lie?" she said to herself in a soft, broken, pained voice. "Isn't it a constant swindle?"

Then she felt very calm and serene, and her lips parted in an airy smile. "I have nothing to regret," she said to herself, as certainly, cleanly, and solemnly as if it had all been a dream.

All of a sudden the factory whistle blew four times—the alarm signal. The workers' wives rushed from the depths of their homes, and in an instant the street was

filled with distressed people unable to tear their eyes from the old factory gate, awaiting some unusual, perhaps terrible occurrence.

When Julia came down—not without fear and distress—all the workers had already left the factory and gathered around a man who told them to meet in the assembly hall for an emergency meeting about serious matters.

The assembly hall, half theater and half basketball court, was full of laborers with their work shirts covered in cotton fluff. Their weary faces were cheerful and curious, and satisfied, too, for regardless of the importance of the assembly topic, this seemed a good moment to relax and joke with friends, at least until the Executive Committee appeared. Almost everyone there wore a red bandanna around their neck, for in San Bruno the workers were "reds," while in other factories in Jalapa, controlled by reformist leaders, the unions were "yellows."

Julia took a seat in one of the front rows.

The union debate president, a veteran textile worker with a long mustache and a patriarchal air, signaled for Fidel—who at the time was scarcely more than a stranger to Julia—to speak. Julia regarded Fidel dispassionately; she noted, though, his medium height, his slanting eyes and projecting cheekbones, his quivering lips and that pale and sickly complexion that made her pity him.

What had happened was serious indeed. For a long time a stubborn and sometimes bloody feud had existed between the unions of San Bruno and El Dique, the two local textile factories, because the former was "red" and the latter "yellow." The San Bruno workers had made efforts to fraternize with the El Dique workers, and now, on the eve of celebrating a pact of mutual aid, it was

discovered that one of the El Dique leaders had been killed late the night before.

"It couldn't be more obvious," Fidel explained to the assembly, "that it's the work of provocateurs. On the one hand it's an attempt to sabotage the mutual aid pact we were about to sign with El Dique, and on the other hand it's an attempt to blame us for the crime so our union can be accused of terrorism. The truth is, Santos Pérez was assassinated by the yellows themselves."

When Julia heard Santos Pérez's name, it was as if she fell into a churning maelstrom that dragged her to the bottom of an abyss where it was impossible to think, or feel, or express herself. A black abyss of annihilation where, at the same time, perhaps monstrously, she found the painful satisfaction of never having lost Santos, of having regained—now that he could no longer deceive her, now that his past without any possible future belonged wholly to her—the imaginary truth that Santos's love had been real and faithful. In that moment she desired him with all her being, with all the anxiousness of her throbbing, nostalgic body.

"When did they kill him?" asked a worker with a wide, lopsided face.

"At three in the morning," an unidentified voice replied.

Julia heard this as if in a dream. At three in the morning. Within the black maelstrom, the only clear thing was those words. Three in the morning. That loathsome worker with the lopsided face. Three in the morning. She had hardly left his arms. "So they killed him an hour later," Julia said to herself. "One hour…"

It was as if an inner revolution occurred in whose light things appeared as they truly were, with a meaning

contrary to what she'd first wanted to give them. "What's true," she thought with pride and pleasure, and even a lofty sense of her own romantic generosity, "is that last night I was the one who did *everything possible* to let him know I wanted to give myself to him."

This "everything possible" encompassed a shocking world of secret details, of kisses and caresses, of unexpected situations and bold behavior unimaginable in any woman. However, because she was convinced that what she'd later said was honest and truthful, Julia no longer remembered today that she hadn't confessed this "everything possible" to Fidel when the two of them—for the sake of greater clarity in their relationship—spoke about the issue. In fact, she'd tried hard, with the most convincing nonchalance, to reduce things to insignificance, and even added—believing that this wasn't a betrayal of Santos's memory, and with that vagueness whose pretended modesty so effectively makes such confessions seem true—that *it* had been "something so absurd and disagreeable, so... I don't know the word for it," that the best thing would be to forget the affair for good. In short, a change of values had occurred for Julia, but a change that by some strange paradox made her happy despite the fact that it had begun with Santos Pérez's death, and one that—thanks to an even stranger paradox—two weeks later (two weeks, for time isn't an ethical category) made her see her marriage to Fidel as logical.

Fidel's marriage proposal had been an enormous surprise, but little by little she'd recovered from the shock. It was entirely plausible that he'd been in love with her from the start. Certainly. (If not, why his insistent staring and all those seemingly chance run-ins on the street?) And

he said he hadn't dared confess anything to her before because he didn't want to get in Santos Pérez's way—but most of all because he thought that, in fact, she genuinely loved Santos Pérez. "Did you?" Fidel had asked. Julia felt extremely flustered by the question. Should she tell him the truth or not? Was it necessary? And if by telling him the truth all she managed to do was drive him away or create a thousand stupid doubts? She ended up choosing an intermediate path, but it seemed so brave and full of integrity to her that she grew in her own eyes. "I think so," she had said, "but that's just a memory now... which I'll be able to forget with your help, if you're able to understand me, if you can understand who I am inside."

But another test remained. "Did you have sexual relations?" Fidel asked timidly and apprehensively. Julia thought she heard him begging to hear a no. (How gladly she would have said no, and how detestable it seemed to her today that Fidel had asked her.)

"It's not that I have some special interest in knowing what went on between you and Santos Pérez," Fidel continued, "but really, I'd rather hear it from your own lips." Even at the time Julia had gritted her teeth with rage. "And he has to be so stupid," she had thought, "that he'll surely want to know all the details. Good God, don't let him ask me anything else!" But Julia's actions didn't match her thoughts. She looked Fidel straight in the eye, and, completely unprovoked, a miraculous flame of purity and sincerity sprang up in her pupils. "Yes," she replied in a very soft, calm voice, with which she seemed to offer her entire soul to him. "Yes, Santos and I had those kind of relations. Do you want to know more?"

When she remembered these things, Julia trembled with righteous anger. What else did Fidel expect from her? Why hadn't he understood things? Why hadn't he believed her words, even if they weren't strictly and completely true? Was it her fault that human relations were so imperfect and full of misunderstandings?

With her head still between her arms and the bunch of *zempaxúchitl* gripped furiously in her hand, she had finally found what she was looking for: that sense of justice that would help her leave Fidel without the slightest regret. "Thank you, God," she thought with a sensation of relief in her soul. "Things are completely clear to me now. Fidel has never had the superiority of spirit necessary to forget what happened, and even today"—she added with her teeth clenched, without realizing what a monstrous calumny this was—"even today he's sure that Banner is Santos Pérez's daughter."

Finally, then, she was able to freely feel a lovely, infinite hatred.

Sitting on a small piece of wood, Ciudad Juárez rocked himself gently, with a stupid alcoholic smile, while Fidel went on typing. Everyone seemed to have forgotten about Banner's dead body.

All of a sudden Fidel broke the silence.

"Can you pass me another candle?" he asked Julia, turning slightly. "This one's about to burn out."

To Fidel's pained surprise, Julia didn't move from her position, and a shadow of bitter foreboding crossed his mind. The fact that Julia was rebelling like this made him feel she was genuinely far away, lost to him, and at the same time he loved her more than anyone else in existence. But he didn't voice the slightest complaint; he

just went to the cupboard like an automaton to fetch the candle that Julia had refused to get for him. "Julia, Julia, Julia," he said to himself despairingly, but he managed to calm down and concentrate all his mental forces on his work.

He read what he had written: "Problem of comrade Gregorio Saldívar, currently in Acayucan, Veracruz." But it was impossible. Julia's behavior had perturbed him and his brain refused to cooperate. "But why attach so much importance to these things?" he said to himself bitterly. "Nothing is eternal, everything changes, everything trans- forms," he added, more romantically than stoically. It would be foolish sentimentalism to believe in love lasting forever. That was something out of a cheap novel. Still, it hurt him to the quick to think of losing her. "Problem of comrade Gregorio Saldívar," he read again.

As if it were all an abstruse puzzle, the most diverse conjectures, ideas, and memories arose in his mind. "Julia doesn't love me anymore," he exclaimed to himself sud- denly, but without completely accepting it. He then made a series of troubling associations between incidents that had to do with Gregorio, because he was looking at his name written there on the paper, and with Julia, because of the way she'd refused to obey him. Her refusal, combined with his premonitory sense that she'd stopped loving him, caused him to see, with some fear, a bitter parallel between his and Julia's situation and a painful domestic dispute in- volving Rebecca, Bautista's former wife. A ridiculous, stu- pid dispute: Rebecca had slept with Gregorio.

He felt terribly alarmed imagining that at this moment his face might be wearing the same expression Bautista's face had then, with his trembling lips and a pathetic, absurdly

sad look in his eyes. Bautista's words had sounded that day as if they were coming from a very old and faraway gramophone—they had a weak, screeching tone, involuntarily and inevitably tearful. It might have been laughable if it hadn't been the same tone one uses to speak of a dead son or daughter. "If comrades Gregorio and Rebecca did it out of love," he'd said, "I don't have any desire to get in their way, so the logical thing would be for them to continue their relationship." He had stared at his wife as if he were caressing her with the most enormous sadness in the world. "Comrade Rebecca is completely free to choose." A long, empty pause full of dreadful silence. "Now, if comrades"— Bautista swallowed a gigantic mouthful of saliva—"if comrades Gregorio and Rebecca did it just to *have a good time*"—the words *have a good time* had been singularly tragic—"I want to say here, with complete honesty, that Rebecca can be sure I'll be able to forget it and that nothing will disturb the tranquility of our life from here on." Remembering the scene today, Fidel felt a kind of chill. He had felt puzzled at the time. He, too, had been able to forget the matter of Santos Pérez in due course, and he'd done it with absolute integrity, without any bad aftertaste. While waiting anxiously for the response to Bautista, he'd aggressively stared at Gregorio. "Naturally!" he thought. "You're not going to say a word, you damned shitty intellectual. You'll appeal to some philosophical phrase, some system, and if it occurs to her to say she loves you, you'll feel you're an honorable man who should marry her, even if she lied and said she wasn't Bautista's wife anymore when she slept with you."

It was Rebecca who broke the silence, and what she said was very different from what Fidel had expected. The

flash in her eyes surprised him: he'd never seen one so fierce and wrathful. "If you've all organized this melodrama just to shame me," Rebecca said with angry composure, "you've made a big mistake. I have nothing to be ashamed of." She said this with the vehemence of someone who's been wrongly sent to the gallows. "Bautista's been away for six whole months"—her tone became faintly intimate, even insinuating—"and I'm a human being too. Damn it! It's completely natural with such a long absence. If Bautista understands this, I don't have a problem with continuing our life together just like before, because I love him."

"Because I love him," she had said. Because I love him. Might Fidel and Julia end up in the same situation? An abominable situation of "because I love him" and "such a long absence"? He tried to go on reading, and when he saw that the candle was guttering, he cleaned the ash from the wick meticulously without realizing what he was doing.

"Problem of comrade Gregorio Saldívar, currently in Acayucan." Pause. Rebecca. Julia. Because I love him. Such a long absence. He read: "...this comrade was sent to the Acayucan region with the purpose of organizing the campesinos." He had written after this that Gregorio didn't understand the Party's policies, that he had the defects of a petty-bourgeois intellectual, and that, in general terms, "he harbored a propensity to invent theories on his own, creating grave dangers for purity of doctrine and clarity of principles."

Reading this paragraph had a pleasant, calming effect on Fidel's soul. "Quite correct, quite correct," he thought, feeling more than satisfied with himself. "There is a destiny

that each of us grants our own life, and we mustn't allow anything to keep us from it." Gregorio didn't know how to create this destiny for himself. He was an intellectual, a pitiful intellectual overwhelmed by doubts and uncertainty. "A typical intellectual," Fidel exclaimed to himself with the most resounding sense of conviction, shrugging his shoulders.

He remembered the day they'd met. It was in highly unusual circumstances, after a rally in the Plaza de Santo Domingo that the police had broken up with clubs and tear gas.

Fidel had been the final speaker, and he'd made his escape as best he could, taking the busiest streets to try to lose himself in the crowd. He noticed, however, that a bold, well-proportioned man with a bundle under his arm was persistently following him.

Fidel managed to sneak through and finally slip into a Chinese café, where he felt safe from the man.

He sat at a table in one of the corners that commanded a view of the street. At the cash register there sat an anemic old Chinese man with a sad look. A calendar hung on the wall above it, displaying a charming color print of a half-nude little woman, with a rosy body and a smile that was equal parts ingenuous and acquiescent, amid almond trees in bloom. Next to the calendar, another color print depicted the scene of the Japanese fleet's attack on the port of Hong Kong; the figures of the officers defending the site were each marked with a symbol inside a circle, no doubt to indicate their names: in a box at the bottom of the print, each symbol was matched with several indecipherable foreign characters. In the upper part of the print, inside an oval, Fidel recognized the figures of Dr. Sun Yat-sen and Generalissimo Chiang Kai-shek.

But now his pursuer suddenly reappeared. He was wearing an old, glossy suit and instead of a necktie he had a carelessly knotted black bow around his neck. He didn't look like a policeman, and so Fidel's nervousness subsided.

The man came up to Fidel without hesitation, set his bundle on the table, and took a seat opposite him.

"Pardon me," he said breezily, pointing to the bundle, "but I believe you're the one I should return this to. A girl gave it to me for safekeeping a few seconds before the police arrested her."

Fidel looked at the package with apprehension, recognizing it by its wrapping as one of the propaganda packets that had been sent to the Santo Domingo rally.

"You can trust me," said the stranger. "I'm not from the police. I'm an art student, and my name is Gregorio Saldívar."

Fidel looked him over carefully and with increasing apprehension.

"What did the girl look like?" he asked.

Gregorio gave a detailed description, adding that she was wearing a sweater "with dark brown, red, and sepia stripes." Fidel shivered with vexation.

"Are you sure they arrested her?" he asked anxiously. Gregorio affirmed this, and Fidel sat for a long moment without speaking.

"Then it's Julia," he thought, worried. "But it's idiotic for them to lock her up—she's three months pregnant."

He wanted to dismiss Gregorio as quickly and smoothly as possible, but Gregorio showed no intention of leaving.

"Actually," Gregorio confessed, "I've been following you people for a long time without being able to track

you down. I want to join the Communist Party. I'm sure you can help me."

They became absorbed in a long theoretical discussion, and Gregorio's wealth of knowledge impressed Fidel very vividly. He never forgot the opinions Gregorio expressed that night.

"I think that you're starting from a point of incredible confusion," Gregorio had said to him at a certain point in their discussion. The start of their friendship, like the relationship that continued to unite them later despite their difference in opinions, had its origin in that night's argument and the insistence with which they revived it at every opportunity.

"A confusion," Gregorio continued, "that could lead you to tyranny or suicide."

To hide his feeling of alarm, Fidel gave a pitifully false smile of superiority, as if Gregorio's words couldn't touch him, though at heart he feared he was right.

High on the wall, the naked Chinese girl smiled charmingly and provocatively.

"Because," Gregorio went on, "you have a finished, complete, one might even say perfect image of man. You've fallen in love with this image and you wouldn't change it for anything in the world. If it were snatched away from you, you'd think your life no longer worth living. This is marvelous; it deserves enormous applause. But it's easy to forget that this man you believe in and ceaselessly struggle for (and not without romanticism too, you have to recognize that) is a man who has never been seen in real life. He's just a man built in the laboratory with the help of all kinds of philosophical and sociological test tubes, flasks, and astrolabes."

The rosy body of the Chinese girl looked fragrant and soothingly fresh beneath the cool shade of the almond trees, and the eyes of Dr. Sun became kinder and more intelligent with each moment.

"That is to say," Gregorio continued, "you've gathered all those historical, biological, social, evolutionary, atavistic facts, let's say ethical ones too (and if you haven't gathered them you know without doubt that they exist), from which one can deduce as truthfully as possible what man is—the way astronomers, using mathematical deductions, can establish the existence of a planet that for the time being we can't see with any type of device, but only by means of pure knowledge."

Gregorio had leaned back in his chair to judge the effect of his words.

"But," he added with a malicious air, "while you know man, you're completely ignorant of what the living men around you are, and you imagine you can handle them like abstract entities who don't have blood in their veins, or passions, or testicles or semen. If you manage to gain power—and God save us from it!— you'll become a horrible tyrant. But if, on the other hand, you ever manage to see men with a tiny bit more humanity, you'll end up, and I'd say with good reason, blowing your brains out."

This speech had been Gregorio's rejoinder to a single statement by Fidel. "I don't care about individual moral problems," Fidel had said, "as long as they're not an obstacle to achieving our goal. Men can be as miserable, contemptible, and low as you like, but"—and this he had said without much conviction—"they'll stop being that way when society is transformed."

After Gregorio's speech, Fidel searched for an effective argument to refute him, but he couldn't come up with the right concepts.

"In any case," he said weakly, "maybe this planet you're talking about can only be perceived through pure knowledge, but if such a type of knowledge exists, then you can't deny that the planet in question has a precise location in space."

Gregorio shrugged.

"It's all the same," was his only response.

Their discussion had ended at three in the morning, on a street corner, hours after they'd been kicked out of the café.

"A typical intellectual," Fidel said again as he removed the sheet of paper from the typewriter to read it carefully.

Julia lifted her face from her arms, and when she saw the bunch of *zempaxúchitl* in her hand, she offered it to Ciudad Juárez with a sad gesture.

"Put it on the baby's chest!" she begged him with grief in her voice.

After obeying, as if all he'd been waiting for was this reaction of Julia's, Ciudad Juárez settled into a corner and soon was sleeping a placid, happy slumber.

Fidel turned all the way around in his chair and looked at Julia.

"Do you feel able to help me?" he asked her. "I want to dictate a letter to Gregorio, ordering him to come back from Acayucan immediately…"

"Yes," Julia mumbled, "but first I want to talk with you." And she took a chair and seated herself face to face with Fidel.

Fidel looked at her with great surprise and at the same time a kind of terror.

"About what?"

Julia made an indefinite grimace.

"About us," she replied in a very sad tone. "I've decided we should split up for good. I think"—her voice seemed to waver—"I think I've stopped loving you."

Fidel had never felt anything like it. "The same expression as Bautista," he thought about his own face, "when that business with his wife happened." His heart throbbed furiously and his extremities went intensely cold. He was certain he had the wide-eyed expression of a fool.

"I don't understand," he stammered, "but you're free to do what you want."

He paused.

"Give me a moment," he said, and went out onto the back patio to get a breath of air.

Shortly after this Julia heard him curse as he came back in with a package in his hands.

"See this?" Fidel said indignantly, holding out the package. "Now I understand how this idiot got drunk! He spent the money that was supposed to be for mailing the newspaper!"

Sure enough, the package Fidel was holding in his hands should have been mailed to the provinces hours before with the money Bautista had brought for the dead little girl's funeral.

But Fidel felt so incredibly dejected and lonely that he didn't have it in him to scold Ciudad Juárez.

VI.

Bautista and Rosendo walked with firm, intrepid steps.

"Give me the can for a moment, I'll take it," Bautista said, reaching for the container of glue they were using to paste up the propaganda posters.

Rosendo wanted to refuse—he was feeling very tired and this invested the act of carrying the can with a dimension of sacrifice. But he couldn't stop his partner from snatching it away. Still, he felt extremely happy, and not with a vain and senseless happiness; it was something very strong, very noble, unfamiliar and beautiful.

The gloom seemed to depopulate the world and suck all of the air from it. Suspended in the middle of the darkness, like two hanged men dangling over an abyss, Rosendo and Bautista strode on through that eternal night toward a murky ideal that surely lay on the other side of the shadows, their feet sinking into the overwhelming expanse of the trash dump, in the middle of the thick blackness, in almost a sheer act of levitation. Like two hanged men.

Rosendo bubbled with an enormous, romantic joy. In the way young people brim with pride when they think they've said something that makes them seem admirable, daring, or brave, he was sure that his enthusiasm and admiration for his comrades' integrity—Fidel's in particular—had earned him a place in a comforting, healthy, ennobling moral hierarchy. And so he attributed Bautista's taciturnity and sober impenetrability as he walked through the night to the emotional reserve of a more experienced militant; he saw it as a way of recognizing this hierarchy.

But Bautista was silent only because he couldn't get Fidel's callous statement about Banner out of his mind—the same statement Rosendo had found so admirable. "She's the one who can wait, because she's dead." She, Fidel's own daughter. Her father's words. Like in ancient Sparta. "Come back with your shield, or on it."

At least, Bautista thought, you might be able to exclaim with passionate, sentimental rhetoric that the girl was both with her shield and on it, victorious and dead in her crib—a brief-lived, involuntary martyr without a coffin. Without a coffin. Without money for a coffin. Fidel had said it, cold and white, cold and white between the cold, white walls next to the little dead girl, guarding her, afraid they might take her to the cemetery that very moment, standing in the way, afraid they might snatch away his sacrificial lamb, his paschal offering. Her father's words, those of an Abraham performing the painful immolation of something precious before who knows what hideous gods.

Bautista pressed his lips together. "Maybe," he said to himself, "if I'm wrong"—if he was wrong when he said the money should have been used for a coffin and not for sending the newspaper to the provinces—"it's just a personal question of filial feelings, or the lack thereof."

But no, that wasn't the issue. He felt like he was bringing up an unpleasant question. Love for your children. Having nothing to bind us to the earth. "For whosoever shall save his life will lose it." Bautista breathed a short, silent curse. Why the Gospels now? It wasn't about that either. Love or lack of love for your children and love or lack of love for the cause. A stark choice. The Communists were supposed to live only for the

cause—they didn't have the right to a personal, intimate, private life. But how possible was this really?

This question led Bautista not to the answer he was searching for, but to the memory of something he'd read that now struck him as surprising. A young Soviet woman (Bautista remembered that it was in the context of a questionnaire a famous writer gave to Russian students), when asked what meaning "bourgeois sentiments" such as love, jealousy, and the rest would have under socialism, had said something like, "If the institution of the family in its current form is called upon to transform itself and disappear, then love for one's children, logically, will disappear too." It was a thorny issue. At heart, despite all rational arguments, he felt an obscure defensive rejection, like the aversion the soul feels toward incest, toward things too far outside the norm.

Maybe it wasn't a "theory" but an attitude, an urge to painfully oppose your own personal feelings in order to suffer for the cause. It was a mode of sacrifice, certainly, but in no way a social idea or a doctrine. Like the Christians, since they, too, in their eagerness to imitate Christ's sacrifice, must have felt gratified to die in the claws of lions. It didn't take much effort for Bautista to imagine exactly how that young Soviet woman must have pronounced her words—with the ardor, boldness, and joyous enthusiasm of young Communists here or in any other country on earth. Rash and boastful, they believed they were capable of being different from the rest of humanity, they believed their immaculate, naïve hearts could be free of the passions that torment the rest of us.

In any case, he found the young Soviet woman moving. Just as moving as the early Christians. As moving as Rosendo or Fidel.

"She's the one who can wait, because she's dead." Bautista still couldn't get the words out of his head, just as he couldn't with Rosendo's candid statement about Fidel's behavior toward his daughter: "For me it's one of the most beautiful lessons." He smiled. The most beautiful of lessons, yes, a lesson in detachment and sacrifice. "She's the one who can wait, because she's dead." Of course a corpse can always wait: it has nothing left to wait for. The most beautiful of lessons, but not just that—it was also stunningly logical, to the point of making no sense, like all excessively rational things.

If the family must disappear, then love for one's children will disappear too, without a doubt. It was as appallingly rational as the result of mixing two known and tested chemical compounds, from which nothing could be expected but that already predicted result: H_2O. Aitch two Oh. Water, no doubt about it. Nothing but water.

Because, indeed, Banner was the one who could lie quietly in her crib. The newspaper couldn't and mustn't sit there quietly. The newspaper is the voice of the Party, the voice of the people—in short, the voice of God. Stunningly logical. Yet despite this, when Bautista imagined the little girl lying unburied until they had the money to buy a tiny third-rate plot in the Dolores cemetery, a shameful feeling of guilt needled him. Why had he allowed it? He could have forcefully countered Fidel's ridiculous claims, but instead he'd let himself be crushed by Fidel's religion, by that Communism of Fidel's that was so Catholic, which presupposed gratuitous sacrifices

with no point other than egotistical moral betterment, for what purpose no one could say.

It was as if Fidel believed in God. A materialist god, of course—all the better if he could be verified in the laboratory. A god capable of renouncing his own existence as soon as they discovered he existed. Or maybe, the malicious thought occurred to him, it was some esoteric yogic exercise like breathing in the infinite through the mouth and nose past the lungs' limits of endurance, and with this technique Fidel hoped to turn his own purity of doctrine into a strange inner saturation of his tissues so that he might attain the nirvana of some extravagant Eternal Marxist Bliss. It was a little ridiculous but not out of the question. Because how else could it be explained? How necessary, how essential had it really been to use the money meant for the little girl's burial to mail the newspaper to the rest of the Republic? How necessary? Bautista bit his lips, unable to come up with an answer. "The newspaper could have been mailed some other day," he said to himself obsessively, but thinking at the same time that the words contained a broader and more general criticism of a whole set of Fidel's practices and behavior. If it was—a smile appeared on his lips at the thought of it—if it really was a yogic exercise, this didn't stop it from having an absurd and boastful quality: in fact, this made Fidel's behavior even more comical and stupid, giving it a lunatic "Hindu" aspect (an adjective that made him smile again).

But suddenly he thought that perhaps he wasn't being entirely fair, recalling that he, too, had fallen prey to behavior much like Fidel's, and precisely in connection to money for the newspaper.

A comrade of his, moments before being arrested by the police, had handed Bautista some money belonging to the organization. This act had made a strong impression on him. This comrade, he'd thought, would rather land in jail without a cent than be set up to take a small amount of the Party's money, even for cigarettes. Bautista had felt angry at the time, but now all the facts of his own behavior came to mind.

As soon as Bautista was given the money, the nightmare began. The twenty pesos began to burn in his pockets. What should he do? The obvious thing was to hand the money over to the organization, but he had no way to communicate with his comrades, who, thinking the police were watching him, had forbidden him to come to their meeting places for the time being. He could have stashed the money at his house, but he rejected this idea, for if his mother and sister didn't have enough to buy food, and they surely wouldn't, Bautista would never have been able to resist the temptation to give them the money. So he opted for the only path left: to wander the streets, preferably near the spots his Party comrades frequented, until he ran into one of them. He spent three abominable days like this without eating.

He would feel a great tranquility if he could find something in himself right now, some impulse sincere enough to let him describe his behavior then as stupid. But, quite the opposite—he felt proud of it today. Proud, heroic, smug with satisfaction.

With a self-pitying, filial tenderness toward himself, the kind we feel when we recall our own acts of kindness, like helping a bankrupt friend or pardoning some insult we've been dealt (in a somewhat forced way, even if we

don't realize it), he remembered how he'd managed to re-sist the temptation to use some of the money after his first twenty-four hours without eating, when taking it would have been so easy and justified. And he remembered his comrades' astonishment later, their admiring eyes and their pity, when one of them finally brought him back to the newspaper office, dying of hunger and without the strength to stand.

His comrades' faces had been unforgettable, but Bautista couldn't forget his own shameful conduct either—the way he'd rehearsed, histrionically and with hypocritical guile, his appearance before them: his air of suffering and fatigue as he let himself drop onto a bench, and the nonchalant calm he feigned when he mentioned the days he'd spent without eating. Nevertheless, they must have considered it to be, just the way Rosendo thought about Fidel today, "one of the most beautiful lessons." Simply intolerable, and just as "yogic," just as idiotic!

So why think badly of Fidel and his awful itch to be a saint? This whole Communist way of life was nothing but a career of sacrifices, a gigantic and clearly unhealthy urge in everyone to be better than the rest, even if this path might be sterile and vain and have no concrete purpose.

Suddenly Bautista stopped short with a muffled shout of rage. "Fuck me!" he nearly bellowed, because he'd felt himself step on something soft and viscous among the garbage. He scraped his foot against the ground and spit another furious curse, as the vile stink filled his nostrils.

"And it's not even an animal's!" he ranted to him-self, trying to clean off the sole of his shoe. "No, it's definitely human." He felt such rage that he wanted to punch someone.

Rosendo was quite surprised by this outburst, and he paused a few steps ahead but didn't dare to inquire. Incredible, almost illusory stars shone in the sky, making him think with childish sweetness that this was the first night he'd ever performed an activity so dangerously attractive as pasting up propaganda in the streets. He'd performed lesser tasks before this—taking packages to the post office, handing out fliers—but tonight this was something different and full of adventure. At some other end of the city lost in darkness, perhaps Rosendo's mother was lying awake waiting for him to come home. The thought, rather than worrying him, made him feel a peculiar kind of pleasure and pride. He would return to her like a new son and kiss her forehead with quivering gentleness, an unfamiliar kiss full of love and eloquence, the only way he could confess to her his lovely secret of life, the only way to transmit to her the calm inner light he bore inside from here forth.

He didn't want to take his eyes off the distant stars. It felt like he was surrendering himself to them and gaining an unshakable belief in something very deep and true. "A model comrade, an extraordinary comrade," he thought, imagining almost beatifically that someone might say this about him.

Bautista knocked his foot against the ground again with a desperate rage that grew more anguished and disturbed with each passing moment. That horrible substance, smearing so moistly beneath his foot!

"From a man!" he said to himself with a repulsive feeling of nausea. "From a man!"

This made him think about the people who dwelled in the dump, those awful shadows whose feelings

always showed with the most raw and cynical stark-ness. Nothing more and nothing less than his fellow humans. Why would they be different from him, different from other men? Creatures of Our Lord. The only difference was that there in the trash dump they had no need, none whatsoever, to disguise their passions and their shames.

In the other world of men—that world that presumes it's not a trash dump—moral filth and misery were hidden by the most chaste of veils, but really they were exactly the same.

"I'm talking like a Protestant minister," he muttered to himself.

These thoughts were clearly a natural result of the soft, oozing, sticky substance he felt beneath his shoe. It was the trace that revealed an entire system of science or ethics. Man's droppings were as good as Newton's apple as a point of departure. Universal gravitation or universal defecation.

A cloud moved into the patch of sky where Rosendo was gazing at three or four glimmering stars, but it didn't dispel his fantasies, which were absolutely angelic, full of calm contentment and kindness. The cloud was like a hand, at first tinged with a distant light, and then black and possessive, a celestial wave that spread to cover a part of the cosmic ocean which had remained magically exposed until then, and which was now plunged back again into its unfathomable realm. Beyond the visible lay the mystery of the infinite—the most beloved of all mysteries, because man will be its master once he is free. The idea made Rosendo feel a vivid excitement. He imagined the advent of a kind of promised land, at once an inconcrete

sense of something very pure and crystalline—abstract feelings of sweetness, transparency of the soul, and love for his fellow people—and an image of cheerful work, optimistic and generous striving among healthy, righteous men, with Rosendo like a winged phantom looking upon it all with a smile of ineffable tenderness. Rosendo felt a hazy, almost nostalgic longing to warmly and chastely love a good and radiant comrade, a woman with whom he would cross immense fields bathed in sunlight. But just then a curse from Bautista burst like a rude projectile into his chimerical thoughts.

"Goddamn it!" said Bautista loudly, and he approached Rosendo looking like he wanted to say something but then didn't, invaded by an inexplicable feeling of despair, bitterness, and fatigue. "Goddamn it to hell!" he repeated. "If it had at least been from an animal!"

It was as if he'd been dealt a cruel insult, but at the same time a stupid one. Cruel and stupid because it came from a human being. From cruel and stupid humanity. He was about to let loose the nastiest curses, but he stopped himself abruptly as an unexpected idea occurred to him, one that almost made him smile with the startling twist it gave to his thoughts.

"If I'm strictly logical about it," he thought with a sensation of relief, "I shouldn't feel offended, since what I stepped in is only the product of a man like me, a fellow man whose droppings, which are my own, shouldn't"— he groped for the right word—"shouldn't... *scandalize* me." He couldn't suppress a short burst of laughter. He was having some fun. But with a certain alarming severity.

Contempt for yourself and love for all the rest! "Fantastic!" he thought. "But really I don't think I could

despise myself sufficiently." He thought about how even when he tried as hard as he could to feel ashamed of himself, the most he could manage was the sensation that he was looking at his image reflected in a convex mirror, and it went without saying that he could breathe easy knowing that this image didn't correspond to his real self. This grotesquely distorted mirror image was at least a form of healthy contempt for himself, without any risk involved. But—the thought began to disturb him—this didn't mean that the distorted image of himself didn't also have an existence just as real as the true image.

He hesitated for a long moment. There was still the possibility of eliminating the mirror. The idea was seductive. All the mirrors on earth, one by one. To not know what you're like, what features you have, what expression. Ignorance of yourself to the point of annihilation, total disappearance. But eliminating the mirror, he thought suddenly, doesn't mean that we've eliminated the *fact* of the reflection of our image as a phenomenon in itself, independent of us. That is, the fact that we're reflectable, whether or not the instrument to reflect us exists. By virtue of what, then, does the image in a mirror become as existent and indisputable as the figure itself that's being reflected? If both exist, which is real? The question isn't whether the reflectant is the truth and the reflection a lie. They're identical, joined like Siamese twins that can't live if one dies, determining each other reciprocally, mutually. It's not a question of replacing the convex mirror with a flat one either. Substantively, the figures both mirrors reproduce are faithful to the original and absolutely dependent on it. That is, both the distorted and the undistorted image exist only while there's a body, a person, to produce them, in the same way that a person

only exists insofar as he can be reflected, verified on the outside, on the other side of himself. Here, then, is the problem of man and his condition, and its explanation: If man has a mirror in front of him that distorts him, he understands that of course this is only the result of a particular property of the mirror, and that the distortion originates in the warping of its surface. If the mirror doesn't distort him, though, but instead reproduces something that he believes, or is convinced, is his genuine image, then things change completely, they're subverted. Now the image in the mirror sees itself in me, in turn, as a distorted image. It has the same attitude I do, of confident certainty that I'm the false version, the trick. Suddenly the convex mirror is me. My own self sees itself in me with other features and other proportions that, nevertheless, are essentially my features and proportions. The torture has begun. Now I won't be able to escape my mirror, nor will it be able to escape me. I too am an awful, hideous mirror of all men. "To see ourselves in our realness," Bautista thought, "in all our contradictory realness, from outside the mirror as much as inside it. To bravely see our real distortions, our excretions."

It seemed impossible, though. "I despise myself," he sighed, "but not in my own person—that's safe from all criticism. I despise my image in the mirror, the image of everyone else; I despise myself in the figure of my horrible, filthy, disgusting fellow humans."

Bautista and Rosendo were now on the slope of a small valley where the hills of garbage converged, a little blacker than the rest of the night—it was like a funnel, one more irritatingly olfactory and gustatory than visual, whose foul atmosphere smeared itself on your body, varnished it relentlessly.

"But what," Bautista wondered, "does despising yourself, in your own person, lead to?" Though he was trying hard to give a certain frivolous levity to his thoughts, they were beginning to make him uneasy, to relate themselves obscurely to something imprecise that was no longer a question of ideas, but rather, you might almost say, a question of sensations. An unconscious, reckless approach, perhaps, to a despotically buried memory that Bautista didn't want to discover, that he wanted to flee from with all his might.

But a beguiling fear, an enigmatic drive, impelled him through this unexpected, tortuous game of cat-and-mouse toward the unveiling of the thing from his past that his treacherous memory kept hidden from sight, and which Bautista, fighting the subtlest of interior battles, both wanted and didn't want to face again. "What are the consequences of despising yourself?" he asked himself again, with a mental tone of light mockery that was a defense against the hidden memory.

"If man," he thought in a last attempt at escape, "instead of despising himself in others, which is the convenient thing for him to do"—the cynicism of the phrase pleased him very much—"were to end up truly despising his own individual self, surely there would be nothing for him to do but commit suicide, like Christ." With this idea, he was on the brink of satisfaction. He breathed in deeply, but a miasmal taste in the atmosphere made him feel a kind of dirty, muted sadness. "And so," he continued, following the thread of his thoughts, "criticizing your own vices and wretchedness in others, seeing the mote in someone else's eye and not the beam in your own—loathing the shit I stepped in just because it belongs to a fellow

man and not to myself or an animal—is nothing but an honorable principle of preservation: preservation of the individual, of the family, of society, of the State, and thus of all humanity. That is to say, it's an ethical principle whose foundations rest in the pristine, aseptic Empire of Beloved Excrement." He paused. "I defecate, therefore I am," he concluded with a smile.

As they walked on toward the factories, the filth on the sole of Bautista's shoe no longer bothered him, but now the dump suddenly seemed immense and endless. "Will we ever get out of here?" They had to cross it, reach the other side, and lie in wait there, in ambush, until it tolled five o'clock in the morning—the hour when the electricity went out in the city. Then right away, protected by the shadows, they would paste up the Party manifestos on the walls so that the early-shift workers could read them before they were torn down by police and watchmen.

"It's so easy," he said out loud, though the words didn't correspond to the thoughts that had him in their grip, "to get lost in all this filth and the goddamn dark!"

Hearing his own voice didn't calm him, nor did it dispel the confused, hostile unease that was oppressing his mind. It was like a desire to have someone by his side, someone placid and loving—and unexpectedly, with painful astonishment and fear, he understood that behind all of this lay nothing more than nostalgia for his ex-wife Rebecca. The paths that had led him to remember her today were strange, revealing, and bitter: he wanted to reject the excruciating memory, but now Rebecca's calm, sweet figure, her eyes the shape of almonds and the color of chestnuts, the deep black bunch of hair gathered at the back of her neck in the bright

flare of a ribbon, the two halves of her body divided by a white blouse and dark brown skirt—the way he'd seen her that last time—had cut into his memory in full detail. Newton's apple. Universal gravitation or universal rot. He gritted his teeth in anguish.

He felt no resentment about their split, he'd always told himself, and none of the tortuous spite, the sad, aggressive jealousy, the revulsion with something unspeakably amorous and sexual to it at the same time—the things a separation leaves behind like the last menacing ashes of spent love. But the extraordinary undermining of his spirit brought on by stepping in that vile shit was like lifting the veil that had been covering his passions, and now the bitter, naked truth was revealed before his eyes. That free, calm, normal, serene, "civilized" attitude he told himself he had toward Rebecca was all a lie. What he felt inside was more like an inferno: he throbbed with passion, with feelings of frustration and incompleteness and at the same time torture by the most inexpressible impulses, with a certain urge for vengeance, with murky possessive desires and jealousy. The convex mirror in which he could view a precise inner reality that had always tried to conceal itself.

Bautista and Rosendo climbed to the top of the hill of garbage, and from there they could see the distant glow of the industrial zone, like the dull glow of the solar corona during some sinister eclipse. Rosendo sighed deeply, paused a moment, and then they headed down the other side of the hill.

Bautista desired with all his soul not to think about Rebecca. "Do I," he asked himself forcefully, his stomach almost contracting, "do I really, *honestly*, still love her?" *Honestly?* He knew just how dangerous it was to

use that word when he was confronted with a problem of this type. This simple word had made him reach conclusions completely the opposite of the ideas he thought he'd begun with—in its light his tricks and sophisms fell apart. "Do I still love her," he thought again, "despite everything?" With rage and sadness he admitted that yes, he still loved her, and that the frustration of this love not only made him miserable, it tormented him with an incapacity to conform to life as a whole; he couldn't ignore the fact that the people he lived among all had a secret, unconfessable corner in their souls where they harbored the worst shames.

Within a second, the detailed memory of their love appeared before his eyes, from the night they'd met until that last morning when Bautista stood watching her disappear down the street into the distance among the passersby, after they'd pitifully and horrendously argued without finding a way out.

That final conversation had been in a restaurant, at a table where their cups of coffee—hot at first, steaming, and then little by little growing cold, a summary of their own love life—sat untouched under the waiter's restless, impertinent gaze while they argued, traversing every shade of anger, bitterness, jealousy, and desire, the eternal problems of man and woman that are at once so huge and so insignificant.

Bautista had believed at first that a clear, joyous reunion could emerge from this conversation—a true love redeemed. But she persisted, with the stubbornness of an immovable wall—though if she hadn't, it would have been the salvation of them both—in her falsehoods and delusions, making it impossible for them to revive the

beautiful openness they'd always had with each other, and which had now fallen to pieces.

The sunlight was pale gold when they parted ways on a street corner, amid people bustling here and there, unconcerned with the torments of good and evil, of life and death. "In any case," she said finally, as they said goodbye, "I'll be waiting for you; I'll always be waiting for you." The image of her white blouse and dark brown skirt faded into the distance then. I'll be waiting for you, I'll be waiting for you. In whose arms? Why, good God, did Rebecca insist on these stupid, hollow lies?

The memory of the evening they'd met was linked to Bautista's memories of a network of night schools for workers that he'd been in charge of running for a time—the innocent festivals, the semester's end, the trips they made to the countryside. The only thing he didn't like about Rebecca was her legs—short, round, and very even and uniform, undifferentiated, solidly cylindrical.

Bautista had arrived a few minutes before the end of class at the school she attended, and after sitting shyly and quietly in the last row of seats, he looked without much interest at the small girl, somewhat round, with full, solid arms, who was writing at the chalkboard. Later all of this began to weave its intense world into his own biography.

Bautista couldn't forget one afternoon when they made a trip outside the city.

The clouds were intensely white, barbarous against the insolent blue of the sky, and the air was so clear that the chain of mountains seemed to rotate—too slowly for the eye to perceive it, but it was as if you could make it out with your heart, with who knows what delicate, occult instruments of awareness.

Rebecca's white dress, stirred by the wind, was a bloodless flame of clear fire burning softly and silently, throbbing coolly. Bautista clasped her by the waist, pulling her down gently onto the grass under a *pirul* tree whose branches cast a slow play of light and shadow upon her flushed and yearning face. The flickering shadows made Rebecca's eyes gleam intermittently, and a deep, still, surprised unease seemed to be revealed in them, a fearful helplessness and wary abandon before the violence of love. Seeing her so transparently defenseless beneath his body like this, almost as if she were asking him to show a bit of mercy, Bautista was seized by a wave of tenderness and love-struck compassion. He covered her with kisses, his hungry desire replaced by an impetuous, utterly chaste impulse.

Rebecca had held her breath as she was pulled to the ground, her alarm shot through with desire. She would have liked—this had worried her since they'd left the city—for this not to happen in the countryside, for it to happen somewhere less poetic, less awkwardly poetic. The man had her in his arms, and the imminence of what was about to happen (she had absolutely no thought of either avoiding or encouraging it) made her lie still. She had an air of such innocence—which was unintentional, for she wanted to express the opposite—that it was like a reproof, a silent and resentful criticism. Still, she awaited the moment anxiously. Now Bautista's hands would open her bra—like that time they'd made the button of her blouse pop off with their desperate, feverish groping—and cover her in childishly fumbling caresses, hasty and nervous.

But Bautista didn't cross the threshold whose gate Rebecca so willingly opened to him. Instead of plucking the lovely

fruit from the Tree of Knowledge of Good and Evil, he let himself be seduced by a certain sense of pity and blame.

Rebecca slipped out of his arms skillfully and gracefully, with a smooth movement that was intentionally and knowingly arousing.

Bautista's face showed great shame and genuine repentance. He clasped her upper arms and couldn't say a word, while his eyes dissolved into tears. "The purest, the most beautiful, the most transparent on earth," he said to himself naïvely, squeezing her with fury. The moment was unforgettable. Overcome with emotion, Bautista didn't manage to break his silence for a long while, while a gleam of playful irony seemed to shine in Rebecca's pupils.

"You're the best thing I've known in my entire life," Bautista said finally, in a high and trembling voice. "I love you very much."

Grotesque, atrocious words.

Now that was all just a horrible part of the past, and Bautista realized with chagrin, as he walked through the dump, that stepping on the garbage and getting his feet dirty had become symbolic of all the things he'd loved so much in the past and never would have wanted to think of as filth and misery today.

Then he noticed Rosendo freeze in his tracks next to him and shiver strangely in fear.

"Did you hear that?" Rosendo asked, as timidly as if he were speaking words of love. "Did you hear that?"

Something was creeping in front of them—it wasn't human, yet it clearly had intelligence and, they somehow knew, the capability of frenzy and pain. It was actively moving and, without a doubt, bloodthirsty too: it crawled hastily, impelled by terror and rage, like a cruel

deaf-mute who wanted to be alone to perform some monstrous, vile deed.

"Stay still," Bautista ordered Rosendo. He was trembling.

There was nothing they could do to stop anything that might happen.

"Don't move," Bautista insisted, though unnecessarily, since Rosendo was hardly even breathing. "Don't move."

The thing thrashed on the ground with a vigorous sound of muffled, merciless struggle.

Bautista finally decided to light a match. There, two steps away, a staggeringly large dog was devouring the bloated body of another animal. The dog didn't move. It buried its muzzle in the animal's guts with an icy, shrewd ferocity that took charge of destiny, of all things.

Rosendo and Bautista were frozen with terror.

"Did you see that?" Rosendo asked, his words coming out disjointedly.

The match's tiny flame, as occurs when the darkness is very thick, lit their faces with such forceful contrast that they appeared more shocked and unnerved than they really felt. In another second the meager light of the match would burn out, and then the terrible dog would grow to reach the sky, the dull clouds, like a black and evil tree.

"We should run," Rosendo said to himself, but Bautista stood glued there, bewitched—a broken, soundless structure.

Suddenly they heard the distant clock of the Penitentiary toll four sets of three strokes.

Bautista rocked with a kind of stupid laughter, and Rosendo immediately joined in. They were like two absurd madmen, swaying back and forth in the gloom.

"Four o'clock!" Rosendo almost brayed. "Four o'clock!"

How had neither of them realized fifteen minutes ago that the clock had only tolled a quarter to four? Still laughing, they walked for a stretch and reached the end of the dump, overlooking the industrial zone.

They sat down on some rocks and, almost delighted, gazed out over that panorama of effort, of struggle, of active combat that was the workers' barrio, with its factories, muscles, and healthy murmur, its fragrance of grease and petroleum.

Bautista was silent for a long moment.

"Look," he said suddenly in a very soft voice, "life is something very full of confusion, something disgusting and miserable in a thousand ways, but we have to have the courage to live it as if it were completely the opposite."

He recalled that these were Gregorio's words almost exactly.

The silence was vast and hard.

They had a job to do, and so they set off, without speaking, toward the factories.

VII.

Two vigorous columns of smoke shot out powerfully from his nose at once—pale yellow at first, and then an intense white upon reaching the warm and vivid space where the beautifully golden shafts of sunlight poured in through the window, finally dissipating in billows very close to the floor, in the sunless region again, back once more in the void of that small infinity.

Jorge Ramos, bent over the work table he used for writing his art criticism (he had a second one next to the fireplace for his professional work as an architect, where he drafted his clear, neat blueprints full of strict proportion), typed the final words of his monthly article for the *Modern Gazette* and, after exhaling the smoke, mercilessly crushed out his American cigarette on the ashtray shaped like the god Xochipilli.

He looked at the extravagant little figure, condemned now to have nothing but the most bloodless sacrifices consummated before him—not the ancient rites of pain and gore, but only this sacrifice of ashes when Ramos decapitated his cigarette of its coal.

Ramos examined the mysterious little idol at length: the face with its eloquent jaw, the legs decorated with flowers, and the posture, which reminded him of the Egyptian scribe in the Louvre. "He's better than the Egyptian scribe," he thought. "He has less dehumanized severity, less cruel simplicity, more poetry." But he also thought that perhaps this comparison was influenced by the article he'd just written about the poetic in the paintings of two representatives of the so-called post-muralist generation,

whose lyric aspects Ramos had emphasized over purely graphic ones.

He carefully removed the pages from the typewriter and began to look over his article with a kind of pleasurable beatitude.

"In both painters' work," the article read, "in Rodríguez Lozano and in Julio Castellanos, there is a poignant thread of poetry that ties the elements together, that grants them the structure of an inner secret, a secret that isn't belabored, that isn't shouted loudly, one that's spoken in a low voice, in a soft and silent transmission."

Not bad at all. Jorge Ramos smiled maliciously. Secret that isn't belabored, spoken in a low voice. Clearly those other "painters who shout" would know they were being alluded to. Ramos's negative opinion of that explosive, loud-mouthed style of painting based purely on tricks of volume and perspective was well known, enough to make the standard-bearers of the latter tendency see the obvious attack. And so his praise of the painters of the "poignant thread of poetry" was no longer gratuitous but rather became—a tenet of all criticism that was aware of its mission—useful praise, combative and destructive by its contrast with the pernicious currents in painting.

"Both painters," he continued reading, "eschew the cheap, bastardized aberrations of functionalism and, without indulging in that nonexistent thing called pure art, transmit a human feeling to us, the closest thing, if it doesn't participate in it already, to disinterested aesthetic feeling."

Something made him freeze when he read this paragraph. Something very displeasing and uncomfortable, like a sense of ridicule. His earlier beatific feeling vanished,

and a stupid, awkward sensation took hold of him. His cheeks flushed with a precise, burning heat.

He read the paragraph again. Nothing chagrined him more than not being satisfied with what he'd written. It was like having to walk across a room naked in front of ten thousand pairs of eyes. Everything became abhorrent, and tracking down errors became like being trapped in the dark loop of a deaf, convoluted guessing game, purely prefigurative, prior to thought—groping like a blind mollusk, solitary and lost, before man appeared on earth, his words disintegrating into letters and then into nothing but isolated marks, beyond the grasp of all intelligence.

He quivered with rage. "Eschew the cheap, bastardized aberrations of functionalism." Clearly that wasn't the poorly written part. That was a clear and courageous statement against the demagogues. He bent over the pages and saw his anxious, angry face reflected in the glass cover of the desk.

Ramos paused with the nervous anxiety of a traveler about to miss the only train that comes through the remotest station imaginable and stops for no more than a few seconds, after which it will be irreversibly gone. Now it dawned on him. It was all just an absurd mix of words in which *nonexistent, closest, transmit, disinterested* hissed in his ears in the ugliest way. So he began by crossing those words out and putting others in their place. "Convey a feeling that is the nearest thing" was better now, but there still loomed that last phrase: "*disinterested aesthetic* feeling." Replace it with *abstract*? An *abstract* aesthetic feeling? He thought it over for a moment apprehensively and uneasily. However, before he could try to fix the ugly sibilance he still heard in the

phrase, the idea of an "abstract aesthetics" bred fears in him of another sort. His article might provoke many people's suspicion precisely where he least desired it: among artists and friends on the left. They were proponents of that "functional art" that Ramos referred to as a "cheap, bastardized aberration"; and along with this they also claimed concomitantly that aesthetics could never be "disinterested"—the whole exhausting question of "class art" and the cultural "superstructure" being determined by the economic "substructure"—and of course, naturally, it was even less possible for aesthetics to be "abstract."

The heroic sadness of a misunderstood thinker gripped his soul as he considered the thousand difficulties of this type he was always running up against. He wished he could keep his ideas about art free of all partisan contamination, but that was no easy task. Often he found himself forced to submit to a certain ideological "reason of State" and extol works that had no merit but about which, on the other hand, no one could say that they weren't useful to the Revolution. His ethos as a critic thus came into conflict with his political ethos, although Ramos was consoled by the conviction that any damage inflicted on his integrity as an art critic was simply the price of his independence. And so his praise of "revolutionary" mediocrities (which, besides, was praise destined to be forgotten along with the mediocrities themselves), intended as it was to mollify the extremists, kept those people content and ensured that no one meddled in what he considered to be "his work"—the "lasting" product of his endeavors.

But there was the article in front of him—a temptation, a trial by fire to test whether he would sacrifice his political interests for the sake of uncompromising criticism.

He didn't hesitate. To hell with the "cheap, bastardized aberrations of functionality"! This decision produced in him a singular calm and a powerful tenderness toward himself. "Rodríguez Lozano as well as Castellanos," he wrote cheerfully, "eschew all tools from outside the field of art, and their work pretends to no aim outside aesthetics. But—and here lies the miracle of their talent— without trying to, they achieve such an aim, conveying a human feeling that speaks of social questions too, and with which, in the end, without indulging in that imaginary thing that is pure art, they convey the most authentic aesthetic feeling."

His fingers rested on the keys of the typewriter, and, without his eyes leaving the paper, his right hand groped like a blind man's across the surface of the desk in search of his cigarettes. He felt like someone who'd made a good business deal—a good spiritual business deal. Life was nothing but a series of transactions, a process of opposites interpenetrating each other—and looked at this way, Ramos was expressing in his article his own inalienable points of view, notwithstanding the fact that he'd given them a certain touch that would flatter people on the left, people who, furthermore, understood questions of aesthetics in such a... such a unique way that there was no need to argue with them.

He lit a fresh cigarette and, inhaling the smoke vehemently, looked around once more at the comfortable study where he usually worked. How far all of this was from the metaphysical anguish of his early adolescence, so naïve, sentimental, and poignant. The wish to die that had tortured him until the age of nineteen. Those extravagant notions of renunciation. The search for God. That

rash, fervent desire to love and be loved. A smile of sympathetic nostalgia drifted over his face. He perused all the objects in his study one by one with a mature, leisurely relish—his little artistic finds, a painting that Diego Rivera himself had given him as a gift, the slender floor lamp. The rug, a clean, smooth ivory color, offered the spirit a kind of repose, as if by seeing it or treading on it you were infected by its velvety silence, its soft, cool caress. The coffee table, placed on the rug just barely off-center, was a beautiful mythological monster, diaphanous, full of fine curves—a swan, almost the delighted, watchful body of Zeus unmoving beneath his seductive disguise of a swan.

He got to his feet and walked a few paces. On top of the record player an old fashion magazine caught his eye, and he casually leafed through its pages. Those awful hybrid forms from 1919 and 1920, and all those years of genuine brutishness! As if man—whose appetites are ultimately what makes women's fashion—had suffered a paralysis, a blunting, a warping of his healthy sexual instincts, and had invented new ideals that were no longer feminine—women with Roman helmets on their heads and their bodies trapped inside huge pillowcases. Postwar homosexuality. And that frightful, hideous 1913 model of automobile illustrated on one of the magazine's pages, with the wheels of a bicycle, headlights from a tilbury, fenders from a landau, one thing taken from here, another from there, from every epoch, the Second Empire, Wagner, the Flying Dutchman, the Locarno Conference, Marcel Proust, Marco Polo, with no originality, nothing genuinely its own, everything heaped together, motley, monstrous!

Ramos felt sad about the destiny of his own era. Wouldn't the generations to come feel this same repugnance toward

the aerodynamic models of eight-cylinder automobiles? Wouldn't they think about the beautiful (to our eyes) Lincoln and Chrysler vehicles of our time the way we think about automobiles from 1900—as nothing but repellent, ridiculous monsters? Troubled, Ramos kept staring at that primitive model, trying to find something beautiful in it. But it was impossible. It was nothing but a deformed phaeton, as sinister as a spider, jagged, without purity, a real monster. The archaeopteryx. The first bird. That sad, hallucinatory animal covered in feathers, with teeth in its jaws, fingers on the ends of its wings, and a vertebrate tail like a lizard. Just like the Azoic archaeopteryx. He felt a profound dismay. He had to find a valid reason for it. Some reason. Hadn't it been Darwin who'd talked about "hopeful monsters"? The monsters that announce the advent of those messiahs of the species that are the new forms, the cardinal classic forms? In other words, maybe the 1900 automobile was monstrous only because its biological "mutations," the forms it inherited from earlier times—those vestiges of the bicycle, tilbury, and landau that monstrously composed it—were destined to create a new and superior future form, a synthesis achieved today with the eight-cylinder automobile, which, being a synthesis fully achieved, would cause neither disgust nor scorn in future generations. Ramos gave a deep sigh as if an enormous weight had been lifted from him. Now he felt proud of his contemporary era, which might be considered classic by posterity.

Through the window, the cobalt sky extended into the distance, tender and languid, lilac and leaden.

Ramos rested his gaze first on the nearby rooftops, which lay below the terrace of his study, then on the

distant buildings, and finally on the backdrop of the mountains, firm and dark against the sky, burnished by an uncanny light. The mountains, the city, the light, all this was life—but the greatest delight was to secretly observe that life from here, from this Olympus, like a hidden god, like a spy of Divinity. From the height of the terrace Ramos felt his own magical omniscience and impunity, that delicious power to not be seen, to slip into others' biographies like a merry demon. Houses, rooftops, balconies, passersby, birds.

There, through her bedroom curtains, the woman looking at herself in the mirror smiles, turns, speaks with her solitude, imagines a thousand kinds of adventures offered to her, then holds her head in her hands, in a posture out of a postcard. Half-naked, her elbows pointing up, she has an infinite grace, but suddenly her pose thaws, she seems to make a decision, and, using both hands, she turns her head on its axis some twenty-four times, as if it were a mannequin's head, and pulls it off as smoothly as someone extracting a fish bone from between their teeth; then she puts it beneath her arm like a warrior removing a helmet and smiles, smiles atrociously, yet this decapitation doesn't leave a single drop of blood where her neck separated from her torso. A handkerchief goes along the street saying goodbye to someone and suddenly weeps, with a flutter of emotion, because someone isn't there at the window. The sad mailman, both dreamy and disillusioned, fearlessly (and with his feet floating above the ground) tosses into the mailbox, after folding it carefully in four, the body of a green ghost that exclaims I'm dead, I'm dead, I'm dead. The rooftops. Two breasts hanging from the clothesline. A thoroughly nuptial bedsheet waving in the air.

On the nearest rooftop, a young woman's delicate brassiere fluttered in the light breeze, provoking in Ramos a series of arousing memories. He was fascinated by the calm, sweet calisthenics with which a woman strips off her brassiere, crossing her arms over her chest and lifting upward with the innocent grace of a trapeze artist saluting the public before launching herself from on high into her incredible play of dragonflies. All women. With a kind of candor, a kind of initial modesty that, once they've taken their bra off, is transformed into unexpected violence, into sexual voracity and savagery, magnificently shameless, even in the most chaste. "Really," Ramos thought to himself suddenly, "you could say I love her." The most chaste. The idea of the immodesty of the most chaste was what had brought his love to mind. "Yes, I love her, but the important thing, of course," he added, "is to preserve my independence."

For Ramos, the word *independence* had a series of logical derivations in every realm: the aesthetic, the philosophical, the romantic. It was a sort of key for navigating life's problems without letting those problems compromise him. Ramos had an almost organic—and because of this highly effective—aptitude for preventing the moral conflicts that torture other people from germinating inside him; he had absolutely uncomplicated ideas about these things. By *independence* he understood the freedom not to be bound by too many duties toward others, and in this way his notion of good was limited to the administration of one's own virtues with sound judgment to produce a useful and tangible result, but applying them with moderation and without the senseless, sterile prodigality of people who claim to live only for others. As far

as right and wrong could be taken, in a very relative way, as stable values, man practiced them without distinctions, regardless of his circumstances. From this fact one could only draw the conclusion of the criterion of necessity in ethics—that is, of necessary right and wrong.

The brassiere on the clothesline swung into a completely horizontal position now, like the body of a woman with no arms or legs, like a woman in the shadows of the infinite bed where she surrenders herself, hands herself back over, with no arms or legs. That brassiere was more than a woman: there was a woman inside, inside where there was no woman. "Yes," he thought again, "I definitely love her."

Ramos thought about his wife. About his wife's chastity. Naturally, knowing exactly when right and wrong are necessary in private life is more complicated, and so here a man had to govern himself according to the principle of upholding the highest virtue among two or more that conflict with each other.

In this way of looking at things, Ramos loved his wife, he did, but at the same time he was unfaithful to her, because otherwise he'd stop loving her, and love must always, in all circumstances, be a higher virtue than fidelity.

He thought proudly that you didn't often find a woman with Virginia's qualities. Her flaws were only the flaws that marriage reveals with the passing of time, like being on an ocean voyage which, as it drags on, gradually reveals the true annoying, stupid, and petty natures of the companions who at first enchanted us. Virginia's flaws were, well, innate and unavoidable, and because of this there was no reason to dwell on them too much or, like those naïve romantics who seem only to be looking

for an excuse to commit suicide, blow them out of proportion. Flaws that were part of the sometimes exhausting ocean-crossing that is marriage. On the other hand, Virginia was kind, sweet, and affectionate, and, although she might not fully understand the intellectual questions her husband dealt with, she at least had the good sense to stay out of them, demonstrating an admiring respect full of superstitious ignorance.

Ramos smiled with an enjoyable egotism when he realized what was happening: the provocative images that kept on suspiciously appearing to him made him realize that these thoughts about his wife were aimed not at her but at Luisa. Luisa, his lover, the other end of the equation in which his sentimental equilibrium was expressed.

Because he was sincere when he told himself that he loved his wife—it would be very difficult and painful to do without her. But he was sincere, too, when he thought that Virginia's intemperance, domestic grudges, and subterranean hatreds could only be balanced out by that calm, voluptuous process of coinciding desires and guesses and deeds that made up his relationship with Luisa, while she, *a contrario sensu*, if she ever became his wife, would be just as inevitably incomplete as Virginia and would then need Virginia—converted in turn into his lover—if she were to endure in his affections.

On the rooftop, the brassiere surrendered itself to a passionate dance—fire, ice, vibrancy, enigma. Luisa was dance too. Choreography of a single human body, whose perfect correspondence of elements was a continual dialogue of torso and neck, shoulders and thighs, breasts and arms, in the wisest architecture of the senses.

Ramos breathed in the air with sensual nostalgia: thoughts of Luisa always came to him in the form of the damp, fragrant memory of her golden armpits in those long, brief nights they spent together, giving themselves to each other with restrained ferocity, anxiously poring over each other's bodies, relearning their geography, newer and more unexpected each time.

At first it had been no more than a novel friendship full of surprises and discoveries, into which they little by little entered more deeply—surrendering themselves to it, though, with full knowledge of where it would end up. An easy, enjoyable mutual interest connected them from the start. Luisa was accommodating and pleasant, and she didn't hide the pride she took in her friendship with Ramos; because of this, in a show of gratitude, he deigned to consider her—although later he had to amend this notion—a woman with "a certain culture." Her mix of naïveté and knowingness, of audacity and reserve, of childish timidity one moment and extravagant passion the next finally seduced Ramos. But what definitively launched them into each other's arms was a certain subtle process that activated mysterious affinities and made them understand that they shared the same tacit language of desire. And not just of desire: a shared language with respect to the forms, conventions, and liturgy they had to use in consummating this desire.

This process began to unfold one night when Jorge and Luisa went to see a film together. Deep down inside, Luisa was armed with the moral resources and the self-awareness she needed to avoid blaming herself for the step she'd decided to take. That afternoon she'd received a letter from her ex-husband, who was spending time abroad

while they waited for the courts to process their divorce. Francisco's letter was violent, bitter, full of resentment and accusations, but at the same time it made clear, without any doubt whatsoever, that she was to blame for the deplorable fate of their marriage. Reading the letter produced an extremely complex and contradictory series of reactions in Luisa. First, she understood that Francisco still loved her, but, second, she also understood that his reproaches were completely justified. And so the letter encouraged hope on the one hand, but on the other irritation and anger at the fact that Francisco was right, simply because it made her see—more clearly and deeply than Francisco himself—how stupidly she'd acted throughout their marriage.

For a few moments it tortured her unspeakably to feel so torn inside, but then she searched for an objective argument that might solve the dilemma. Hadn't Francisco showered her with insults in his letter? Hadn't he expressed himself with hurtful, offensive language? This last thought was so persuasive that it made her suddenly feel hurt and wronged, and the banner of the most holy and legitimate indignation fluttered in her hands. At that moment, miraculously, the telephone rang: it was Jorge. Luisa picked up the receiver with joy.

After hanging up, she sat in confusion, her cheeks flushed. Surely Jorge hadn't realized what it had meant when she'd so innocently accepted the invitation to go to the Joan Crawford movie together, but for Luisa it was an act that affirmed her independence and freed her from her resentment, thus resolving her discomfort at no longer feeling any guilt toward Francisco, despite his legitimate accusations.

Considering their past and all those things Francisco considered with touching candor to be the purest in his life—the frankness between them and the absolute lack of lies in their loving relationship, which had united them for so long—he and Luisa, in what could only be called a stupid and naïve pledge, had promised to preserve, no matter what happened, a kind of mutual loyalty of spirit after their breakup that above all meant carrying on like two comrades. At heart Francisco was just following the romantic script; still, because the idea was compelling even if she didn't believe in it, Luisa did her best to practice it in various ways. The easiest was to strike up an imaginary dialogue with Francisco in which she made the bravest and most serious confessions, wept, repented, suffered. Less easy, but something she could also do with impunity, was to record—in a very ardent, corny, lyrical, feminine style—all of the intimate events of her life in a diary, even though, as with her confessional dialogues, Francisco would never know about them.

Before going on her date with Jorge, Luisa opened this diary. "Cherished Francisco," she wrote—although it wouldn't be long before she'd be using that cherished adjective to address "cherished Jorge"—"today, the 6th of December, my dear Francisco, I want you to hear the most intimate truth straight from my own lips: today I have decided to give myself to another man. I don't know myself why I'm doing it. Perhaps because you've been so unfair with me: perhaps only out of morbid curiosity to know how *it* is with another man, after many years in which I've only known it with you."

Enveloped in the shadows of the movie theater, Luisa, intentionally plaintive, weakly murmured to Jorge that

this was the first time she'd gone to the movies with a man since her divorce. With these words, and Jorge's response to them, the two began to realize, with the greatest joy, that they could be reliable accomplices in any kind of crimes or adventures or shameless pleasures, simply by comprehending the allegories, parables, and double meanings needed to cover up their complicities, including—or especially—from themselves.

"It's peculiar," she said, "or I suppose I should say it feels a little strange—this is the first time I've been to the movies with someone besides my husband." This could have been interpreted in two ways, both wrong: as either nostalgia for her husband or a sign of prudent courtesy to Ramos. But he read its meaning in the most satisfying way for Luisa, and his only response was to slip his arm around her and kiss her neck while one of his hands slid, without useless preambles, between her breasts.

Joan Crawford wandered down Main Street in Los Angeles, with a horribly vacant expression on her face. She was beautiful and sad, and, like an obsession, she repeated a name incessantly to all passersby. Suddenly she collapsed and was brought in an ambulance to a hospital. Here the director of the film exploited the most effective techniques at his disposal: with a low camera angle, from the point of view of the protagonist lying on the gurney, first the hospital exterior appeared on the screen, and then, inside, the walls madly rushing by, as if the audience, who maintained a complicit and morbid silence, were in the place of the sick woman as she was hurried through the long corridors.

But Joan Crawford disappeared completely for Ramos in the warm, throbbing base of Luisa's neck, where the

intermittent cinematic fragments projected on the screen were a smooth flutter of light and shadow, a flickering from which he didn't remove his lips.

Ramos was perceptive enough to understand the eloquent meaning behind Luisa's behavior, and she was infinitely grateful to him for it. Indeed, Luisa wasn't going to give herself without first expressing, before her own conscience, a kind of apology to the memory of her ex-husband—mainly because it was glaringly obvious how much she'd loved him, or perhaps still did—but also making sure that this apology wasn't so emphatic as to intimidate her new lover. Because Ramos could have asked a stupid question—and both he and she had the same thought at the same time about how stupid such a question would be—about whether Luisa still loved her ex-husband. If he'd done so, the purely formal impossibility of her giving an answer one way or the other would have made everything hopelessly fall apart. The result was that from that moment on, they both understood that the question of what's called love in relations like theirs consisted in having the skill to detect those unapparent shades of meaning and subtleties of tone that provide such graceful cover for two lovers' sexual union.

The next skirmish in this game, which revealed how harmoniously they identified with each other as they learned and played it, had occurred in her apartment after the movie.

The secret pact that joined them, obliging them to use a shared language of symbols, involved acting as though nothing had happened in the movie theater, that there was no "bill to pay"; instead they had to proceed according to a system of signals that must be correctly translated by both of them for the surrender to occur.

Luisa had asked Ramos to take her coat off for her. "If he's stupid enough," she thought at that moment, "to make a move in an indiscreet, brutal way now, I'll unfortunately be forced to tell him off, and it'll all be over." By *indiscreet* and *brutal*, she meant if Ramos said or did anything that implied it was Luisa herself who was most interested in the longed-for sexual denouement.

But Ramos took off her coat very smoothly. Then, as if this innocent action were the sole purpose of his visit, he walked over to a small stack of classical records and began inspecting them with an expression of concentration and interest.

He turned to Luisa, offering her the names of three composers, and she, with an intense sadism, chose the exact piece she had the habit of listening to with her husband in that same spot, on that same sofa where tonight, with an air of vague, expiatory sadness, reclining in a pose of distracted, evocative reverie, she would now listen to it by Jorge's side. "The first time with someone besides my husband." She repeated to herself the phrase she'd spoken in the movie theater, this time completely forgetting that it was a lie.

Everything occurred so happily that first night that Ramos felt, perhaps exaggeratedly, that this was how it must have been in the beginning of the world, for Adam and Eve. From this point on, Luisa became an obligatory complement to his life. Absolutely obligatory, since she summed up for Ramos the most perfectly balanced expression of his morality and sexuality.

Ramos walked a few steps back to his desk and, his demeanor now calm and serene, began to reread the final words of his article.

The memory of his lover comforted him, and he was filled with a euphoric sense of fruitfulness and plenitude. The pores of his body seemed to absorb a kind of enchantment that vibrated in the air, as often happened to him when some great idea was gestating in his brain. In such moments he felt as if he were floating in an unknowable reach of space where all of his forces were concentrated, waiting for the miracle of creation.

He looked around, astonished, as if the most ordinary objects had acquired an uncanny character—the shelf of books, the picture window, everything enveloped in a subtle, unfamiliar magic.

Just then a swelling breeze carried in two youthful voices, like ones heard far off in the countryside. Though he couldn't explain it, a vague, intuitive premonition, almost instinctive or genetic, made him sense the presence of something remarkable on the neighboring rooftop. He peered in that direction: the roof sat in the lower foreground of the view over the terrace from the window. Lively, marvelous voices. He'd never experienced anything like it. It was as if he'd gained the power to change the inner condition of things, yet without making them into different things. New, but still the same: they had the same outlines, but new invisible, intimate, secret ones, too. Those two voices had come from another world to cast a spell on ours, yet that other world was here too, within the realm of what the senses comprehend.

Suddenly the voices stopped. Ramos looked outside anxiously, afraid it had all been a delusion. So it was. Nothing obvious was visible, no particular change. On the clothesline the pink brassiere waved slowly and caressingly, like a soft flag. In the middle of the flat rooftop lay

a rectangle of blue-and-white-striped tarp, which he had seen the building's tenants sunbathing on in their swimsuits on hot summer mornings. Not far from the tarp he saw an old bedspread they must have put out to dry in the sun, and in the background, in abrupt perspective, the anarchic, jumbled façades of the whitewashed houses clustered next to each other, white monsters of geometry.

The scene was the same as always, but Ramos couldn't keep his senses from reaching out, more finely and eagerly receptive with each moment, waiting and ready for the extraordinary occurrence. Everything seemed unspeakably pregnant with possibility.

Why had that tremulous, dreamy song stopped? The extraordinary thing about those youthful voices—and the fact that they'd suddenly stopped so mysteriously—was that they didn't seem to have a point of origin; they'd seemed to come out of nowhere, out of a dream, mingled with deep corporal reminiscences and a diaphanous, calm sensuality.

But now they came again, carried by the waves of the air in intermittent fragments, now here, now there, like the heaps of harvested grain tossed to either side by a farmer in the furrow. Ramos felt a surge of adolescent ardor, strong and unfamiliar, undisturbed by his usual skepticism and irony. Protected by his solitude, by the welcome absence of spectators, he abandoned himself without qualms to enjoying that transparent emotion.

The song sounded healthy and confident, but the invisible swells of the wind's tide seemed to drown it in another silence until finally, graceful and lithe, like the branches of a young tree, the two adolescent girls who were singing appeared on the rooftop. They seemed to have been

placed there by the hand of a painter, their arms around each other's waists, their shoulders touching, their faces turned to the sky, while their hair stirred like a bird's wings slowly flapping. Most likely they didn't exist, most likely they were just a fiction woven by the gods. With their light clothing, through which the solid shapes of their bodies were sculpted in the air, they looked almost completely naked. They looked at each other admiringly and with astonishment, still singing, as if the melody encoded a secret dialogue only they understood. Maybe they were nothing more than two statues who'd fled the stone that clothed them and appeared there, out of nowhere, on a rooftop.

They stepped forward as if seeing the world and its objects for the first time, naming them as they went—this is a cloud, this is a bird, this is sky, this is silence. Their voices thinned out, grew intimate and close until they became the murmur of a young, skittish brook. They'd stopped next to the sunbathing tarp. Surely they were going to take a bit of sun, but it was evident that this was a sacred ritual for them, which they surrounded with elusive ceremonies, mild reluctance, pleading hesitation. Suddenly uneasy, their gazes darted here and there, as if the girls were considering, with fear and devotion, where the most noble and fitting place to perform their holocaust might be.

Ramos's heart beat with joy. He was, from his Olympus, a bold divine spy, a yearning, blissful god. His senses encircled the two girls without them noticing it, creating them anew, setting them with their virginity restored upon the chaste terrain of a rediscovered earthly paradise. They were entirely his, a deep part of his own self.

The older of the two adolescents broke away from her companion and ran across the rooftop with the fluttering movements of a happy, dancing swallow, her body weightless, while her friend followed her with her gaze and their soft tune accompanied her movements.

But suddenly the older girl noticed the brassiere hanging from the clothesline and stopped with a jolt, incredulous, faltering, electrified by the unbelievable discovery. From that moment the scene transformed itself enigmatically. It was as if an inaudible command, from very far away, from hell, halted their singing. That brassiere held a bewitching, lethal seduction. The girl stood there, blind, pale, dead; her unreal hands felt their way across the air like a sleepwalker's until they met with that garment, that empty body of a girl, and, trembling, religiously caressed it. Her friend watched her, breathless, as pale as if she were on her deathbed.

It had the quality of another world and time. The two girls looked at each other in disbelief at the fascinating, mute language they were speaking now, with a pleading terror, as if they'd just then discovered something that made them afraid of themselves. Inconceivable, bloodlessly pale, they were in the most deliberate sphere of their dream, alone in this separate universe they'd discovered through a terrible miracle. They returned to each other, looking for protection, but now they were different—silent, indecisive, with a helpless shyness that didn't even let them hold hands. A dark tempest had been unleashed in their souls. They were two grievous enemies, sisters together in the land of the unpronounceable secret, the nameless desire.

In the sky a cloud sailed along like a skiff, and in the distance the mountains grew more transparent.

The girls wandered across the rooftop as if it were the surface of an uninhabited planet, and after a few moments they stopped, as if humbly asking to be forgiven for something and at the same time offering thanks for that same thing. They were under the influence now of something stronger than them, which seemed to have fiercely taken charge of their hearts.

They kept their eyes lowered, in prayer perhaps, their shoulders touching, trembling with dread—an unearthly sight. Surely they were praying. A long and terrible moment passed, but then, unexpectedly, the younger girl turned to her companion, her face illuminated by a pure, courageous smile of challenge. The prayer was bearing fruit.

She shook her hair with a joyous, lively gesture and ran to the tarp with the agility of a dancer. She lay down in an anxious swoon, her arms behind her head like two columns fettered by the dark forest of her hair, her body in the sun, her eyes closed, her breath full of yearning, and half the length of her lovely thighs exposed with intentional abandon beneath her skirt.

Timid with gratitude, the older girl followed the younger girl and stood by her side with a look of infinite, sweet repose. She gazed down at her friend for a long while, angelically transfigured, victim of a mortal fascination. Their motionlessness might last a century. A touch would turn them to ash. Suddenly the older one shivered, as if she were waking from the dream, and looked around with an anguished, maternal apprehension. She understood that this was like a crime, that the two of them had broken definitively with the rest of humanity: they were no longer fellows of the rest, they had to flee from them

and defend themselves against them. She tiptoed to the far side of the rooftop, and, leaning cautiously over the railing, looked toward the interior of the building, scanning it with hatred.

The younger girl waited in the pose of someone asleep, without moving a muscle, surrendering herself to the powerful grip of trust, while the other, after spying in all directions, returned to her side.

A new, endless era began. Once again the older girl stood motionless above her friend, unable to tear her burning eyes from her body, her amorously homicidal gaze seeming limitless.

It was impossible for their stillness to continue without risking death. And so—very chastely, though, and without the younger girl showing any sign of being disturbed by it—the older girl gently lifted the other's skirt, offering herself the sight of another portion of those lovely, compact, living thighs.

She stood contemplating her friend like this; then she lay down next to her, and in this position, facing the sky, with their eyes closed, they both started singing again.

Ramos could hardly understand, hardly wanted to understand. What did this mean? What indiscernible, unutterable game of purity or sin? He listened closely to their voices. They weren't the same now. Now they were trembling. Now a certain agitation was audible, a certain impatience...

But the singing was unexpectedly cut short. Cut short as if a guillotine had fallen. There was a hard, firm silence. Then, after a smoldering pause in which dark things seemed to brew, the older girl, with movements that seemed too abstract to be movements, turned almost soundlessly toward

the other's body, rolling over slowly with voracious, sweet precision. Those two incredible creatures were the only living beings in the entire vast universe.

Ramos held his breath. In the following moments, something like a bloodless combat, a silent, fierce, crushing invasion occurred before his eyes. Then suddenly the older girl quivered nervously like a wounded steed. An idea must have occurred to her, because she broke off mid-motion, hopped over her friend's body, and went over to the corner of the rooftop.

The younger one followed her with a lifeless, desolate turn of the head and a look of sad, hopeless pleading. Was she abandoning her? She covered her face with her forearm, perhaps to weep. "Stupid!" the older girl chided her sweetly, coming back. She was carrying the old bedspread, and after this both of them, giving small cries of victorious joy, hid feverishly beneath its shelter, protected from all gazes, safe from the divinity.

There was something desperate and agonized in what followed. The girls were two castaways in a shadowy, glowing ocean, tossed about with a frenzied animal madness at death's bidding, forced to battle each other to annihilation, with the tenderest and most hostile fury, the slowest and most amorous haste.

Ramos felt himself grow weak, bathed in sweat. He vibrated with a sick excitation down to the last cell of his body. But he tore his eyes away and stared straight ahead at the wall. Just then a pallid, hemophiliac vermilion color was cast upon the walls of the study, and Ramos heard a familiar voice behind him.

"Sorry to interrupt you," said the voice with a sibilant inflection, ironically polite and well-mannered.

Ramos turned with a quick, defensive movement. The sunlight, wounding the skirt of Virginia's dress with its rays, drenched the entire room with its watery blood, bathing the walls in the dress's ambiguous, uniform, hermaphroditic color.

Ramos nervously and hastily pulled down the blind so that Virginia wouldn't see the spectacle on the rooftop below. She seemed to remark the action with a furtive, mocking gleam in her eye that dissipated instantly. Ramos gritted his teeth. The divine spy. Only he had that right. He trembled. Now his wife's presence was an absurd, unexpected complement to his excitation, his convoluted, lustful desires. He looked at her with feverish longing.

Virginia remained a few steps from the window, poised there like a sleek automobile holding back while the light is red, the brazen lines of her body revealed by the transparency of her dress in the sunlight. Her eyes had a bold, knowing gleam and her nostrils pulsed imperceptibly, while her legs, lit from behind, formed a captivating, almost poisonous juncture beneath the smooth inverted cupola of her belly.

Ramos was afraid to analyze whether Virginia's expression was ironic or not, whether it perhaps had an air of merry perspicacity, of tingling suspicion. He desired her now with burning urgency, which was unusual when it came to his wife, who, in the end, was simply a family member, a trusted person he shouldn't crave too much. This desire made Virginia take on a terrifying dimension in his eyes.

But further, when he imagined that she might have noticed the rooftop scene, Ramos felt, in a certain pathetic way, as if Virginia had cheated on him with other men,

and the vague jealousy this stirred in him produced an urgent impulse to reaffirm his right to romantic possession. Had she, too, been a divine spy? Beneath her frigid, calm appearance, could Virginia be hiding a buried cynicism that might surface at any moment and reveal a frenzied capacity for every excess imaginable? Perhaps all it would take was a sign, a coarse phrase, an obscene invitation, and spotless Virginia would transform into a wanton, tireless, depraved bacchant.

Oddly, even though he was thinking about his wife, the idea didn't make him angry in the moment; on the contrary, he felt seduced by the wildest images.

He sensed himself on the cusp of uncovering the possibility of an entirely new type of relation between them. Though he felt enervated to the point of delirium with a zoological, almost unmanly desire to possess her, one he'd never felt toward any other woman, at the same time he felt tortured by a mistrust, a stubborn suspicion, and even if he'd rather avoid discovering this new and intoxicating type of relation, he felt impelled with an animalistic drive to find out whether there might not be another woman hidden inside Virginia, a previously unsuspected, brutal, insatiable female—but one he'd never truly know because she could only be discovered by another man, that omnipresent rival, the stone guest who may or may not appear in our lives but always threatens from the shadows.

The cupola of her belly. The juncture of diagonals between her thighs. Ramos looked her in the eyes, where an incriminating, ignominious perversity seemed to seethe. What hidden meaning lay behind the phrase she'd spoken while he was watching the two girls? Had she too peeked into that world of the love "that dare not speak

its name"? Could she have been his accomplice in that...
sacrilegious spying?

"Sorry to interrupt you," Virginia said again, bringing him down to earth.

Desire trembled in his body, but her voice was so natural and indifferent that it was impossible to draw any conclusion from her words: she could always play the card that she assumed coming up to his study always interrupted him—it didn't matter in what—since this was where he shut himself away to work.

Still, he couldn't be sure whether "sorry to interrupt you" was a malicious reproach—yet also elusively sexual, a kind of challenge—that implied unutterable things about the girls on the rooftop. Or was it simply a polite turn of phrase without any deeper meaning?

Ramos was breathing hard. If it was true that Virginia had another, unknown woman, adulterous and deceitful, inside her, then Ramos yearned to be that other man, that stone guest with whom she was going to cheat on him sooner or later.

Paralyzed, his brain could only move in one direction. He'd been completely overcome by the fabulous urge gamblers feel for absolute and eternal possession, which only becomes more fabulous the more it has to hide behind a mask of superhuman indifference. To possess her. To possess Virginia again for the first time. She should give herself to him, she should be unfaithful with the act of giving herself to him, but not in any other way, not with a different man, God no.

To comfort himself, he wanted to imagine Virginia in her status as his wife—that is, to think of her, brutally, as an object that belonged to him, at his disposal whenever

he pleased. But then he also thought, discomfited, that even if he asked to sleep with her right then and there, she'd find such force of conviction in the argument that such behavior was unorthodox, undomestic, unmatri-monial—simply by saying, "What's gotten into you?" or "Are you crazy?"—that she could refuse in the most nat-ural way possible, without exposing that buried female whose existence Ramos now felt mysteriously sure of.

During this vast moment only a few seconds passed. Virginia stepped into the middle of the study, and the outlines of the lower half of her body, once she left the direct sunlight, no longer showed. She had on a roomy, draped skirt the color of bougainvillea, which, gathered at her waist, gave a splendid animal roundness to her hips, like a mare's, while her platform shoes, like elegant hooves, completed the image. An ardent mare. A genu-ine female centaur.

"They just telephoned to say," she explained in an affectedly neutral tone, "that the comrades from the Party"—her voice was now disdainful and dull—"will be here within the hour for a meeting."

Her irritation was palpable. "The *com-rades* from the Party." There was a hint of spiteful scorn which seemed to include him, too; she seemed to want to make him de-duce her implicit resentment, an unspoken recrimination against him. On the other hand, though, there was noth-ing unusual about Virginia demonstrating the annoyance she always felt when the Party Central Committee held a meeting in their house. Her love for bourgeois traditions would rise up with a violent, rebellious hatred every time. Why did these people have to invade her home—and so rudely and inconsiderately, without even bothering to

ask? They simply used it as if it were their own proper-ty or a public house. Ramos's explanation that his luxu-rious home would never be suspected as a place where Communist leaders would conspire didn't assuage her. What did she care about the Communist leaders?

"For the time being," she added with animosity, "I've had the rug taken out of the living room so they won't get it dirty."

But Ramos could no longer think rationally, could no longer understand the meaning of what she was saying. He seized Virginia by the waist and tried to kiss her on the mouth. The gesture was so clumsy and childish, so lack-ing in experience and skill, in contrast to Ramos's usual aplomb, that a feeling of hilarity bubbled up in Virginia. A cruel giggle escaped from her throat. She dodged her husband's lips so that he barely managed to graze her cheek and earlobe, and there he was before her, flustered like a schoolboy, with a foolish, woeful look.

"What's gotten into you?" Ramos heard, through a dense fog, his wife's irritatingly singsong voice.

The exact words he'd imagined she'd say, but which an idiotic calculation had made him not expect, to the point that he felt surprised to hear them.

Virginia shrugged. She said something completely in-comprehensible about how outpourings of affection at such a time—she looked at her wristwatch—at a quarter to noon, only had the unpleasant effect of ruining her hair and smudging her lipstick.

"Besides," she added, with a pained tenderness appar-ently meant to soften her rebuke, though at heart she was reveling in her proud triumph, "besides, *my darling*, you must understand that I'm not an unfeeling machine or an

instrument of pleasure"—the turn of phrase was plagiarized from the language of the suffragists—"that you can use at your whims, without at least giving me the right of reciprocity." Monstrous, abominable, "unprejudiced" women's suffrage.

But suddenly something extraordinary occurred. A long, piteous cry rang out from outside, and, like an electric shock, paralyzed them where they stood. They looked straight into each other's eyes with a supernatural foreboding.

Her torso trembling strangely as she stood up, Virginia pulled the cord of the blinds to open them completely. In that revealing moment, Ramos understood without a doubt that she'd been his accomplice in the morbid contemplation of the events on the rooftop.

They rushed to the window. What they saw was comical and grotesque, like the final act of a farce—but a Satanic one.

Terrified, the two girls were clumsily running back and forth in huge, ridiculous leaps, like two moths dazzled by a light, pursued by a robust older woman, repulsive and mannish, with a stick in her hand, who was beating them with cruel, conscious precision on their arms, their heads, and their stomachs.

"Pigs!" the woman shouted hoarsely. "Filthy queers!" The Avenging Angel had descended from heaven in female shape, flaming sword in hand, to confuse, jeer, and crush the reprobates. From a distance the spectacle was like a painless game. It seemed impossible to imagine that it might be anything other than a gleeful make-believe chase in which the Good Angel tried to punish two miserable little devils, just to have fun and entertain the

audience. But the Angel was beating them with sadistic fury. "Pigs! Filthy little rotten queers!"

Reduced to idiocy by terror, the one thing the girls understood was that they mustn't separate in this hour of affliction, in this hour of the slaughter of the innocents, and so they held onto each other's hands, entangling themselves and tripping over each other, making their tormentor's task all the easier.

But then the older girl fell to her knees, her face bleeding and arms crossed as if she were praying, and the younger girl had no choice but to seize the chance to escape from the woman's reach.

It happened with incredible swiftness, a matter of a few seconds. The younger girl climbed onto the railing, glanced around as if she were afraid someone might come and stop her, opened her arms wide, and, after silently moving her lips, leaped vertiginously into the void.

At this Virginia fainted. Ramos carried her away from the window, laying her down on the sofa. He was immensely anguished, not because of Virginia, but more by a terrible fear of his own self that seized him in that instant. A muffled, angry murmur of pain and astonishment rose from the street.

Virginia's face was a white mask. Over the utter pallor of her flesh, her makeup had a funereal consistency, like lifeless matter, and her temples and forehead were covered in countless drops of sweat.

Ramos poured a bit of cognac onto her lips, and then, after rubbing the nape of her neck, he unbuttoned the top of her dress so she could breathe freely. The lace of her black brassiere was exposed beneath the angles of her collarbones, moving with the rhythm of her shallow breathing.

Ramos squeezed his temples. His surroundings seemed to wobble. Deep inside his brain, an unspeakable catastrophe had interrupted the continuity of his self. Disturbed by a tormenting fixed idea, he no longer felt master of his own actions.

Virginia's cheeks gradually regained their color. Her breathing steadied again, and it became clear she'd recovered from her faint, though she still lay there with her eyes closed. Vertigo overcame Ramos. Driven by a force beyond his control, he slid his hand over her chest until he cupped one of her naked breasts in its palm.

Right away Virginia's breathing grew quicker and more intense, and her lips pursed slightly and mischievously. But her body gave no signs of life other than intermittent shudders that pulsed through her, synchronized with Ramos's caresses.

He wore an ebullient, triumphant expression. Certain of victory, he threw himself onto his wife's body with brutal violence, pressing kisses on her.

At this, Virginia jumped to her feet as if an electric current had pulsed through her, her cheeks flushed and burning. For a moment the cunning expression remained on her lips and a shrewd flash still gleamed in her eyes. He knew she was perfectly aware of what was happening, she too was pierced by the keenest desire—but it evaporated at once, and a look of flustered innocence fell over her face, a surprised naïveté, grievously inquisitive. She pretended not to know anything, not to understand what was going on, and she used this spotless innocence to silently tell Ramos that she couldn't be blamed for fainting, that she wasn't responsible for the way her body had been caressed and aroused with such impunity, like a child being

robbed. She made a puerile, enchanting grimace, like a schoolgirl, and buried her face in the palms of her hands.

"It's horrible, it's horrible!" she babbled in a shaky voice, referring to the girl's suicide as if she knew nothing about what had happened before it. She began to sob convulsively, with pathos, and paced from one end of the room to the other, being careful, though, to look at the floor through her half-opened fingers, so as not to trip.

Ramos turned his back on her with hatred and left the study, slamming the door behind him. At the top of the stairs he tried to pull himself together and calm down, but it was impossible. He went slowly downstairs, and when he reached the living room he paused with a thoughtful, melancholy look.

When he saw the black telephone on the table nearby, his face lit up with encouragement. Then, as he dialed Luisa's number, he heard the soothing, tranquil sound of an orchestra coming from the study. He smiled. His wife was calming herself down with symphony music. For the time being, this was her bloodless form of infidelity.

VIII.

"And what you have said, Saul, concerning Reb Istephan, that you would hand him over to the Sanhedrin: do you mean that? Would you become an informer? Why?"

"Because he is my best beloved brother," answered Saul, quietly.

Sholem Asch, *The Apostle*

Engrossed, with an expression that seemed full of sadness, Fidel kept his eyes glued to what must by now be a cold bowl of soup while, heedless of his own movements, he brought a large spoonful to his lips with a trembling hand. He grimaced with discomfort and distaste, though not at the soup; it must have to do with his thoughts and worries. "Something serious is going on with him," Gregorio thought, interested and concerned, suppressing his own displeasure; he didn't remove his eyes from those sunken cheeks and those eyelids drooping with fatigue. "Something very serious," he repeated to himself apprehensively.

From the moment he'd met him at the bus terminal, Gregorio had been puzzled by a certain melancholy reserve in Fidel, an unaccustomed air of pent-up sorrow, which showed in the way he spoke without affect, seeming unaware of what he was saying, and now in the way he sat staring at his bowl as if looking into the depths of an abyss. Gregorio felt sorry for him, but he was also extremely curious. He'd become used to never seeing the

slightest intimate suffering ever seep through Fidel's inhuman veneer, and so this struck him as extraordinary.

With an utterly vacant air, Fidel mechanically sipped another spoonful of that vile liquid in which various types of noodles and two or three chunks of rotten potato floated. The action indicated no physical sensation at all: Fidel's entire being was absorbed in a potent, stubborn inner torment that failed to manifest outwardly. His lips were coated with the greasy, opaque varnish of the cold soup.

Rattled, almost with the anguished surprise of someone who's woken up in an unfamiliar place, Gregorio looked around at the large convent patio they were sitting in a corner of. He gazed a long time, uncomprehendingly, at the sturdy, rectangular capitals of the short, baseless cylindrical columns that formed a sober, shadowy arcade. Only then did he hear the chords of a guitar that was accompanying—and perhaps had been for several minutes—the sad and aching voice of a singer. As if before this he'd been deaf. It made him feel peculiarly uncomfortable.

Where are those steeples of Puebla,
where are those churches of gold,
where are those sacred urns,
ay! the war destroyed it all...

The patio's appearance was a depressing combination of prison and market, but, strangely, with no movement or sound. A prison for the dead. In the galleries of the arcade, two or three families clustered at the foot of each column—down-on-their-luck men, women, and children

who sat there quietly, looking almost imbecilic with resignation, the little ones in their mothers' arms or laid out on the ground on sarapes. They sat in an abiding atmosphere of love for their misfortune: it was as if the fact of sharing this old building, now run by the Unemployed Workers' Council, instilled in them all a kind of surrender to the fate they'd been dealt, an inclination not to resist anything or anyone, since they were all suffering, weeping, disappearing together.

Where are those steeples of Puebla...

No one seemed to be listening to the old *chinaco* song, but when for some reason or other the singer broke off, a clear voice urged him on:

"Don't stop now, compañero, at least so we won't be so sad..."

A staggeringly indifferent voice. One that surely didn't give a damn about anything, including the song. "So we won't be so sad." The melody, full of bygone laments, told of Puebla's woes in the days of the French Intervention—the homes destroyed, the churches razed by artillery, and, in the midst of this scene, the death of General Zaragoza, which left the city bereft of its most lion-hearted paladin.

The song seemed remarkably current here among these people who were the same as fifty, a hundred, three hundred years ago, with the same indifference toward their own sorrows and helplessness. And perhaps it was comforting to know their grief came from so far back, for the song produced an imperceptible ripple of satisfied nostalgia, as if they were calmly settling into a firmer motionlessness.

In the center of the patio a woman was squatting and washing some tin vessels, using the back of her hand to push away a dirty strand of black hair that stubbornly kept falling in front of her face. Beneath her skirt, seeming alive with an animal consciousness, a dirty little tongue of water carrying grains of rice and other bits of food waste slithered round the rough flagstones, stopping and starting; it seemed almost lewd and obscene, as if it were coming out of the woman herself.

There was nothing unique or strange in the scene. The woman was furiously scrubbing her miserable collection of empty sardine tins by the spigot. That was all. But suddenly that damned, foul-smelling rivulet appeared beneath her skirt, creeping with perverse malignity, crafty, pausing here and there, moving steadily toward its goal. To Gregorio, watching from behind, the woman suddenly took on a cynical, hallucinatory character: he expected the crudest, most eccentric, most barbarous and incredible things from her, as if she were a madwoman. He felt terror and an almost perverse curiosity in his awestruck soul. She was insane. Definitely insane.

Gregorio shuddered with a bitter feeling of loneliness. The painful desire for a world of beauty where everything obeyed a fair and balanced order hurt his soul, because the hope seemed so hostile, antagonizing him with its impossibility and remoteness. Who knew what filth would pour out of the madwoman's body now. Gregorio felt suddenly stunned at the extravagance of these thoughts. Was his sickness causing it? He absolutely had to go to a doctor as soon as possible. He looked away from the woman and at Fidel again, and this produced something like an electric shock inside him.

Fidel was leaning forward in his seat with an unusual stillness, his eyes dead, his face absolutely colorless. His suffering was not of this world. It would be useless to attempt to communicate with that utterly solitary soul.

The stream of dirty water crept toward Gregorio's feet, and, unresisting and impotent, he let it arrive. On the other side of the patio, as if across a measureless distance, he could see the man with the guitar lying against the wall, in the pose of someone just executed by a firing squad. Everyone else listened to his song without even trying to approach him, from their places in the arcade, next to the columns, with the eternal quiescence of sick people taking sun in the hospital, inert, now no more than ruminating objects.

In another time, before the crisis and the factory closings, these shadows had been workers, and the wives and children of workers. But destitution stripped them of dignity. Today they were much closer to the criminal underworld, with unexpected passions, feelings, and vices. They were no longer the same dauntless people of years past; now they were people with a creeping, mistrustful, selfish, calculating spirit.

Gregorio saw a shape in the patio out of the corner of his eye. He turned quickly. An absolutely apocalyptic dog had approached to drink from the spigot in the center of the patio, but then darted away with a kind of rancorous squawk, sounding more like a bird than a dog, when the dirty woman who was washing her tins threw a pebble at it to scare it off and defend a little dish of beans she'd set down nearby where she could keep an eye on it. The squawking of a big, impotent bird that hides its rage with a ruffled, painful, comical desperation.

The woman stood up straight with an exaggeratedly righteous air.

"Got no shame!" she shouted with a sharp voice full of pathos, turning to the onlookers around her, confident they'd support the legitimacy of her cause. "No shame! The people got nothing to eat, and you think there's enough for a dog?"

Her head was flung back, defiant and proud, waiting for the people to endorse this statement that summed up the whole desperately human drive to persist in the face of all enemies and competitors, even the dogs. But no one seemed to notice, and the woman sank back into her own misery and solitude, defeated.

Fidel's and Gregorio's eyes finally met, and immediately, almost involuntarily, a bond of comprehension arose between them.

For the first time in a long while, Fidel's gaze was misty and affectionate, but a little ashamed of being so. His thin fingers drummed imperceptibly and nervously on the bare pine table. Something very deep was troubling him, something that must have been completely alien to his self—or to his external mode of being, at least. Gregorio couldn't hide his impatience. They'd spoken about everything they needed to in the three hours since Fidel had arrived in Puebla, here in this patio where they'd arranged to sit and talk. Fidel's purpose was to inform Gregorio, who'd made the trip from Acayucan specifically to see him, about the resolutions adopted by the Central Committee in its most recent meeting in the architect Ramos's house; but Gregorio understood that Fidel needed to tell him something else, something that didn't have to do with political matters, another type of problem—though perhaps of such

a personal nature that it could only be expressed in vague and metaphorical language.

It didn't matter. It would be a triumph, Gregorio thought, if suffering and pain made a genuine man of Fidel again and he ceased being this horrible believing machine, this horrible machine that never felt doubt.

He waited anxiously for Fidel to speak. Fidel recomposed his face, and a spirited, lively color reappeared on his cheeks. Still, he kept silent for a long while.

"I'm completely sure"—Fidel licked the grease of the soup from his lips (he hadn't wanted to eat in a restaurant, despite Gregorio's preference; he insisted on eating the revolting food they dished out to the people in the Unemployed Workers' Council, saying he had no right to treat himself any better)—"I'm completely sure you'll understand my political stance," he insisted, with the same uninflected tone that had surprised Gregorio earlier: empty, devoid of intelligence, not his usual way of speaking.

"He's suffering far more than I imagined," Gregorio said to himself, following his words closely. Fidel paused sorrowfully. His gaze was pleading, like a dog's. Inside, he must be battling against something that had nothing to do with his words. "He's looking at me as if I were going to hit him," Gregorio thought.

"You know," Fidel said in a very low voice, looking away from Gregorio, "that my opinions run contrary to yours. I've combatted your opinion on different matters, and I've worked to make the Central Committee take resolutions against you. But our friendship has nothing to do with all this."

Gregorio closed his eyes with what looked like assent, but it was dismay. He was dumbfounded. It was as if he

were blindly trying to find a word in the dictionary. He knew what the word meant, its characteristics, its function, but he had no idea what the word itself was. It meant something like smoothness, something like a certain hue, something like a presence that barely impacts the senses and isn't so readily perceived; but no one could tell him that all of this was simply the word *blue*. Gregorio knew the characteristics of Fidel's suffering, he could see them, but he couldn't discern its name.

Fidel was a man who... how could he put it? Gregorio squeezed his temples with his thumbs. How could he put it? Rather than a man, he was a schema, a deformation into spiritual schematism. (This image bothered him and made him feel cowardly and unfair. It felt wrong to think this way of Fidel, when, along with this "schematism," he had truly exceptional virtues.) It was frightening to think about the possibility that such a man might reproduce himself, today, tomorrow, here in Mexico or anywhere else in the world, in ten thousand faces, inexorable, crafty, full of abnegation and generosity, full of purity—blind, criminal, and saintly. A machine, good God, a believing machine. Gregorio kept his eyes closed. Fidel's attitudes and opinions, the ways he conceived of life, floated up in his consciousness.

One night before Gregorio had left for the port of Tampico on an express train whose car attendant was a Party comrade, he'd sat waiting with Fidel on the platform. The sky was thick with stars, and the whistles of the locomotives came in deep, sad tremolos that vibrated the air into palpable ripples that wounded one's very skin. "There's no greater joy than being a Communist!" Fidel suddenly exclaimed in that atmosphere steeped in silence.

It wasn't a mere lyrical outburst. Fidel's dreadful credo was based on that abominable statement. With an absolute lack of self-respect, Fidel believed in his own happiness and, even worse, in the stupid happiness of all humanity. How could he possibly confess now, in the teeth of that belief, that he was suffering because of things like love, loneliness, death, and uncertainty?

"You know it?" Gregorio had retorted that night, gritting his teeth with rage. "You know that man is nature's most beautiful miracle?" He gave a romantic emphasis to his words, feeling more and more moved as he heard them. "Well, then, why do you want to reduce him to the condition of a happy, pretty little pig? Man is matter that thinks. Do you understand? Matter that's conscious of its existence, and this means it's also conscious that it will cease existing. The 'highest product' of matter: that's what Engels, that gentleman you've never read, called the thinking mind. Okay then. Thanks to an inexorable law, this highest product must end up extinguished within a limited space, the solar system or what have you, and in infinite time, the constant and eternal becoming of matter. This awareness that he will be extinguished is the root of man's true dignity—which means his true pain, his purest hopelessness and solitude. So what we aim to create, when it comes down to it, is a world of hopeless, solitary men. Of course, not in the Wertherian and bourgeois sense, not in the narrowly individual sense. In a certain way you might say it's in the biblical sense, the way Ecclesiastes expresses it—*For in much wisdom is much grief: and he that increaseth knowledge increaseth sorrow.* No more and no less. The sorrow of knowing. The grief of wisdom. A heroic man, cheerfully hopeless,

215

helplessly alone. And with no belief in absolutes. To hell with believing in absolutes! Men invent absolutes for themselves, God, Justice, Liberty, Love, et cetera, et cetera, because they need something to grasp to protect themselves from the Infinite, because they're scared of discovering man's intrinsic uselessness. Yes, the amazing thing isn't the fact that absolute truths don't exist, it's the fact that man searches for them and invents them with such feverish, overblown zeal, like a gambler who cheats, or a high-class thief. When he thinks he's discovered these truths, he breathes easy. He's made a great business deal. He's found a reason to live. Bah! We have to shout it at the top of our lungs: man has no purpose, no 'reason' to live. He should live in the consciousness of this if he wants to deserve to be called a man. As soon as he discovers things to hold on to, his hopes, he's no longer a man but a poor terrified devil, intimidated by his own greatness, by what could be his greatness, completely unworthy of it, unworthy of being the 'highest product' of matter. Some brave Communism yours is if it limits itself only to aiming to make social classes disappear! Class will disappear, no doubt about that! It certainly will! But that's only one step toward the advent of man. Man hasn't been born yet, among many other reasons, because social class doesn't let him be born. Men have been forced to think and struggle according to their class aims, and this hasn't allowed them to seize their true lineage—the lineage of matter that thinks, of matter that suffers because it's part of a mutable infinity, and a part that dies, that gets snuffed out, annihilated. Let's fight for a society without classes! Great! But not to make men happy, rather to make them freely unhappy, to snatch all hope from them, to make them into men!"

Gregorio smiled when he recalled these words. The fact was, the thoughts hadn't exactly been his. José Alvarado, an active militant in the revolutionary student association at the time, had published something similar in the *University Review*. Gregorio had been profoundly impressed by the young philosopher's ideas, and, with an enthusiastic vehemence, rushed to make them his own.

He sat for a long time with his forehead in his hands, eyes closed, concentrating on his thoughts. His right index finger drummed once a second, nervously and actively, like the little lever on a telegraph machine, against the upper part of his forehead. Fidel noticed that between this finger and the middle finger, Gregorio had an almost black nicotine stain. "He must be smoking too much these days," he thought to himself, unable to remember having ever seen the stain before.

Now small groups of two or three men began to come into the patio carrying posters with red lettering, with which they roamed the streets of Puebla every day. They looked pitiful, sad, and at the same time—perhaps because of how indifferently they bore their condition—vaguely shameless. They wore old pale denim coveralls or plain wool dress pants with the lower part covered in mud. Their faces were yellowish, the sparse hairs of their indigenous beards dirty and grown-out. Some went barefoot.

They propped the posters against the wall and then sat down against it with their legs crossed. They spoke as softly as if they were at church.

"Ah…" Fidel heard clearly from where he was sitting downwind, the voice seeming to crawl and stretch itself over the flagstones, the monosyllable *Ah* long, melodious, singsong, and heartrending. "Ah, compañero!" someone

was saying, so indolently that it seemed unlikely an interlocutor even existed. "Ah, compañero! When's this *creesis* gonna be over—when, huh?"

The response came several seconds later: "Well, one of these days, compañero, God willing."

Then a deep, depressing silence.

Unsettled by Gregorio's behavior, by his wordlessness, Fidel closely examined his face: it was a bold, noble face, with a wide, straight forehead and a narrow, gentle, almost childish chin. In a certain sense it pained Fidel to fight against him. As he saw it, the only thing that separated them was their different understandings of political tactics and strategy, but this didn't prevent Fidel from seeing Gregorio as a friend he could trust absolutely. It was precisely in order to distinguish between this friendship and their divergent ideas, and to keep the friendship from influencing the strictness with which questions of principle ought to be treated, that Fidel so viciously attacked Gregorio.

And so, with regard to Gregorio's work in Acayucan, Fidel had spared no efforts fighting against Gregorio at that atrocious last meeting of the Central Committee, until he secured the resolution requiring Gregorio to appear before the next plenary assembly as a transgressor of Party policy.

Fidel fought for his cause in active, constant opposition to all personal feelings that stood in his way: friendship, love, whatever they might be.

That last Central Committee meeting at Ramos's house was engraved very precisely and unhappily in Fidel's memory. It marked a change in his life, an unexpected transformation. It marked, in sum, the loss of Julia.

It had been humiliating and vile. After they'd dealt with the matters on the agenda, Fidel had had to make his personal report. He'd felt hatred for everyone there, for he could tell that beneath their seeming naturalness and blithe Puritan expressions, they were listening to his words with a kind of ironic, malign delectation. Everyone. He'd felt hatred and jealousy because of what they must be imagining, because of the filthiness of their thoughts.

As usual, the meeting was held in the living room amid the peculiar atmosphere of chic bohemia created by Ramos's art objects, paintings, and books. Fidel spoke for scarcely five minutes, without lifting his gaze from the foot of a horrible console table. Nauseatingly horrible. It was shaped like a faun with splayed legs and a diabolical smile on its face.

"It has to do with a personal matter," Fidel said. There was a barely perceptible stirring of pleasure around him, for everyone knew what this "personal matter" was and they were curious to see how Fidel would frame it. "A personal matter, but one that has implications for the organization," Fidel added without moving his eyes from the console table. An ambiguous hush fell, and the whole group stiffened, like a clam receiving a drop of lemon. "Comrade Julia and I have decided to separate," Fidel continued. He felt he was conjuring up a very concrete, intimate image in his listeners. "And, well, comrade Julia has no family. She lives in our illegal office, as you all know. It's easy to understand that it's a little bit violent for us, yes, a little bit violent for us to both live under the same roof in these new conditions." Fidel trembled. Now every one of them would imagine the possible scenes, the bottled-up desires; now every one of them could leave the filthy tracks of his

imagination all over that whole invisible process that turns two people into strangers, when barely a week before they were intimate, trusting, loving, and familial. "The issue, then, is to find a suitable arrangement for her; she's a trustworthy Communist," he concluded, without moving his eyes from that demonic table.

The faun's aquiline nose curved toward its sharp, insolent chin. Now Fidel felt more uncomfortable and vexed, realizing they felt sorry for him, realizing that his tone, despite its coolness and the apparent serene objectivity of his words, had let his intense bitterness shine through.

There was a deep sense of relief when Fidel lifted his eyes to look at everyone. After a brief debate, they adopted a resolution to commission Julia, with a modest stipend, to work in the Aid Organization for political prisoners.

Fidel couldn't forget any of the harrowing details of what had happened earlier when he'd first arrived at Ramos's home.

He'd shown up early and from the first moment felt restless, invaded by a dull irritation. That house, that furniture, that luxury. He felt enormous contempt for all those people the Party called "sympathizers," those people of a certain economic and "social" position—some of them even had ties to figures high up in the Government—who reduced the duties of their political conscience to mere donations of money. It was as if they bought their comfort and tranquility, while the rest of the Communists braved all the dangers. Lowlives.

After sitting on a wide sofa in Ramos's living room for a few minutes waiting for the others, Fidel noticed with annoyance that the clock on the coffee table indicated he was a little over half an hour early for the meeting.

He leapt to his feet as if launched by a spring, frustrated and angry, with a sense of failure at his own inability to adapt to the inexorable autonomy of time, which flows along at its sovereign leisure, leaving us powerless before it. He looked around him like a castaway, and then, almost insolently, began to examine all the objects in the room one by one with a gratuitous, unnecessary thoroughness that gave him the look of an idiot. Old bits of Tarascan ceramic; a music box with Florentine decorations; eight pipes with different shapes; a filthy, disgusting crucifix riddled with worm holes.

One particular small painting above the fireplace caused a mysterious reaction in him: he felt disdainful and angry, yet fascinated. It must be one of those surrealist or modernist things, something like that. An incomprehensible combination of geometric figures—triangles, trapezoids, rhombi, cylinders cutting across one another, their shapes broken by diagonal and horizontal lines that went from one side to the other. Fidel immediately felt a singular contempt for this work, a contempt suffused with a profound, moving, and surprising awareness of his own superiority, far above such ways of viewing life. Why so sterile and meaningless? It struck him as horrible... and immoral. A symbol that summed up "bourgeois decadence" completely.

Something churned inside him, and, trying to rid himself of the feeling, he went over to the bookshelf to look at the titles. No improvement. There wasn't a single volume of socialist doctrine. He looked at the clock: barely five minutes had passed. What to do? He picked out a book and read at random. "I'll tell you who does need a good doctor, and that's our friend Swann." He closed the book

and put it back in its place with a feeling inside of distress. Julia. Julia. He had to bring up the subject of Julia in the meeting. It was terrible. But all of a sudden, in the opportune solitude and idleness, a morbid temptation assailed him, an inexplicable clandestine pleasure—there, five steps to the left, the fireplace again: he could look at the surrealist painting again, without bashfulness, without anger, without regret. There were no witnesses, after all; he was completely, utterly alone in this comfortable living room that was, despite everything, so welcoming and benign.

He examined the painting with uninhibited, total cynicism. To look at it was to commit a crime no one would ever be aware of. Rhombi, rectangles, pyramids, cylinders, cubes. Lines of mauve, incandescent whites, pink backgrounds, and in the upper right corner a flash, an aggressive green stain.

All of a sudden he heard a lilting voice behind him, and he turned around quickly, stunned and awkward, not knowing where or whom it came from.

"Do you like that little trifle by...?"

From the top of the stairs Ramos's wife finished the sentence with a foreign word that must be the name of the painter. Crack. Something very similar to the noise you make when you open a walnut with your teeth. "Little trifle." The indulgent label absolved the painting of everything extravagant and foolish it might contain.

Virginia smiled from above with an air that was faintly sympathetic and full of curiosity. She was wearing a lilac-colored dressing gown with discreet decorations that looked to Fidel like tiny fleurs-de-lis.

Fidel felt himself blush to the tips of his hair. He was about to respond in the blunt way his ideological

conscience dictated. "I don't care if it's a trifle. In any case it's *criminal*"—that would be the proper word—"to make art that's incomprehensible to the masses." But before he could even open his mouth, Virginia had moved on.

"I'm sorry if I interrupted you," she said with a silky warmth that didn't register on Fidel. "The fact is, honestly, I didn't mean to. I'm looking for some help up in the study. A little favor."

Without quite being sure how he ended up there, Fidel found himself in Ramos's study trying to move a bookshelf that Virginia's ring had rolled under. As he set to the task, she watched him with an air of malicious delight. The look of ingenuous concentration on his face made him more captivating, more innocently tempting.

On the sofa, still warm from Virginia's body, lay the dress she'd taken off fifteen minutes earlier, when, after observing Fidel from above, she had decided to lose her ring.

Virginia came a few steps closer to Fidel, calm and easy, as if she were in the presence of a eunuch. No, he couldn't do it by himself. She'd help him. She bent down toward the base of the bookshelf and braced herself so she could tug on it, exposing one naked leg, which protruded from the folds of her dressing gown. Now that was better. She looked at him slyly: wasn't it? Another try. Maybe now! Bah! That hadn't worked. They had to keep trying. Virginia's naked leg slid forward with youthful, casual boldness, enough to touch Fidel's tensed inner thigh, and there it rested, stubbornly motionless, without relaxing its sweet and intentional pressure, provocative and challenging.

To assess her effect on him, Virginia probed Fidel's face with her wickedly curious, mocking eyes. She couldn't

suppress a smile of confident triumph. He was stiff and serious, with that eager and slightly nervous solemnity Virginia recognized as a clear sign of things to come. Yes, anything else would have been impossible: now his compact, masculine thigh responded, moving shyly at first, with quivering wariness, and then no longer holding back, thrusting forward in a brutal split second with a fierce, magnificent violence. Virginia almost shouted with joyful panic. Her eyes, no longer mocking, unexpectedly avid and hungry, anxiously searched out Fidel's gaze. He maintained his rigid, tense expression, the solemn gravity that presages love, but then suddenly his muscles slackened with a burst of almost childish glee, his head tilted, and, victoriously rising to his feet, he held up the rescued piece of jewelry.

"See, no need for a magician!" he said with spontaneous elation.

Virginia looked at him uncomprehendingly. She'd never heard of such a thing in her life. Her whole body shook. As if in a dream, she accepted the ring Fidel held out to her. He looked serene, guileless, insufferably chaste and innocent. No, he wasn't pretending. The man wasn't pretending. He simply, he simply... Good God! She was about to weep like a schoolgirl!

Like a sleepwalker she walked him to the door of the study. She couldn't articulate a word, but she had the strength to detain him before he left. She shook her head, obsessed.

"No one would have believed you're such an idiot!" she said in an unearthly voice, slamming the door.

She swayed, just about ready to have a syncope. She walked a few steps and then, shattered, flung herself face

down on the sofa and burst into long sobs. For a second—but only a second—she regretted not having surrendered to her husband half an hour ago, after that stupid little girl had jumped off the roof.

After he took his place among the comrades in the Central Committee meeting, the console table immediately caught Fidel's eye. Without meaning to, he'd sat down right next to it, perilously close to the mocking, malicious faun, which almost seemed to divine his thoughts and inner turmoil.

In an essentially ritualistic habit, everyone took notes while Germán Bordes, the Party chairman, gave the political report. Fidel brought out his notebook and pretended to take notes. Nothing. Just his own name some twenty times, Fidel Serrano, Fidel Serrano, in block letters that were camouflaged immediately under fresh scrawls that made his name completely illegible: *Eidec Sapano*, or something like that. The tiny fleurs-de-lis. The lilac dressing gown. Her naked leg. But worst of all his own triumphant gesture, which now appeared to him in all its pathetic comedy, as he held the ring up high. "See, no need for a magician." Pathetic. Like the clown who flubs his act but pretends not to notice the booing, thanking the audience with gestures that everyone finds sad and pitiful, and even when the bad performance seems to have been left behind, a hurt feeling lingers inside him, a desire to cry... "See, no need for a magician." The dirty little faun, with its obscene, hairy limbs and its lustful pupils like a rat's.

"It's an incontrovertible fact," Bordes was saying in his high, metallic voice, like a whetted razor, without the slightest trace of feeling, "that the Mexican bourgeoisie has sold out. Our Party's task, in consequence, is to wrest the campesinos from them, to form a campesino worker's

bloc under the leadership of the proletariat, and lay out the demands of the Campesino Workers' Revolution: all land to those who work it, all the factories to the workers, all power to the Workers', Campesinos', and Soldiers' Councils." Jargon devoid of lyricism, hammered home, stark as a quarry.

Bordes was wearing a gray suede jacket, striped wool formal pants, and an out-of-fashion pair of shoes with metal grommets for the laces. Still, he didn't look ridiculous; on the contrary, his appearance was dignified and severe. The dignity of a Khan of India. Of a chubby, fat-cheeked Buddhist priest. One might have taken him for Malay or Chinese, too, because of his oblique eyes and the shape of his black mustache, which fell down below the corners of his mouth. His force of conviction—or at least a great part of his gifts of persuasion and his inarguable ability to impress—was due to how he used his hands. He stuck his thumb out toward himself like an inflexible spur, as if his hand were a contortionist's, and then, as if it were an autonomous object that moved on tracks, he pushed the whole hand forward, fingers curled toward his palm, with short jerks, stopping at the invisible limit where the tracks ended.

"It's a fact"—here Bordes's hand began its advance—"that the bourgeoisie has betrayed..." His slack fingers accentuated the jerks of his hand (and the bourgeoisie's betrayal), and so his speech entered one's consciousness with a strange clarity, through pure superstition. Even if no one heard his words, the gesture alone might let him delineate his discourse and syllogisms.

Major premise: the bourgeoisie has the campesinos in its power (the thumb is drawn incredibly far back, as if

broken, the width of a spatula, like the thumbs of those bank employees tasked with incinerating bills who must count million after million until their fingers and spirits are bent out of shape). Minor premise: the bourgeoisie has sold out (the hand describes a path through the air, from Bordes toward his listeners; it plunges along this path, quivers, and halts). Conclusion: our party's task is therefore to wrest the campesinos from the bourgeoisie (at the word *wrest* the fingers contract inward and the hand withdraws toward the speaker, eloquent, victorious, with all the campesino masses in its fist). Immediately after such a display, Bordes would raise his right hand to push up the spectacles on his nose with his thumb and first two fingers, while glancing out of the corner of his eye at his notes. He did so now. He looked down at his notes with his eyelids lowered, amid the devout silence of everyone present. The lilac dressing gown. The fleurs-de-lis. Fidel imagined Virginia. She must be upstairs, in the study, naked beneath the dressing gown with its fleurs-de-lis. "No one would have believed you're such an idiot." He remembered Virginia's faltering rage when she said those words, the desperate, furious desire in their intonation.

"In accordance with this characterization," the chairman's high-pitched voice continued with the report, "right-wing opportunism, within the Party, can be considered as the tendency not to believe that the bourgeoisie has sold out and to suppose that it still contains revolutionary reserves, to the point of believing that it's possible and even necessary to come to an understanding with it, under the guise of fulfilling the aspirations of the Democratic Revolution." Bordes paused. His small eyes

landed on the surrealist painting. He had time to briefly assess it: "An excellent Braque," he thought. "I wonder if it's authentic." His cheeks quivered as he cleared his throat. His hands arranged and adjusted the fan of little papers in front of him. "Comrade Gregorio Saldívar, sent to the Acayucan region by our Party, is a *classic* example of right-wing deviation"—his small Asian eyes looked inexpressively at each member of the Central Committee—"that is concomitant with practices of desperate, anarchistic petty-bourgeois leftism. A deviation that isn't scrupulous about its means:"—the colon here was palpable—"Saldívar has tolerated cases (just one case, to tell the truth, and one that's quite commendable in other respects)"—Bordes smiled at the innocent cynicism of this aside—"of individual terrorism, and has even allowed the assassination of Macario Mendoza, if he himself isn't the one who inspired the crime, perhaps for personal reasons, instead of..." Bordes broke off suddenly, his face very pale. He had been about to say "instead of rendering him ineffective by means of the organized struggle of the masses," but he stopped in apprehension. The doorbell had rung, and in such an imperious, authoritarian, and insolent way that everyone could guess who it was. They hurriedly stashed their papers in their pockets and sat motionless, feigning an air of regular visitors, but their minds were flooded by the details of the scene they imagined was about to occur. "Comrade Fidel, please tell the señora," Bordes ordered in a low voice.

Fidel went up to the study. There were the fleurs-de-lis over her naked body. She turned and looked at Fidel with rancor and animosity, but grew concerned when she noticed the pallor of his face. Naked, yes, because a breast appeared and disappeared, like a wet, shining dolphin

plunging back into the water, when Virginia rose from the sofa with a worried expression.

"The police?" she asked with wide eyes. "I'll be there right away!"

It was indeed the police. The group sat silently and listened, without breathing, to the conversation between Virginia and the police captain in the entrance hall.

"Do pardon me." The voice was polite and soothing. "But we need an eyewitness, and we thought someone here might have happened to see it: a girl, a servant in a building nearby, jumped off the roof." In the living room everyone breathed again. Some even smiled. They smiled with beatitude, with dumb looks of joyful sweetness.

"How awful!" Now it was Virginia speaking, sounding upset, almost about to shed tears. "It's the first I've heard of it! Poor girl! No, no one could have seen it from here. Not even the servants. It's their day off." The door shut. The fleurs-de-lis went up again to the study, grazing Fidel's shoulder as they passed, leaving a perfume. A perfume.

Bordes began again with his metallic voice, sharp as a razor, and from this point on everything was a jumble of bitter memories in Fidel's mind—Julia, Virginia, the faun's legs, the console table, the Central Committee, Gregorio, Julia again. Again, like a mark burned into his thoughts by a branding iron.

It was intolerable. In-tol-er-a-ble. His lips felt dry, as if he were sick with a high fever. He looked at Gregorio uneasily, afraid he might have managed to follow his train of thought. But Gregorio sat motionless, and through his half-open fingers, held under his forehead to shade his eyes, one could see his eyelids blinking rapidly, almost artificially, like a doll's.

A troubled, bitter sadness overwhelmed Fidel's heart. A formless unease that nevertheless had a precise consistency, making him feel frustrated and impotent, weighed down by a disheartening inferiority. As if trying to decipher an absurd hieroglyphic, he examined the distant, incredible things around him: the perfect arches of the patio, the columns of solid stone, and the groups of people, like a scattering of living stains that hardly managed to move, prisoners in an atmosphere that seemed to oppose them with an invincible solidity. A cloud crossed the sun, and an intense, dirty shade of gray spread over the patio, but once it had passed, in a matter of a few instants, the flagstones shone again with an unusual gleam.

"The Unemployed Workers' Council," Fidel thought without feeling any particular emotion. He looked at his fingers, whose knuckles were swollen like chickpeas. His mind gradually cleared. According to the Party's resolutions, Gregorio was supposed to organize a march on foot, from Puebla to Mexico City, with the unemployed laborers and their families, to protest against the lack of governmental measures to deal with the crisis. It would be grueling. He imagined the terribly exhausting walk, the ragged legion of men and women trekking more than a hundred kilometers on the hot asphalt highway. But it would be a magnificent day of propaganda against the regime.

Just then he noticed an ugly, skinny woman crossing the patio with a stack of empty tin cans in her arms. He watched her without actually seeing her. Sensing his insistent gaze, the woman bared her yellow teeth in a gloomy but also very accommodating and polite smile, with the desire to please. Something inside Fidel, the

sole part of him that perceived her smile—the rest of him was faraway and unaware—shivered with a chill of revulsion.

The woman went behind Gregorio to a column where a black rebozo hung from a spike, bulging with the weight of some heavy, round object. Unsure why he was doing so, Fidel followed her movements with a kind of incredulous surprise, yet without understanding them at all. "What a poor devil Gregorio must think I am," he said to himself in a sharply guilty tone. The woman took down the rebozo from the spike with a tender, caring delicateness, a fine and noble grace that contrasted implausibly with the ugliness of her face, and the little bundle was transformed into something alive and animated that emitted harsh, fussy shrieks like a rat's. It was her child.

Roused by this zoological noise, Gregorio looked up. "The same one," he said to himself when he saw the woman out of the corner of his eye, "the same damned witch." It was the woman he'd seen in the middle of the patio washing her cans.

His eyes, filled with a sad and commiserative glow, alighted on Fidel.

"I don't think you heard me," Fidel interjected hastily, tripping over his own words, afraid that Gregorio might think the conversation finished even before hearing him out. "I told you I pushed the Central Committee to declare those resolutions against you, but that our friendship doesn't have anything to do with this."

He regretted his words immediately. They weren't just useless—they didn't correspond to what he was trying to confide in Gregorio. He'd said them out of timidity and now they seemed aggressive, severely formal.

Gregorio's hands twitched convulsively.

"That wasn't what you wanted to tell me," he exclaimed suddenly with animosity. He searched for the right way to say it. "No, it wasn't. Something very strange is happening to you," he added in a much lower voice.

The fact was, Gregorio wasn't expressing his true thoughts either. He couldn't reproach Fidel for not speaking his mind when he himself wasn't doing so. Still, he thought, "He's scared to admit he's weak and defeated—weak and defeated for whatever reason, I don't care what, but recognizing that it's true is only one step away from recognizing the mistakes and lies he's lived with his whole life." He would have liked for Fidel to hear it like this from his own lips, but at the moment he felt prey to a strange splitting of his consciousness, and he was impelled to say, if not the opposite of what he was thinking, at least things that had no resemblance to it—or worse, things that corresponded to thoughts he didn't want to express, *shouldn't* express concerning himself, and this hindered him from touching on opinions about Fidel that he did want Fidel to hear.

"Are you feeling *sick...*?" he asked involuntarily, without thinking, and he instantly felt dismayed at having asked it. The raw, painful thought flashed through his mind that the real sick man was him. He still hadn't had the chance to go to a doctor, after two weeks. It made him feel a horrific rage.

Fidel imagined that Gregorio was feeling an unexpected spark of pity, the flicker of unavoidable dread when one realizes one is about to be made complicit, made the repository of a misfortune that demands sympathy or

solidarity, or of a confession that might bring even worse trouble. "It's obvious," he said to himself with shame. "Maybe he'd prefer not to know anything."

"Sick?" Fidel said out loud in a quavering whistle. The word made Gregorio shiver afresh. "Maybe I am!" Fidel moved his eyes restlessly, hoping this might lessen his pitiful, helpless look. "You could call it a sickness, yes. A sickness like any other, only one that doesn't show, one you can't see…"

Gregorio didn't understand. Only isolated words reached his comprehension, with cauterizing heat. Sickness. Sickness that doesn't show. He needed to go to the doctor, urgently. He almost felt hatred toward Fidel. "As soon as you clear out of here," he said to himself with gritted teeth.

"Maybe you know already," Fidel went on, with sorrowful energy.

He paused for a short moment to gather his strength.

"It's about Julia, just Julia," he said. The whites of his eyes had turned reddish. "Like the eyes of that miner from Pachuca," Gregorio thought. A miner who'd been rescued from the bottom of a shaft after a cave-in had entombed him for three days—Gregorio had been there when it happened. In the middle of the smudge of dirt and blood that was the miner's face, Gregorio had seen the two embers of his eyes, with their sclera that looked made of flame, like burning brands. Like the eyes of a rabbit, or of certain birds.

Julia. Fidel was speaking about Julia, he reminded himself.

Fidel's voice became childish, utterly defenseless. He resembled a little boy singing a silly song out of tune.

"Maybe you can do something when you talk to her," he implored, "something to make her come back... the thing is," his voice grew as thin as a single hair, "we're not living together anymore..."

A little wave dying on the beach, wet and salty. Two tears slid down Fidel's cheeks, past his mouth, and one of them stopped, suspended from a hair on his unshaven chin. It looked solid, like a drop of glass. A bubble on the rim of a defective drinking glass.

"He has his hands and feet tied." That was what Gregorio felt: Fidel was handing himself over with his hands and feet tied. "Now he'll understand that life isn't a dead theoretical schema. That it's not the torturous abstraction he thinks it is." He regarded him with sudden sympathy.

"I have something to tell you too—a confession you can't imagine." He was going to say these words and tell Fidel what had happened in Acayucan, but Fidel's voice came again, seeping through his skin and making him shiver inside with anguish, not letting him confess his brutal story.

"Will you do something? Tell me, will you speak with *her*?" The pronoun made her more distant, more hopelessly a stranger.

Gregorio realized how absurd, how poignantly senseless this was.

"He's lost," he thought. "Julia will never go back to him. Why is he asking me for these things?" But suddenly he stopped short, astounded, seeing the horrible, ashen face that Fidel suddenly wore. Ashes. Nothing but ashes everywhere, around his lips, beneath his cheekbones, on his forehead. The teardrop had finally fallen from his chin

onto the table. Fidel wiped the surface with his thumb, leaving a faint, dark wet spot like a saliva stain.

"I never imagined his love was so strong," Gregorio thought. He tried to evoke Julia's image, but the more clearly she appeared in his mind, the fewer connections and ties he could see to Fidel. Thin, small, fragile as the stem of a plant, Julia had dark eyes, but it wasn't just their pupils that were dark—they were dark all around, below her eyelids, like the shadow cast by a violet, with the faint dampness of the black earth in a corner of the garden where the sun doesn't reach. They had a cool, unchanging light that flashed with understanding and accusation at the same time. In the middle of Julia's upper lip, when she wasn't speaking, a childish, naïve, playful little point stuck out.

The memory made Gregorio feel even sorrier for Fidel. At heart Fidel was a very lonely man, but the worst part of it was that he was incapable of comprehending his solitude, a solitude Fidel was only now going to become aware of, yet without loving it at all.

"Sometimes I think," Julia had said to Gregorio once, hesitantly at first, pausing tremulously and doubtfully before continuing, "sometimes I think Fidel is an odious person. It's not that I don't love him"—a certain intense emphasis here, her gaze serious, the point of her lip severely adult, no longer childish—"because I really do love him." Gregorio had smiled, because this insistence might indicate the opposite of what her words were saying. "But there's something in him that's simply frightening... something terrible."

It was one afternoon in the "illegal office." An unbelievable suspicion had been planted in Gregorio that he

didn't dare put into words. Something in the way Fidel had acted when he left earlier, a certain air of confused bewilderment, of indecision—but especially a fleeting glance he'd shot Julia's way, stern and pleading, before he said goodbye—had made Gregorio wonder if Fidel was deliberately leaving them alone together. Julia's words now only made his suspicions grow. Gregorio seized her by the wrists, squeezing them furiously.

"He left us alone on purpose!" he shouted, his face contorted with rage. "He wanted to put you to this idiotic test! Didn't he?"

Julia simply lowered her eyelids. This contrition lasted a second. Then she looked him in the eye suddenly with a shameless expression.

"I don't see why not..." she began, but Gregorio left immediately, without letting her finish. Later he found out that Fidel hadn't come back until after midnight.

From then on Gregorio feared Fidel and felt pity for him because of the infinite suffering he unknowingly condemned himself to. There wasn't really anything dirty or despicable in it; it was simply a horrifying game, an awful desire for proof in which Fidel sought to make the pieces of his theoretical schema of life fit the real pieces that life, very far from any schema, presented him; he made them fit even when they didn't (for it was almost impossible for them to do so), by distorting reality to make it match his preconceptions. A mysterious and tragic process—as clandestine and secret as a taste for drugs—that drove him, out of fear, to protect himself from certain threats he seemed to scent in the air, to protect himself from life as it is, opposing life as it is with life as it is not and, most outrageous of all, with life as it will never be.

After that afternoon in the "illegal office," Gregorio understood that Fidel wanted love to be an unprecedented, total, and superhuman surrender (and of course Fidel was capable of such a complete surrender for his part). But he couldn't see that he'd never find a woman who would fulfill—or even understand—the need for this sacrifice of loving him truly. That is to say, of dissolving herself in him, expecting nothing, loving him like an idea—in short, everything that a woman can offer a perfectly simulated veneer of, but which she'll never give in authentic, impossible reality.

For the fact was—Gregorio shuddered at the thought—Fidel seemed to try to create favorable circumstances, by the most skillful and ingenious means, for Julia to cheat on him with another man; because when she didn't cheat, Fidel's overblown idea of love was bolstered, along with—the most terrible and inaccurate part—his belief that Julia was so faithful to him because she, too, loved impersonally, loved him like an idea, like a destiny, like part of the cause. Although if she never actually betrayed Fidel ("Which doesn't stop her from being a piece of trash," Gregorio thought), it was owing to very different reasons, if not calculated considerations.

An intense, leaden silence spread over the patio. Fidel sketched invisible, obstinate shapes on the surface of the table with the nail of his index finger.

"You know how hard it is for me to speak this way," he stammered, without lifting his eyes from the figure-eight doodles he was making with his finger. Gregorio followed his finger. No, they weren't figure-eights. Fidel was stubbornly and obsessively drawing a capital *J*: Julia.

"But, anyway," the words welled up from very deep in Fidel's chest, along with a pitiful sigh, "...breaking up with Julia has been awful for me." He'd stopped drawing the shapes on the table, and his eyes drilled into Gregorio.

A rebellious muscle moved in his cheek as if some angry worm were burrowing through the tissues beneath his epidermis.

"Wait!" he added with an unwarranted gesture, since Gregorio was listening to him without moving. "Wait, I haven't said everything! It's true, I'm losing an idea of love with Julia, something that's surely worth more than Julia herself..."

He looked at Gregorio for a long while in silence, his lips as tense as a knife. He was about to say something that cost him blood. His eyes seemed to swell.

"But the terrible thing is something else," he continued very slowly, in an unfamiliar voice. "What I can't stand, what drives me insane, is thinking she might belong to another man. That—that's what tortures me most of all."

A man of flesh and blood, but one who refused to accept his own filthy condition. Gregorio didn't know how to reply. This diabolical game seemed to bewitch and enervate him, like a narcotic. He began to understand exactly where his differences with Fidel lay. It was in their different attitudes toward the problem of solitude. While Fidel tried to deceive himself when it came to solitude, inventing lies about human beings and their superiority, Gregorio accepted solitude as a cherished fact and embraced it, without letting himself be defeated.

To let yourself be defeated was to compromise, to corrupt yourself, to cease being alone, to be complicit with

men in their vices and lies and shames—in other words, to become complicit in your own shames, lies, and vices, like the part of humanity you are. Fear or love of solitude; wanting or not wanting to endure it.

"This is the struggle," he thought. "To learn to live in solitude of spirit, to love this solitude despite—or really because of—the fact that all our suffering and anguish, which are the only things that are true and real, derive from it." Gregorio was trying to see life with a hopeless courage, without illusions, with an authentic hopelessness of spirit. He didn't expect any substantial transformation in man, and he believed even less in the childish notion of causality—typical of those eighteenth-century alchemists of materialism, especially the most romantic among them—that presumes a new man in a new world. "I don't want to commit that ridiculous poetic sin of the social dreamers," he said to himself, "that naïve mistake of thinking that the man of the future is good, stainless, free of evil (that Rousseauian weepiness we've inherited as Communists). No, I want to think about the only man who exists—real, contemporary man, essentially dirty, essentially ignoble, vile, contemptible. Thinking about him means not thinking about him as someone outside you; it means thinking of him as an indivisible moral whole that every one of us belongs to, with whom we have solidarity and for whom we are individually responsible—*individually*. I can feel horror at all the unheard-of cruelties of the Nazis in Germany and the Japanese in China, but I, Gregorio Saldívar, am guilty of them because these cruelties have been committed by *men like me*. I'm ashamed *for my own sake* that wars exist; I'm ashamed *for my own sake*, and there's nothing to exculpate me of all the crimes,

the nasty deeds, the vile acts, the sins that are committed on earth by men, by my fellows. And I can't go looking for solace in the idea that, in contrast to humanity, *I* am a moral, noble, upstanding person, and so on. None of that! I'm responsible for others the same way I'm responsible for myself."

He paused for a moment to try to come up with a general idea that would bring all these thoughts together. His closed eyelids insulated him in a reddish darkness, and through them he felt the restless presence of Fidel in front of him, like a shadow. An unlikely commonplace suddenly came to mind: "Workers of the world, unite." It occurred to him as a perfect example of the type of concrete, accessible phrases Fidel liked so much. "Well, there's nothing to object to there," he went on. "Unite! It's a proletarian solidarity that excludes everyone else, the bourgeoisie and the exploiters, but it still presupposes a general human solidarity that will be able to express itself fully when neither the bourgeoisie, the exploiters, nor the proletariat exist anymore. Human beings, unite! Perfect. But solidarity isn't enough in itself, it's not a characteristic unique to man, it's not a specifically human capacity—it's just an instinct that animals participate in too. The question is to find the specific thing that can distinguish man as man, that morally defines him as a concrete species different from the others. Man's task, if one exists, is to become himself, to separate himself from the animal kingdom. The problem is in acquiring, *from here onward*, the consciousness inside ourselves, inside our individual selves, of what man is as a whole, in his condition as a tangible, contingent being, always in the current moment, with his vices and his virtues. Solidarity

is a simple, mechanical instinct practiced by every species of animal as a form of individual self-defense; and so we urgently have to search for something like, say, a form of inverse solidarity, something that will destroy us, annul us, liquidate us, depersonalize us as individuals. And this form of inverse solidarity has to be a shared responsibility for good and evil—but a responsibility we each have under our own personal name. Now this could be the characteristic that distinguishes man, but only on the condition that we take it as neither a means nor an end, but instead as something naturally implicit in the laws governing man's development, his becoming, to the point of his final consummation."

Letting himself be carried away by his thoughts, Gregorio imagined for an instant the world of the future with its new society and men free of all exploitation. Would the men of that future society be better than men today? Absolutely not. They would be the same within different norms, in relation to different norms—that is, the same with respect to a new moral system in which good and evil would have different names than they did in today's world, but no more than that. A question of translating things, of transferring them to another scale.

The new world would come to pass, without any doubt, and Gregorio devoted all the forces of his existence to its advent. But humanity as a whole would never accept man's real task, or rather his total lack of tasks, his purposelessness, his defining condition, which is the affliction of being, the affliction of knowing himself infinite in time and yet finite within the limited span of his life and history. Gregorio thought that if human beings didn't destroy themselves—not such a remote or hypothetical possibility

at all—with capitalism, fascism, and wars, the society of the future still wouldn't be enough to erase one crucial distinction among human individuals. That is, the division of men into the majority who will never have metaphysical concerns, in the highest sense, and a minority—representing the majority—who live perpetually tortured on the rack of uncertainty and doubt, of whys and what fors. It wasn't far-fetched—Gregorio smiled at the idea—to imagine humankind's final revolution, a revolution of men no longer divided into classes in a Communist world, as a revolution against remorse. The great, idiotically happy masses, drunk with the conquest of bliss, would put the philosophers, poets, and artists to death so that they'd be left in peace once and for all—tranquil, prosperous, dedicated to sports or some other toxic equivalent. And so the cycle of history would come to a close, to recommence a fantastic prehistory of technological mammoths and civilized brontosauri.

Gregorio smiled again. No, it wasn't that future revolution of blissful men that concerned him. He felt a painful, searing anxiety when his cheerful comrades didn't understand him. They were all infected by Orison Swett Marden or Henry Ford and believed in the duty of Optimism with a capital O in the same dogmatic way other people believed in God. There was Fidel with his tragic, risible optimism. Fidel concocted Julia, a woman who didn't exist, an entirely abstract chimera of love, a double of his own cold fire and his own capacity for sacrifice and death—but, and this was the curious thing, without deceiving himself about this woman's nonexistence. At heart he had to be aware of the fact that Julia was just a human being, with all the relative qualities of

a human being: someone who, when placed in certain conditions and circumstances, will react to them, now like a faithful, self-sacrificing, loving wife, now like entirely the opposite. But the fantastic thing about Fidel's behavior was that it was precisely the opposite of what reason dictated—firstly, he acted as if the woman he'd invented really existed, and secondly, he acted as if Julia were constant and invariable in her ethics, no matter what eventualities might arise. It really was a diabolical game, Gregorio thought, but one that was fascinating for its painful audacity, for its hair-raising risks, for its senseless daring—and for its agonizing cowardice.

Fidel used this procedure, this philosopher's stone that made experiential truth out of lies, to plunge into a labyrinth of proofs that would verify his romantic schema. And even when the proofs were false—false, but *in favor* of his schema, which made them true—they safeguarded his moral system, gave it strength and spirit, and bolstered his faith. His faith. He needed a faith. "As long as such a woman and such a love exist, so great and absolute," Fidel seemed to say to himself, "I'll be able to preserve my own purity and rectitude."

Gregorio paused, disconcerted. To live without becoming corrupted, then, did you have to live under constant moral self-deception—a higher form of deception? His mind responded with a furious no. Life, it's true, tends to make us cynical and mean. Thus, to be able to live with dignity—the only possible way to live—we need to live life as it is but act individually as if it were different and nobler: like madmen, like enlightened beings, like idiots, but with no illusions, without the defense or solace of any self-deception, like the self-deception Fidel

sought in Julia—simply naked, alone, unarmed. "But still," Gregorio wondered, "I'm part of all this filthiness of life too, aren't I?"

There had been a long silence. The atmosphere filled abruptly with mistrust and confusion.

Fidel felt exposed, utterly exposed. From now on it would be impossible to conceal his tricks in the face of Gregorio's inhuman, violent, stark penetration.

"Look," he said with great effort, "I wish I could tell you that I don't love her anymore…"

Gregorio pressed his lips together.

"Of course, I understand," he said in a dull hiss. "You can't say *I don't love her anymore* about a woman until she no longer exists for you, until she's definitively dead. But before that moment comes, there'll be a whole litany of hesitations, doubts, and fears, the sharp, painful desire to be with her again… The terrible thing is that you'll never give up, you'll never let Julia stop existing *inside you*, because you've created a Julia inside yourself who never existed. And that's the most romantically idiotic thing imaginable."

Fidel felt that an unbridgeable distance was establishing itself forever between Gregorio and himself. Gregorio let his hand drop like a lifeless weight onto the table. His words became mysterious, as if he were speaking a secret, coded language.

"It's because we're still so poor…" he said weakly and enigmatically.

He got to his feet with a careless, fatigued expression. He thought about his illness with displeasure and a revulsion that was at once painful, ironic, and sad. "Look at me, I'm sick with a disease I caught for ethical reasons,"

he thought sarcastically. He couldn't believe how quickly the infection had progressed, already becoming unbearable. "But the worst part," he thought, "is this sensation of being an invalid, of feeling like I'm different, inferior to everyone else, separated from everyone else by a wall."

He walked a few steps into the patio until he stepped on the edge of the straight line of shadow that traversed it all the way to the facing wall. Fidel followed him with his eyes, vaguely hating him.

A tall, skinny man with dangling arms that didn't seem to belong to him—they moved somewhat independently of the rest of him, like a marionette's arms—wearing very short, tight denim pants, his head small and spherical, with enormous, sad ears and round black eyes like a monkey's, came in through the doorway, looking around for a moment and then striding directly toward them. He was smiling. Fidel rose to meet him. The man greeted them both with admiring affection and polite, respectful esteem. He was the president of the Unemployed Workers' Council.

"Our little comrades are going to meet in an hour," he reported about the Council assembly which was to approve the "hunger march" to Mexico City. He used the diminutive the way they did in Puebla, a locution that was vaguely paternal and also humble in its way, since he was speaking as the leader of people who, as a polite formula, had to be belittled slightly in front of visitors to their home; at the same time it was an expression of servile affection. "They've all been notified. The Party group agreed on the hunger march last night, so there won't be any problems in the Council"— he was referring to the customary procedure by which the Communists in any "nonaffiliated" organization would

meet ahead of time to define the points of view and proposals they would advocate in the mass meetings.

Animated, he turned his face hopefully toward Fidel:

"Will little comrade Fidel give us a bit of orientation at the meeting...?" he asked smoothly. Used this way, the diminutive was appalling.

Fidel had recovered the practical, objective, firm bearing of a Communist leader.

"No, comrade Cabaña, comrade Saldívar here is in charge of joining you in the name of the Central Committee. I have to go back to Mexico in a few minutes, on the next bus. I only stuck around for a moment to eat."

Cabaña rubbed one of his elephant ears with the palm of his hand. It was a tic he couldn't suppress, even in public when he made speeches.

"What a shame," he said, "but so it goes!"

An elephant's ears, but at the same time they were a bit like the extremities of a palmiped—wide and membranous, very sad on the head of a human being, to the point of making you feel sorry for him. He added something with an apologetic air about where the meeting would be held, and left quickly the same way he'd come in, with long strides that made his shoulders rise and fall, dehumanized and asymmetrical like the racks of clothes carried by itinerant garment vendors that bob monstrously above the multitude in the streets.

The sky, unexpectedly clear of clouds, poured a plural, unanimous clarity into the space, a clarity that was felt in every corner.

"I almost forgot to tell you!" Fidel exclaimed suddenly, slapping his forehead with the palm of his hand. "Bautista

Zamora... do you remember him?" Gregorio gave a puzzled look. Why wouldn't he remember Bautista? Fidel's cheeks turned red. He himself didn't know why he'd asked this stupid question. "Well," he continued, "a week ago Bautista was in Atlixco. He has orders to come to Puebla to help you organize the march. He'll arrive tomorrow or the day after that." He paused a moment to reflect. "All right. I think it's time for me to go. Will you walk me to the bus?"

They walked out of the Council in silence, side by side, with the mutual certainty that something definitive had sundered them for good.

*

After seeing Fidel off at the bus station, Gregorio headed quickly to the clinic he'd noticed ten minutes earlier in a nearby street.

Over the wide entrance gate, white letters against a faded blue background announced that this was "Public Outpatient Clinic Number Two." A large old house had been adapted for the clinic's various departments, their closed doors facing a shabby little interior yard. But the arrangement looked strange and unnatural, perhaps because the building wasn't originally intended for use as a clinic, or perhaps because the white glass in the doors made them look bound and gagged.

Gregorio crossed the little yard toward a small doorway over which was written *Information*, black and ugly against the plaster of the wall, in the clumsy, unprofessional lettering you see on signs in barracks. It lent everything a depressing aspect, giving him the sensation of having entered a jail.

As he passed, three hideous pigeons, as horribly fat as chickens, moved aside calmly, showing no desire to fly, with a satisfied and almost obscene air. Gregorio entered the office with unexpected timidity, shaken.

A gruff and somewhat masculine woman, wearing a white coat whose pockets bulged with dirty handkerchiefs, a ring of keys, and a pack of cheap cigarettes, sat motionless in her chair behind a desk ridiculously small for her proportions. She showed no surprise when she heard Gregorio speak the name of the illness. Her response was to hand him a grimy slip of cardboard with a number on it and point toward a door at the far end of the narrow lobby.

Gregorio, despite the woman's gesture, didn't move, but stood perplexed in a pitiful attitude of forlornness, of impotent loneliness. The woman looked at him mockingly, her gaze deeply scornful yet clouded with complicity.

"You're sorry now, aren't you?" Her tone was merely sarcastic at first, but then it became perverse, dull, spiteful. "But how about when you were screwing?"

Gregorio closed his eyes partway. It was a lash of the whip. He would kill her. Right there, the filthy rat, without pity, he really would. "I'm not a man to her, I'm not a human being," he thought with a sensation of orphaned sadness. He had the bleak feeling that this woman was profaning the most pure and beautiful thing in existence, all the loveliness and fertility that sex contained, all the sacredness and splendor of that affirmative, dignified, joyful, free act. "Worse, worse than the lowest prostitute," he thought as he walked toward the door with a lump in his throat. "And I didn't say anything back to her, I just smiled like an idiot." That the

woman might have interpreted his dumb smile as a sign of acquiescence, of admitting his own blame for catching the disease, wounded him to the quick. He felt an impulse to burst into tears.

He then found himself in the waiting room, among twenty other people, sitting on the end of a gray bench next to a greasy white bin with a yellow-stained piece of cotton sticking out from beneath its lid. A faint stench hung in the air, a mingling of phenol, iodine, urine, filth, saliva, vinegar. It seemed the people gathered there were emitting it, as if each one of them carried the stench with him, along with his sad human condition, inside his underclothes, aware of it with a melancholy humiliation, ashamed and imploring.

Without consciously meaning to—perhaps it was simply one of the unconscious means his disease used to gain an awareness of itself, of being lodged there inside him, undeniable and unconcealed, in front of these fellow people with the very same virus who waited there with their own cardboard slips in their hands—Gregorio breathed in the air so as to perceive this ill-defined smell, as if he wanted to measure it, analyze it, break it down into its component parts. He almost seemed to taste rather than smell it, to the point of feeling nauseated. An unspeakable sweetness, something between the smell of a corpse and the scent of candy.

The patients' intensely questioning eyes followed a thickset nurse with indigenous features and short legs as she crossed the room with a haste that had no purpose other than to lend her just the right amount of confidence and superiority. She walked toward the door of a doctor's office that connected to the waiting room without looking at anyone, master of the high rank that the

patients in their low and invalid state gave her by contrast, but she couldn't avoid a light, artificial emphasis in her gestures that betrayed a pleasure in this ephemeral, unaccustomed superiority—an undeniable sign of how different, how insignificant and servile, she must be in front of her superiors.

As soon as she disappeared, everyone returned to their sad, resigned indifference. The hope they'd harbored for an instant that this woman, who knows why, would solve some conflict in their existence, their health, their future, their happiness, was dispelled completely.

Gregorio looked around at the others with resentful fear. For the most part they were poorly dressed laborers, and even the ones who appeared the least intelligent had a thoughtful look in their eyes, for they were preoccupied by a single idea that wouldn't let them go, even for an instant: their sickness. Bitterly, he thought that just as he was unable to conquer his muted reserve and mistrust toward these people by virtue of knowing what they suffered from, other people in turn, people who mattered more than these—the healthy people, the men and women he knew in that distant world that wasn't this world of sickness—no matter what attitude they might show outwardly, once they knew he was a victim of this unspeakable disease, would become (and already were, in fact) foreign to him, cautious strangers, full of reticence and hidden duplicity. All of them, both men and women. Especially women. He abruptly realized he was staring vacantly at a young student sitting in a corner, who blushed under his gaze, somewhere between apprehensive, uncomfortable, and ashamed. Gregorio felt sorry, felt an obscure pity and a distressed

urge to beg the young man's forgiveness, but before he could, the student, overwhelmed by the clairvoyance with which he'd read Gregorio's thoughts and distorting them only slightly to imagine they were directed at him, pretended to bury himself in a book while his face grew alarmingly red.

Gregorio turned to look at something that had been outside his field of vision while he was staring at the student, but which he'd discerned with a sort of implicit visual memory—something that had remained latent in the depths of his eyes after he'd seen it earlier without being conscious of it, and which had struck him only as the vague impression of a sharp, vivid color. This was a woman in a red skirt of stained and wrinkled artificial silk and an open-necked black sleeveless blouse, whose eyes were obstinately glued to the floor in an idiotic stupor, blinking at long intervals. Next to her a man murmured words into her ear, his eyes all over her, his demeanor covetous and immodest, while he toed one of her ash-blue satin high heels with his shoe. The woman gave no sign of hearing, but suddenly she shook with a tremulous, naked giggle, without taking her eyes from the ground. In a hoarse, clownish voice she said with perfect clarity, awful and barbarous: "But how about it, now that we're gonna get cured?" Gregorio felt a dry and icy substance strike his brain and slide down his spine, spreading through his body, paralyzing him with suffering. "But how about it, now that we're gonna get cured?" The same scatological boldness the woman in the lobby had, the same vile baseness. "God, God, God," Gregorio murmured, unable to contain himself. God, was this what human beings were?

He looked up and scanned the wall above the prosti-tute's head until he saw a hygiene propaganda poster that he didn't understand at first. Little by little the image of a boy with no pupils, like a horrible statue, crossing the street in his denim suit while an automobile hurtled to-ward him, grew clear in all of its sadistic cruelty. "Blind because his parents didn't get treated in time!" read the caption. The eyes of a statue, white as milk, and his lips pulled back in an aimless smile. Only a wicked soul full of rancor and spite, only someone very unhappy, very lonely, could have come up with this cruel and ineffective pro-paganda. Gregorio stood up abruptly, ready to flee this hellish place.

"Fifteen, sixteen, seventeen, eighteen, nineteen..." said a hateful, squeaky voice in the waiting room, with a curt, empty pause between each number.

The nurse's aide, an asymmetrical and deformed being, an angular lizard, who truly had saurian eyes and a small malignant head, her temples sunken as if they'd been dented by a finger, was lining up the sick people in nu-merical order to enter the doctor's office, scolding them, shoving them around with the assurance of a sergeant.

The patients didn't protest against this offensive vio-lence, but rather climbed over each other in their eager-ness to fall into line the best they could, submissive, show-ing a hurried and servile gratitude.

But suddenly the lizard-woman looked surprised, in-credulous in the face of a phenomenon beyond all logic. Her long, aged neck craned all about with the tense, an-gry precision of an asp.

"I said nineteen!" she shrieked. "Number nineteen! Where's number nineteen?"

Gregorio felt a chill and a sort of vertigo, the objects around him seeming to expand in his vision. "Here," he said painfully, and then, without protesting, just as submissive as the rest, he took his place in line.

Inside the doctor's office he was assailed again by the same sense of bitter helplessness he'd felt in front of the woman in the lobby, that disturbing sensation of indignity and offense. That collective thing. That sense of being crushed. He looked at the men who'd been called in the previous round, seated there in a line. No. Complete nakedness wouldn't be horrible. Perhaps there might even be a certain pride in it, the beauty of something clear and direct. What was horrible was the *partial* nakedness of these people seated there calmly, as if they were sitting on benches in a park. Except they were very attentive to their own bodies, their pants lowered, almost appearing satisfied with their sickness, their eyes fixed on a single point as if they were meditating deeply and stubbornly on something very serious and hard to comprehend. Fixed on a single point between their legs, on the awful metal probe the thickness of a finger, another inhuman sex organ penetrating their sex organ, dehumanizing it as it emerged like a key, like a monstrous can opener.

None of them seemed surprised or even interested by the other five patients standing there. Their attention was placed there on the spectacle of their own selves, the astonishing spectacle of this intrusive, hostile material lodged in the dark precinct of their genitals.

The patient in front of Gregorio turned toward him, extremely pale, as if to demand his help, his support. It was the student from the waiting room.

"Here... in front of those women?" he said in the faintest of voices, indicating with his head the aide and another

female nurse, who stood next to the operating table. On the table there was an apparatus of filthy—though disinfected—yellowing rubber whose bottom end opened over a bucket, almost full to the brim, into which the liquid used to flush the patients dribbled in an insistent, resonant, discontinuous stream.

After saying this, the student forced a clumsy, shamed smile, a grimace of apology.

"How stupid!" he went on. "Actually it has nothing to do with anything. It's perfectly logical."

An obsessive yet distant gleam shone in Gregorio's eyes.

"It's not logical at all," he thought in response.

The first patient was now on top of the table, his skinny naked legs trembling, while the purple liquid in the irrigator flowed down under the calm vigilance of the second nurse and the doctor applied the cannula, making the man's hands clench with pain, twitching like a frog in a lab. Gregorio felt a sharp pain like a needle in his sphincter, an unexpected reflex of organic sympathy.

As he viewed this scene, anguish gathered in his throat—a shadow, a noise, a little animal in his throat.

At the other end of the room, with the priestly air of a stern warden, the aide went back and forth between the men who were being subjected to the probe. This was her kingdom, her inalienable domain. There was something poignant in her attitude, something revoltingly dignified and solemn. Then all of a sudden she paused with a malign and calculating expression, and, after checking her watch, leaned, with the impertinent closeness of the near-sighted, over the sex of one of the patients, who blushed in torment at her unexpected scrutiny. The aide was in her kingdom. She wasn't about to renounce this protocol of humiliation

with which she sank her teeth into the patients. The tor-
turing can opener jutted out, tense. The woman prolonged
her examination interminably, but then abruptly, without
warning, yanked on the probe with cruel gusto, making the
patient jerk while he tried to stifle a hoarse shout.

Like an officiant of a severe religious cult, the second
nurse had an impassive, esoteric air. As she dispensed her
treatment she gazed at the sex of each sick man with the
blank and absent fixity of someone who isn't thinking, or
whose thoughts lie a great distance from what she's look-
ing at. She might have been in love with a prince from an
Oriental fairy tale. She seemed far from the world. But
the doctor finished with the patient and she stopped the
liquid with a pinch of her fingers on the tube, with a deft,
smooth efficiency that was hard to believe given her ab-
sorbed air. A priestess. One of Torquemada's assistants.
Her eyes burned like two coals, perhaps made solely for
caressing her blue prince with their gaze.

Gregorio took two steps forward, undoing his belt and
holding his pants up with his hands. It was the student's
turn, and he climbed onto the operating table with the
movements of an invalid, clumsy, stunned, and confused.
Gregorio felt his own knees tremble. A few more minutes
and he'd be there too, reclining on the unclean rubber on
top of the table, alone, alone in the world.

Unintentionally, he looked straight into the eyes of the
second nurse, almost out of sheer timidity. The priest-
ess's eyes seemed to accept the challenge and bored de-
fiantly into Gregorio, two icy flames full of an incon-
ceivable scorn. Gregorio clenched his teeth. "That stupid
woman, she's going to think I'm hot for her," he said to
himself, and the thought kept him from tearing his gaze

away, impelling him with animal hatred. The woman's pupils glowed with rage.

"And they still have the nerve to stare at a woman!" she said in a cold hiss, her dead eyes fixed on Gregorio.

The doctor turned his head slightly toward her, like a bird.

"Sorry, you were saying?" he asked, and when he received no answer, his affectless gaze returned to the spot it had been looking at. "Next!" he said, suddenly sad and tired.

The student, with his pants gathered between his hands, jumped down from the other side of the table in a ridiculous way, like a tadpole.

Gregorio listened to the doctor's questions; they had the unreality of words heard in a dream.

"It's your first time here, isn't it?" The doctor addressed him informally, just one more manifestation of all this abasement and measureless contempt. The doctor's hand, like a prosthetic hand inside its black rubber glove, squeezed hard as he auscultated. Gregorio couldn't keep himself from cringing in pain.

The doctor's voice grew cavernous, reproachful:

"They're worse than animals," he said despairingly to the nurse. "Our *friend* here should have come at least two weeks ago. Look at this—" and he pointed. The nurse's lips drew back with repugnance.

Gregorio felt a sob rise within his chest, so solid it was corporeal. What the hell did this doctor know about how he'd contracted this goddamn, stupid, miserable disease?

An act of love, of gratitude, of desperation. Perhaps, though, something also very close to suicide. With this conscious and deliberate infection, Gregorio was

cleansing himself, making a sacrifice of his sex, an affirmative act of renunciation with which he reintegrated into his being the sense of purity, isolation, and solitude he needed in order to receive, in his own flesh, an indication of the destiny of his fellow men. For if he were capable of letting go of one of those supreme inalienable goods—whether it be health, love for a woman, or something similar, it didn't matter exactly what—those goods that we cherish so much, and which for this exact reason can end up becoming the supreme obstacles that keep us from enduring the true despair and solitude that men must aspire to, if he could give one of these goods up, then this would mean that other men, other human beings like him—humanity in general—could also, in the order of things that came, accomplish the absolute relinquishment, the absolute renunciations, that would make man into the human being *par excellence*, the proudest and most sorrowful being, despairingly conscious of his humanity. How one got there didn't matter; it would always be a matter of mere accident.

Epifania, the prostitute from Acayucan, had resisted up until the last moment, and Gregorio, of course, could supply no reason to convince her. In the end she gave in, though, without arguments, without words, simply by amorous submission, like an ordinary, dark beast.

For Gregorio it was a voyage, a visit to a non-terrestrial atmosphere. The sexual act's similarity to death, the sameness of the two things, suddenly became clear and impossible to doubt. How to describe it? The woman throbbed beneath his arms and he throbbed above her. Both of them a single body, one inside the other. It was a cessation. A cessation precisely of nothing, an

inexpressible blackness, a will toward being, toward existence, but also toward Non-being. The return to a neutral point in which one isn't yet, but is about to be, or the reverse. Much more than pleasure—strictly speaking, no pleasure at all: a transitive state, a disintegration, an attempt. A passage through that place prior to thought, where matter vibrates at the very moment in which it will take on a new form, or reacquire its old form. Prior to speech. Death. Without any doubt, Death. Gregorio remembered Epifania's image, her naked body on the straw pallet, calm and gentle after the mortuary act of possessing her.

He knew that she loved him, possibly, as no woman ever had. He remembered One-Eyed Ventura's words by the river, the night when they'd discovered the body of Macario Mendoza. "If someone who loves you hadn't gotten rid of him, your hide would've been strung up to dry before you knew it." Someone who loves you. Now Ventura's behavior was entirely clear, the mystery in it, the prophetic guile in his single eye.

Gregorio had gone to Epifania that morning simply to find out the circumstances under which she'd killed Macario Mendoza, but everything had turned out differently.

She was waiting, frightened, in a corner of her shack, her great round eyes opened wide with candid fear.

"Please, don't hit me!" she begged in a feeble voice, shrinking from him.

The light of dawn through the sticks and branches of the shack was like the used, soapy water from a laundry tub.

"No, I'm not going to hit you," said Gregorio. The woman looked down at her chest, her eyes lowered.

"Well then?" she asked, raising her chin toward Gregorio.

"I just want you to tell me how you killed him."

The woman made an imperceptibly happy gesture and walked out of the shack, heading toward the marsh. This was a dead arm of the river that became a muddy swamp, over which a tree trunk was laid as a bridge. She told him the details, pointing at the old tree trunk, where Macario had slipped:

"All I did was rock it that way a little bit. The marsh swallows everything."

Gregorio remembered listening to her tale silently and impassively. Afterward they went back to her shack together. Gregorio clasped her around the waist, but she reacted with alarm.

"But really, don't," she said in a trembling voice. "Don't do something you'll regret." She addressed him formally, as if to make her refusal more serious. "I'm sick with a real nasty disease," she added softly, with humility.

That was the whole story.

Gregorio heard the doctor's voice with its suffering, tired air: "Next."

For a few seconds he didn't understand, but then he hopped down from the other side of the table, half-naked. He was sure his movements must be just as comical and pitiful as those the young student had made earlier. Just like a ridiculous tadpole.

IX.

...and knowest not that thou art
wretched, and miserable, and poor,
and blind, and naked.

John, *Apocalypse*, 3:17

The sensations were the same he'd felt on that immense-
ly dark night on the banks of the Ozuluapan, but now
deeper and more pronounced because of his solitude. He
couldn't say how long he stood there without moving,
alert, muscles tense. Had it been a half hour since they'd
tossed him in here? It was impossible to say. Time simply
didn't exist. It wasn't even like blindness, for the blind
have their way of perceiving time with eyes of some sort.
No: when Gregorio could see nothing, the passing of time
lost its reality for him, and, strangely, this was precisely
because he wasn't blind. Nor did the darkness become
penetrable the way it always does after a few minutes—
that confused and gradual revealing of forms, here some-
thing sticking out, there a denser body, there an angular
contour. Instead it remained limitless, without any refer-
ence or dimension: empty.

Maybe a half hour, but also, probably, two hours. Or
four. Muscles tense, motionless, ferociously alert. Even
the sound of the door slamming behind him was nothing
but nostalgia now, nothing but pain, the emptiness of
no longer believing the sound existed. Like an auditory
frontier, a line in the air, and on this side of it he now
found himself in another country, a territory without
contours or surfaces. A sound that surely had existed,

but which he couldn't be sure of now. The imprecise memory of a dream.

He finally managed to move with the anxious, guessing slowness of someone forming his very first words. His back to the wall and his palms flat against it, he ventured six half steps to one side in an infinite gliding, until he reached the corner where this first wall ended. Like reaching port. As if he'd arrived at a dock in the shadows that made it possible to know the space wasn't endless.

"Almost two meters," he murmured. He felt the perpendicularity of the other wall against his shoulder, a firm, living pressure, and, gradually, magically, a certain laborious and primitive notion of a cube formed in his brain. The form this idea took—as if this were the first time in history it was being experienced, though it was less an idea than a series of nameless and novel feelings— was the abrupt sensation of a plunge through the endless void in which his body had floated; it was the assurance of belonging to something, the regaining or acquiring of a homeland, a territory of the concrete, and at the same time it was also the sensual satisfaction, the joyful astonishment of being, as if through an act of your own will—through self-conception, self-begetting, precisely the act of giving birth to yourself, emerging from your own womb like the ancient gods.

He walked three more steps in the new direction, but suddenly his shins collided with something cold, hard, and stubborn. This unexpected object was a second being, almost a second self, the first fellow-being he'd stumbled upon as his intelligence progressed toward knowing the cube, something as kindred and as opposite as a wife, an Eve to his Adam. The solemn terror of finding

a new shape in a part of the cosmos where you couldn't imagine encountering anything but the limited number of assumed dimensions, the elemental boundaries previously constructed in the mind. He was like the astronomer who, despite his calculations, is suddenly surprised—not because it's a fluke occurrence but because he lacks the blindness necessary to orient himself in the blackness of space—by a secret planet that might turn out to be the only one that truly exists.

In the beginning was Chaos—not disorder but Chaos, simply a stage prior to experience, in which nothing and no one had determined itself. Then there was light, and perhaps then—as in Gregorio now—a kind of mute language had begun, with which the Forms (in the beginning were the Forms, and Gregorio, too, was and began as nothing other than a Form) communicated among themselves by means of furtive touches and stammering caresses. From here forth Gregorio was less alone—his idea of the cube would no longer be the idea of the cube alone, it would be the idea of something else at the same time, the idea of this thing here at his knees. He was less alone now, even if it was an inanimate object that kept him company, for its previous absolute nonexistence was enough to make this matter now take on life: Gregorio's mind hadn't granted it prior existence, and now suddenly finding it here gave it an equally absolute condition of being.

Now an extraordinary learning process began for Gregorio. Hitherto unknown things began to reveal themselves faintly, one by one, coming out of the void. A magician or sorcerer pulling weird and fantastical objects out of his black top hat, a bat's wings, a horse's eyes, a moan—or more still: stupendous objects that must be

ciphers, hieroglyphics representing the earliest states of the soul. Like an infinitely long, dark tape without end, a symbol of the strange, ambiguous anguish that is the birth of the consciousness of your own self, the consciousness of being in a certain spot; or something like a pair of lips, a kind of tongue, a kind of salivary secretion, representing what surely must be perception, the cognizance of the fact that you're a living animal purely through touch, with all the other senses desperate, useless. Touch as the earliest manifestation of life, prior to intelligence, like in jellyfish or paramecia, amid the long shadows.

A blind man might walk from one point to another, might measure, establish. But for Gregorio this was the process of nothingness, the moment when one's consciousness, in the throes of existing, acquires the elemental data of knowledge, in suborganic form still, but can't yet give this knowledge name or place or measure. The earliest learning about things, the First Day of man, but at the same time the opposite, for entering existence is equivalent to leaving it, and, for the human mind, acquiring ideas is identical to losing them, a supreme transition that's simply the petrified impulse—you could just as well call it crucified, an impulse that redeems all on the cross— in which nothing is real but desire in its rawest, starkest antonymic nature: desire and the opposite of desire.

He understood all this by means of an augury, a portent, a hazy presentiment. It was death, the other extreme of the faculty of understanding, the process not of coming out of nothingness into existence but of going from existence into nothingness, the moment when the data of consciousness start to assume other names and forms until they become nameless. The throes of death, a strange,

jubilant passage of surrender and transmutation, of hal-
lucinatory distortion of perception. A certain quality of
dreams, the naming of things in a secret, strangely person-
al language that no one's ever heard before, not even you,
and which thus can't be translated. The image of someone
kissing us or stabbing us with a knife—anything at all,
down to the simplest image possible, the drinking glass
by your bedside, a bedroom ceiling, the view of the city,
anything we can remember—and then the transmutation
of this image, the construction of an inexpressible mino-
taur or Medusa's head within us, and the kiss becomes
mud, the wound becomes a swan or a dog or a caiman or
a cloud or a tower or a ship, until all words leak away and
we're left with only a sole, ungraspable inheritance: de-
sire, the desire to pronounce words that don't exist. A loss
of memory through the strangest hybridities of thought,
the sight of new landscapes that have a dreadful familiar-
ity, that we vaguely recall with some other celestial mem-
ory, with a black and stuttering logic.

"Let's imagine we're thinking about color," Gregorio
thought, "and the last image we see when we die is, say,
the color red, and that this image is expressed at first in
its simplest manifestations." A flag, a spurt of blood, the
kerchief over a woman's hair. But then everything dis-
sipates: red is just red, abstract, the mere awareness of
red, a vault that imprisons us, the sensation of being the
center of something and at the same time that thing's sur-
roundings and circumference; and then suddenly not even
that, just a sort of dysphasia of red, which then becomes
the desire to remember something though we're not sure
what, and then the urge to be someplace else though we
don't know where.

A shiver of astonishment ran through Gregorio. In the language he was using, the anticipation of the sensory knowledge of death was recurring, under different conditions and for different reasons: this was what had tried to reveal itself on that night in Acayucan with the fishermen. But now his solitude enveloped him in a darkness that encouraged the profound symbiosis through which Gregorio would convert himself into the herald and Messiah of his own self.

He was in his mother's womb, not as an embryo, but at his current age, manly and naked. Her warm walls, her vast tissues. She was infinity and death. Beautifully, death. He dwelled inside her, dumbfounded; he traveled through her, unable to imagine her bounds. Strange network, unknown homeland, tank of dense air where you coupled with death, savored it with your whole body, and were permeated with Chaos, with undiscovered elements. A sexual act before your sex is even formed. A sacred sexual act, the first foot upon the earth. Everything returned to that point of origin, that door whose threshold is the border between life and death and at the same time death and life themselves. It had happened with Epifania. The prostitute had for an instant, by virtue of a warm, mysterious transfiguration, in the moment of possessing her, been his own mother. His own mother in the moment when he lodged himself in her inner ducts, driven by a superhuman impulse to return to the womb, like a prodigal son of death, which is true love. Nothing like this had ever happened with another woman, because there was no other he'd slept with as a moral and essentially religious act meant to return him to his primordial lineage, an act that would encapsulate and exalt the condition, the

destiny, the history of all human beings. Man, he thought, has experienced sex as shameful because he doesn't think about death with any dignity. "Not loving death," he said to himself, "implies not loving or respecting sex—it can lead us to the worst perversities."

Death is transmitted from parent to child; it's nothing other than the unspeakable, painful, heart-crushing pleasure when the sexes join. We are death, inside our parents, and our children inside us, and we express it—children and parents in turn—through the delight our parents feel when they die one moment and which we all feel when we die in that dark and barbarous coupling, the will and yearning to be born.

When Epifania had given herself to him, she had made Gregorio recapture the incredible memory of that earliest and remotest sensation of being nothing but a crippled entity, an ovum and a spermatozoon each with a separate sentience, unconnected and uncommunicating, until their union formed the autonomous cosmos whose birth allowed his parents' love to undergo the grim, deep, Faustian pleasure of dying.

Now, from here, he thanked Epifania for this humble truth.

He stood there without moving for a few minutes, next to that object he felt against his knees, unknowable and yet, just like Gregorio himself, an addition to the cube, a kindred excrescence within the cube's inhuman rigidity and despotism. His foot probed in front of him with an agonized yearning to decipher the object. It seemed to be a little freak of nature, an obstinate, deaf little planet, stubbornly determined to not be born, to stay there in its shadows, powerful and hostile. A monster. There had to

be some language to know it by, some system of signs of relation. But for now it could only be defined in the negative: it's not a bird, it's not a church, it's not the sea, it's not an angel, it's not a woman, it's not an altar, it's not an arch, it's not an entryway, it's not a drop of blood, it's not a star. Still, there was the comfort of knowing it was something other than the cube, an enemy of the cube, in insolent solidarity with everything that was not the cube, giving the cube an unexpected, vulnerable relativity that Gregorio on his own, without a point of reference to help him, could never have discovered. Theseus facing the Minotaur, Theseus without Ariadne's thread. For this object wouldn't offer itself to Gregorio as a valid reference as long as he failed to recognize it, as long as he didn't know what it was, what its attributes were, its bounds or lack of bounds. It might be a bell, because of its roundness, or the statue of a small god, shrunken at the bottom of its tomb. What a shame that he wasn't blind so as to see it, that he didn't lack the use of his eyes so as to behold it. Nothing can escape a blind man, not even the smallest crevice. But no, not for Gregorio, who was made for the light, built for it, inclined toward it.

His spirit moved in the realm of magic, in the age of the mythological—subjected, enslaved to that idol there, that demon, that god who would explain everything. That God. Vishnu, Ahriman, Brahma, Jehovah, Shiva, Huitzilopochtli. He didn't know if it was a god of good or evil. Or of both. It wasn't going to yield itself to him, not at all. It was going to deny itself as long as he didn't pay a price, and not even in exchange for knowing it, but simply for being able to name it. For to give a name to the unknown is the same as giving it bounds—and here lies the illusion, the maddening

sleight of hand—while transferring to this unknown thing all the attributes of the infinite, making of it, at best, nothing but an infinity with a name. Now he understood that the Minotaur wasn't the cube—it was this object, this god. The cube was innocent, the cube was nothing but a slave as well. It was necessary, then, to placate the god, pay it reverence, keep it satisfied, invent a religion and cult to render it tribute. Because the Minotaur was also refuge and salvation, consolation and hope.

He continued moving until he reached the third wall, and there a strange noise coming from the monster made him stop in his tracks with joy, awaiting the revelation. The Sphinx was going to reveal the answer to its riddles. It was speaking. It was a miserable human being expressing itself in the language of men, a death rattle, a hoarse, animal cough. So very grave and solemn: he ought to laugh, but Gregorio felt the need to display humility and dismay before it, as if faced with a miracle. He should fall to his knees and pray before the marvel of these belches from the darkness of the sewer, for with this magical noise the monster named itself and emerged from the shadows, complete and clear, crisp and perfect in its eminent status as a toilet. "Here am I who elect you among all mortals to tell you who I am and communicate my essence and my attributes to you." The miracle wasn't that the monster had converted itself into a sanitary fixture, but that it had spoken in this language that gave it away. "Monstrum Dei qui tollis pecata Mundi."

Still with his back to the wall, Gregorio slid six half steps further until he met with the iron door, and finally he found himself where he'd started. He breathed. He had traversed the four walls of the cell, and in a certain way he

had taken ownership of the darkness. "About two meters long and one and half wide," he calculated.

Fabulous darkness, beloved shadows. They were the memory of one's being, the remotest animal memory. Man, born from shadows, began to exist because he was inside them, receiving them as his first perception, his first idea: all is dark, all is solitary, the links of a chain of infinite solitude. A million stars are revealed; then another million, then the galaxy in which our earth moves, and other galaxies, and others, and along with this the doubt of not knowing why or what for. We get past the first hill and beyond it rises the next one, and always, eternally, one more—one more century, man alone, wrapped in his shadows, a century and the mirror image of another century, a millennium and, again, without any possible end, the mirror image of that millennium. The never-ending circle of the night of humankind, from the night of our mother's womb to the night of the cosmos; the uncertainty, the uneasiness, the sadness, the hopelessness of man, like the fruit of his terrible origin in the shadows, of that first dart with which conscious life wounded him, and then that senseless, clumsy struggle, that mad combat against something man will never be able to get rid of, since he carries it inside himself like the mark that defines him: death. Why not recognize it, then, why not love it as a part of us, instead of deceiving ourselves and lying to ourselves about it? Why not accept the uncertainty, the eternal and endless anxiety, as the true, inalienable human condition? The only condition that's heroic and brave, the only one capable of granting us authentic dignity?

Gregorio readied himself. This was his secular mode of prayer and seclusion. He wanted to remember the events

that had led to his imprisonment, and the terrible things that had happened to him here in prison, but despite the clarity with which they appeared in his mind, they were foreign and impersonal and didn't belong to him anymore, they were no longer connected to his life. A soldier comes back from the war and when he sees his old house, the faces of his wife and children, when he observes all those things that once had or might still have some significance in his life, he feels that one of the two experiences, either home or the war, has stopped belonging to him—they don't fit together, they no longer match what he's become. Only one of the two will exist for him from now on: he will either be the man he was in the war—that unfamiliar, terrible man who has lost the right to cuddle his children and kiss his wife—or, if the war didn't give this other man inside him a chance to come to the surface, he will be the one he used to be at home, at work, with his family and everyone else he knew.

In the same way, what had happened to Gregorio in prison distanced him definitively, transforming him into a separate person, endowed with painful knowledge, stripped naked. It made him feel an immense gratitude for his destiny, which would let him die in peace at the hands of men. He couldn't understand his past in the same terms anymore: that past was something new and alien, with no link to him, the past of a stranger.

Even the physical pain—the swollen joints of his fingers, the sharp soreness hovering in his torso and kidneys, the excruciating throb of his jaw—didn't seem to belong to him, didn't seem to be his in any way.

He'd peered into an abyss to gaze for the first time, at its bottom, upon the face of his fellow humans, the true and

barbarous face, and it had made something new of him, something unprecedented, with no trace or register of any earlier part of his life.

He had to recall the facts, go back over them, assimilate them. No other way to prepare to die with dignity. It was as though the figure of the living God had presented itself to a believer in his final moments. This was his living God. And a fearsome thing it is to be in the hands of a living God.

The underlings at the prison had beaten him stupidly and savagely, but that wasn't all—there was also something else, some unspeakable other thing. Try as he might to describe what had occurred with detail and precision, he could never find words for that nameless thing, beyond any language, that he'd seen and felt. First, it had to do with a sort of amiability in the four men who'd led him through a narrow cement corridor, and the dreadful smiles they wore, like lovers. They looked at him as though they were looking at someone who, in a strange way, belonged to them. Friendly, with shining eyes. They took Gregorio into an elevator, which they stopped between the basement and the ground floor. So no one could hear. And it all started like innocent, cheerful, entertaining fun. The men had something childish and carefree about them, like schoolboys playing a slightly rough sport. When they stripped Gregorio of his clothes, they did it as if it were a parlor game, with loud and jovial laughter. They surrounded him; Gregorio was stunned with fear. The first man, behind him, tugged on his arm.

"Don't be scared, we're not gonna do anything to you, just give you a little warm-up. We saw what a big boy you were out there." An excited hiss sounded in his voice, at odds with the jesting tone of his words.

Gregorio felt the bones of his shoulder crunch as one of his tormentors, with a quick, unexpected, skillful upward movement, lifted his arm above his back, pulling off his shirt and tossing it to the man in front of him, who then, yanking on Gregorio's legs, stripped off his pants as his skull hit the floor. Then they tossed him between them like a rag, each giving a punch or a kick. Gregorio would never forget—and this had been the terrible thing—one of their faces, which had a gold tooth peeking out between its lips: a distorted face, alarmed, with wrathful eyes, and at the same time a man's face, the face of nothing other than a man, revelatory, hallucinatorily pure and just, distorted by the idea of justice and rightness. The face of the man who stands before his mother's murderer and feels the duty to punish him without pity. An extraordinary, fanatical face, full of astonishment and holy fury.

"What! Son of a bitch! You don't like it, huh? You think we're bastards?" The man had turned to his pals. "Look at him! The fucker doesn't like it!"

In the midst of the brutality, the savagery, there was something simply wondrous in these words. "The fucker doesn't like it! He thinks we're bastards!" Gregorio was being transformed from offended to offender. Words like a magic button you press to absolve yourself of all blame, to cleanse the executioners of all sin. "I thirst." So they gave him vinegar to drink: nothing more logically human. The lackeys had a banner to rally under now. "He thinks we're bastards." Now they weren't beasts, they were holy, justice-dealing human beings. And they really were, yes, with their beautiful men's faces hardened by hate, by crime, by rightness.

Two of them held Gregorio down by his arms and legs, and the others began to beat him joyfully and furiously, until he lost consciousness. His sickness did the rest.

Gregorio shuddered as he remembered the scene. It wasn't the beatings or the torture. It was those faces. The face of man, which no beast can have. The face of the hero brutally annihilating his enemy in combat. The face of the pilot who drops a bomb onto a city spread out below. The face of a seducer in the moment of possession. The face of Savonarola condemning sinners. The face of someone grabbing the seat in a lifeboat that should have gone to a child. The face, the face of God, because man is made in his image and likeness. Now and until the approaching end, Gregorio would see this face revealed in all the circumstances of his past, in the smiles of his comrades, in the love of women, in the expressions of the dying. Men could no longer conceal from him the secret truth of this real, hidden face. No one, no one would ever be able to hide it from him.

All retrospective images of what had happened now shone in a new light, appeared different and remarkable, in a turbid, rarefied atmosphere.

He tried to reconstruct that world of memories so near in time, but which he was so far from now. He could see the San Lázaro gatehouse beneath a gray sky full of heavy, ancient clouds. Then that group of men, women, and children on the highway, with a terrible hope in their souls, a criminal hope, their faces trembling with eternal things that had no relation to life, no connection to this earth.

Bautista and Gregorio were at the head of the "hunger march," and a short way behind them were Ventura and Epifania, who had joined them in Puebla after arriving from Acayucan looking for Gregorio.

The light of dusk was dusty and suffocating. The blue gendarmes stood out against it, demons with sabers held high, the blood drained from their copper-skinned faces. At around six in the evening they charged on the unemployed masses, and the battle went on until almost eight. The expression on those policemen's faces, that pallor absolute to the point of agony. They were insane, insane despite their children, despite their wives, despite their homes.

Gregorio remembered Bautista's profile, bathed in lovely, shining blood from a saber blow he'd received. Pure blood, a blaze, as if he were a saint, his eyes bright and his voice unfamiliar. That singularly deep, hollow, loveless, wrathful voice, not the voice of a man:

"Bastards!"

Above, against the sky, the electric cables, tangled at the tops of the posts like snakes in their nest; the parallel lines of the train tracks coming out of the station; and then the stoker who slowed down his locomotive at the checkpoint and, leaning down from the tender, offered his hand to Gregorio—which Gregorio didn't accept—to help him escape on board the train. "Hop on, comrade." The face of the railroad man, yes, and, despite his sincerity, behind its features the face of the executioner, fully convinced of the justice of his cause, his features distorted by this terrified conviction.

Everything had an incredible appearance, turned upside down. The face of the executioner. Some essential divorce had taken place inside the people, some deep rift had appeared that erased any resemblance they had to anything in the world, transforming them, making them astonishingly incomparable. It wasn't even the terror or hate some

felt; it was an element far darker and more primitive, and it was in all of them equally, pursued and pursuers, as if their souls had stopped existing. Precisely that. Beings who no longer had souls. Horrible equations.

The Society of the School for the Blind offered a terrifying spectacle. They had come to the gatehouse, along with several workers' syndicates, to greet the "hunger march." Those eyeless men were from another planet, a horrible submarine world. Each had his palms on the shoulders of the comrade in front of him, forming a chain, and they swiveled the void of their masks in the direction of the tumult, like fish out of water, the ceaseless blinking of their eyelids like the desperate gasping of gills. The officer charged them, along with six or seven other gendarmes on horseback. Absurdly, the blind men's orphaned hands clutched at the air like the frenzied claws of fifty raptors, anxious to sink themselves into any point in space. The men fell in the dust among the horses' hooves, and then dragged themselves away to flee with their particular venomous terror.

One of the blind men, standing on the base of a pillar, his face pitifully and imploringly turned toward the sky, his head leaning to one side, berated the police with pathos, but, sadly, in the wrong direction.

"Comrades! Brothers! We're all brothers! We're all comrades!" He tried to sum up in his cry an absurd message of fraternity, his visage distorted by an atrocious grimace of faith—it, too, just like the face of the executioner, sending its message into the void.

But the melee shifted to another part of the gatehouse and they all left the blind man behind. He went on with his harangue, but then suddenly he stopped, struck by a

tremendous realization. He was alone in the universe. He got down from his platform and walked with a thoughtless air along the street, sad and aimless.

At the other end of the gatehouse the mass of blind men marshalled themselves again as if by miracle. A certain agglutinative power of attraction, something almost dirty, a secret instinct, made them cluster in a single nucleus beneath an old arcade that was part of the former customs house. They sang "The Internationale" with alarmed voices, from the very depths of hell. "Arise, ye prisoners of starvation! Arise, ye wretched of the earth!" The muscles of every one of their necks seemed about to snap, while their eyeless gazes swung in all directions, green and wild, as if they could see everything, impossibly, all the way to the inside. Deranged by fury, a sergeant flung himself upon them with saber raised. He seemed possessed by a demon, his lips dry, his leathery cheeks completely bloodless. Someone, who knows who or how, managed to knock him down, and then the blind men fell upon him with a supernatural hatred. The sergeant made a vague movement, perhaps one of pleading, and succeeded in crawling two or three steps on his knees in a grotesque posture. They beat him all over, kicked him, hit him with rocks, trying to reach his eyes. His eyes above all. The sergeant seemed to smile with a confident, indulgent, almost amiable incredulity, the equivocal grimace of someone who doesn't think he deserves a wrong he's been dealt; but now that grimace was nothing but a deceitful expression of helplessness and fright.

Gregorio had managed to regroup one of the scattered segments of the unemployed marchers with the aim of leading them toward the center of the city. Their gazes drilled

into him with a kind of bitter and rabid faith, but at the same time a stunned look.

A woman held aloft her baby, a chubby little indigenous boy with the face of a Kirghiz, showing him off like a banner—she was possessed, insane, mute, her hair undone, her eyes popping out of their sockets, her lips moving without saying a word. Gregorio, standing on a canister and addressing the marchers, didn't pay attention to her. But the woman advanced through the crowd, a black ship with its triumphant prow high above the waves, still holding the child aloft, until all could see, on the young creature's body, a machete wound that had sundered the fragile little bones of his shoulder. The baby looked tranquil, the color of ashes, not suffering, with his little eyes unmoving and devoid of light, the cold eyes of a fish. Again the face of the executioner. Again the face of men, displayed in the little boy's features.

Gregorio didn't have time to find out if the baby was dead or alive. At that moment a new cavalry charge forced the crowd back against a wall and suddenly, before he had time to react, he felt himself grabbed by two agents who immediately put him in a police truck.

His memories were suddenly eclipsed. He looked around his cell again. Now he could see certain things, almost by a kind of divination, a kind of ordering that lent him confidence. All of this, he thought, was simply the form of his destiny. A destiny he was called upon to consummate at any moment. Soon the moment would arrive.

"Destiny," he thought, "means only the consummation of your own life in accord with something you want to arrive at, even if the form this takes might be unexpected and surprising not just to everyone else, but to you as well." He had an enormous curiosity as to how his life would be

consummated, and at the same time this made him feel somehow ashamed, as if he were enjoying an undeserved boon. He thought about his comrades. In time they too would attain this privilege of consummating themselves according to what they aspired to. According to what they aspired to, yes, because this ambition doesn't have the same essence in everyone. In a certain way it's a private, personal matter, dependent on temperament, and each person has to find it for themselves. For it's a question of bearing your own inner truth, enduring it, even if this truth is a lie. "Enduring the truth," Gregorio thought. "That's the right way to pose the question, because the truth is the suffering of the truth—not so much the determination of whether this truth is true, but of whether you're capable of bearing it on your shoulders and consummating your life according to what it demands."

He constructed in his imagination the tormented and torturing world of men, and the more it took on consistency and contours within his mind, the more troubled he felt, and yet he was also placid in a certain sense, feeling something like an enjoyable suffering along with certain confused desires, certain nostalgias, and a kind of painful need to be protected and loved as if he were a helpless child.

"To bear the truth," it suddenly occurred to him, "but also the lack of any truth."

At that moment the sound of the lock in the iron door made him turn around. The door clanged open and light blasted into the cell. The executioners again. Gregorio didn't move.

They would bring him somewhere else, no doubt, to torture him again. To crucify him.

That was his truth. It was good.

Archive 48

This book would not have been possible without
the generous support of:

José Pedro Jiménez Fernández Somellera
Alejandro Castro Jiménez Labora
Rodrigo Peñafiel Torras

We would like to thank you for your generosity and honor
your commitment to this peculiar publishing venture.